THE
DIGITAL
RENAISSANCE

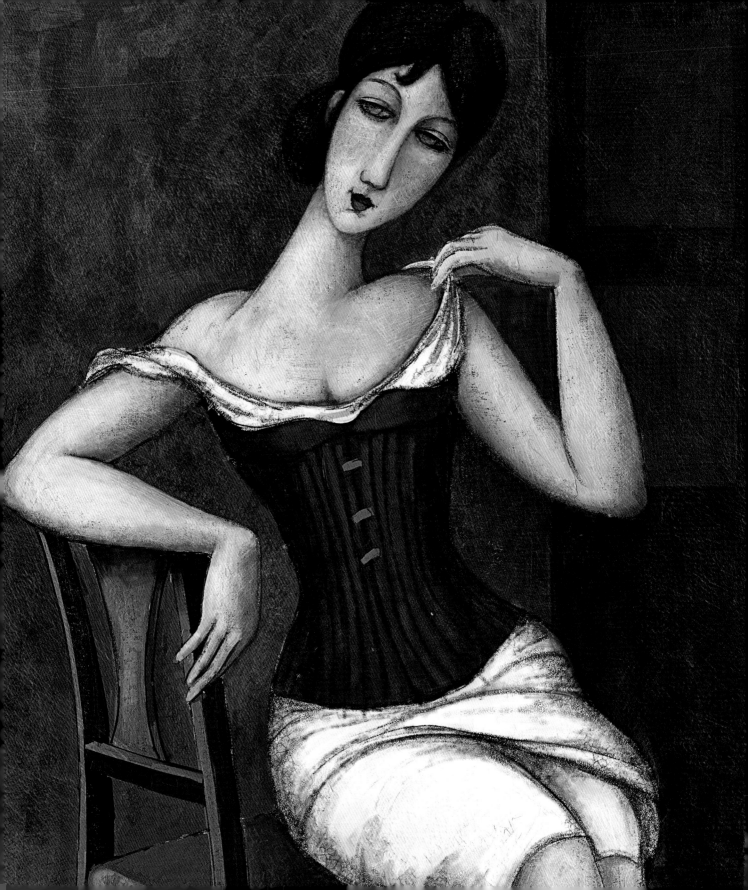

THE
DIGITAL
CARLYN BECCIA
RENAISSANCE

OLD-MASTER TECHNIQUES IN PAINTER AND PHOTOSHOP

ILEX

THE DIGITAL RENAISSANCE
First published in the United Kingdom in 2014 by
ILEX
210 High Street
Lewes
East Sussex
BN7 2NS
www.ilex-press.com

Distributed worldwide (except North America) by
Thames & Hudson Ltd., 181A High Holborn, London
WC1V 7QX United Kingdom

Copyright © 2014 The Ilex Press Limited

Publisher: Alastair Campbell
Executive Publisher: Roly Allen
Associate Publisher: Adam Juniper
Managing Editors: Natalia Price-Cabrera and Nick Jones
Commissioning Editor: Zara Larcombe
Specialist Editor: Frank Gallaugher
Editorial Assistant: Rachel Silverlight
Creative Director: James Hollywell
Art Director: Julie Weir
Design: JC Lanaway
Picture Manager: Katie Greenwood
Colour Origination: Ivy Press Reprographics

British Library Cataloguing-in-Publication Data
A catalogue record for this book is available
from the British Library.

ISBN: 978-1-78157-137-8

Printed and bound in China
10 9 8 7 6 5 4 3 2 1

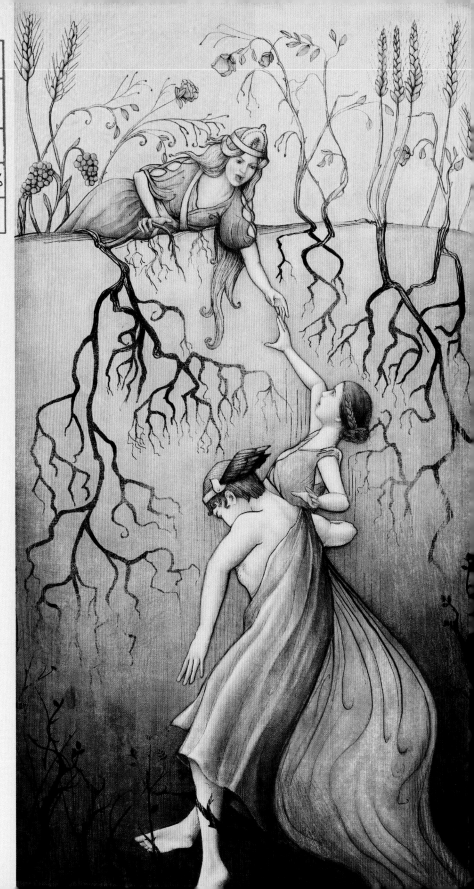

▶ **Hades Kidnaps Persephone**
Carlyn Beccia

CONTENTS

INTRODUCTION

STEALING LEONARDO

Dear Reader,

This book will teach you how to steal. We won't be stealing silly things like hotel soap or really cool street signs. We will be stealing art secrets from the greatest master painters that ever lived. Now, you are probably thinking, "I don't want to steal. I want to create original art." We all know copying is bad. From the moment we are given our first box of brightly-colored crayons, we are taught the artist's creed: do not copy. Then we go through art school and it is beaten into our heads: find your style.

Ironically, this is the opposite of how Renaissance artists learned to become great painters. Renaissance apprentices were required to copy masterworks for at least ten years before they were allowed to paint their own original works. They then moved on to painting backgrounds, hands, and garments. Only after many years of copying, were they allowed to paint faces and forms. A young Michelangelo began his art education by visiting the chapels in Florence and meticulously copying the frescoes of Domenico Ghirlandaio. Leonardo da Vinci's famous Vitruvian Man *is now believed to be copied from an earlier version by Giacomo Andrea de Ferrara, a Renaissance architect and expert on Vitruvius. Auguste Renoir copied the paintings of Raphael in order to learn the secrets of the classics. Van Gogh painted for only ten years of his life, but he spent the first six years doing studies and copying works by Jean-François Millet. Choose any master artist and you will find a work he copied.*

Trying to paint like the great masters has certainly been a humbling experience. Will you mistake my paintings for a Van Gogh? Maybe if you have had a really big swig of absinthe. Still, Van Gogh did teach me new understandings of how colors interact with each other. Can I now paint like Matisse? Hell no. Yet, I was able to free my concept of spacial perceptions. Can I now smear paint like Sargent? Only when I have delusions of grandeur. But I do feel like I have learned how to create stronger movement in my paint. Unless you are exploring a career as a professional art forger, replicating another artist's painting techniques should never be the end goal. It is a means to an end. Consider it part of your Renaissance training: first we copy, then we make it our own. Picasso said it best; "Good artists copy. Great artists steal."

So let's pull up a chair and become the most wicked of thieves.

CARLYN BECCIA

"I am rather glad that I never learned how to paint."
VINCENT VAN GOGH

Vitruvian Man
Leonardo da Vinci
c. 1490
Pen and ink with wash over metal point on paper.

The Great Wave off Kanagawa
Katsushika Hokusai
c. 1829–32
I have focused on Western art in this book, but I encourage you to explore the Eastern masters. Many famous artists were influenced by Japanese prints including Matisse, Van Gogh, and Picasso.

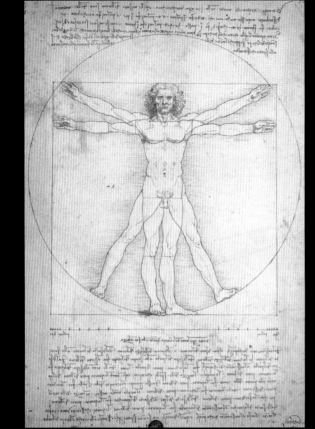

WHO THIS BOOK IS NOT FOR

This book may cause increased blood pressure if:

You want to learn how to use Adobe Photoshop, Corel Painter, or (insert other software program here).

I teach how to paint digitally. I do not teach how to use software. If you want a book on software programs, go look for one of those brightly colored yellow books with the word "dummy" on it. If you want to learn how to paint digitally (and learning the software is an added bonus) you are in the right place.

You believe buying this book will turn you into (insert name of famous artist here).

There is only one Picasso and he will never be duplicated. This book might turn you into Picasso's diabolical prodigy, leading the next art movement, but it does not promise to reincarnate the dead. For that, you are in the wrong book section. Look for the bohemian dressed lackeys under the "New Age" sign. Those are your people.

You want a detailed biography about (insert famous artist's name here).

I read through hundreds of letters, witness testimonials, and second sources to focus on each artist's painting technique. Yes, you will get a few personal biographical details sprinkled on top, but if you are looking for a full biography from birth to death, please refer to the bibliography in the back of this book.

You are impatient.

Some of the tutorials in this book are really tricky. They are going to require you to walk through the steps...slooooooowly. Yes, you can still learn from skimming, but not if this is your first time picking up a digital painting book. Vincent Van Gogh once questioned, "What would life be if we had no courage to attempt anything?" Well Mr. Van Gogh, I would say that life would be pretty dull. Approach each of these tutorials with courage, and if you get stuck, you can always email me.

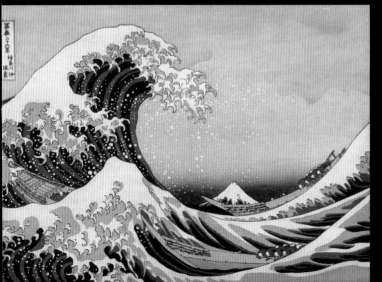

"If heaven had granted me five more years, I could have become a real painter."

KATSUSHIKA HOKUSAI

ABOUT THE AUTHOR

Welcome to *The Digital Renaissance*. I guess if you bought this book you might want to know a little bit about the author. That's me below, dressed like Anne Boleyn in a French hood and a brown damask gown trimmed with cloth of gold. I am smiling even though my stays are cutting off my circulation and my brute of a husband won't stop flirting with the hired help. If that sounds like gibberish, then I probably am not going to run into you at a Renaissance Fair. That's OK—perhaps our paths will cross elsewhere? In the meantime, here are a few random facts about me when I am not playing dress up:

I am an award winning children's book author and illustrator. My books are mostly about things you don't want your kids repeating at the dinner table.

I am an ellipseophile. I love to put ellipses in my writing. If you find too many ellipses in this book, blame it on the editors. I have no self-control.

I am an uglitarian. I only eat ugly animals. Lamb and pigs are out. Chickens and fish are fair game.

I often make up words and try to convince others that they are real words. I tried to name this book "The Digissance," but the Marketing folks didn't find it very catchy.

I love goats—their crazy eyes, the way their ears flop around as if they don't belong on their face. I believe everyone would be happier if they spent more time around goats. I recommend reading this book in the company of goats.

I don't like monkeys. They are always up to no good. You will not learn how to paint monkeys in this book.

Details from the Angel Series
Corel Painter
I have focused on portraits in this book because they personally inspire me. Portraits always tell a story. I recommend that instead of following these tutorials with the exact same subject matter, you find your own narrative voice and pick a subject that inspires you. It doesn't matter if you are painting femme bots or fruit, the results will be the same if you apply yourself fully to the task at hand.

> *"It is not enough to know an artist's works. One must also know when he did them, why, how, in what circumstances..."*
>
> PABLO PICASSO

DIGITAL VS. TRADITIONAL PAINTING

Quick, answer this question: What medium did Picasso work in? The correct answer: Who the heck cares! I was taught as a classically trained artist, using mostly oils. I still use traditional media and combine them with the digital medium. A medium is just that—it comes in the middle of the artist and their work. Mastering a painting medium is an important step in becoming a better artist, but while it makes us skilled craftsmen, it does not make us great artists.

YOU ARE AN ARTISTIC GENIUS

As a children's book author, I often get asked which of my books is my favorite. My answer is always the same—the one that I have not done yet. Style is like a humming bird: if it stops moving, it will die.

Perhaps it is for this reason that many famous artists destroyed their work. Botticelli and Michelangelo threw their work into the flames; Monet preferred to slash his into bits and pieces; Modigliani dumped his work into Livorno's Royal Canal.

It is not hard to see why these great masters destroyed their work. It can be extremely painful to look into the past, especially when it comes from a place we no longer recognize. I personally think Matisse's early work is derivative and uninspiring, but his later work blows my mind. I find Van Gogh's earlier brown palette and dimly-lit portraits depressing, while his later works with their brightly juxtaposed complementary colors make me weep (in a good way).

I encourage you to embrace the fact that at this moment in time...your art sucks. OK, maybe it only partially sucks, but it really sucks in comparison to the work you will do ten years from now. Don't take offense. We are in this together. My future self will also look back at my past self and say, "sheeeeesh, you were such a hack." So let's embrace the inescapable fact that we are all currently untalented bunglers. But ten years from now we will be geniuses!

TIP BEYOND THE BOOK

This book is accompanied by a website:
 www.CarlynPaints.com
Additional painting tutorials can also be found at:
 www.CarlynBeccia.com

And I answer emails (eventually) at:
 info@CarlynBeccia.com

Heart in a Box
*Digital &
Mixed Media*
I often combine traditional and digital painting in my work. I created this shadow box by painting the pieces in Photoshop and Painter, and then printing them on my digital printer. I combined the prints with collage elements and acrylic paint.

DIGITAL
RENAISSANCE
ESSENTIALS

GETTING STARTED

So what experience level do you need to learn from this book? Well, to start, you should have a basic understanding of the software interface. That's where this chapter comes in. In writing these tutorials I have assumed very little prior knowledge. I have spelled out every step so that you can walk through the tutorials if you are a beginner or have a light jog if you are more advanced. Still, there will be a heck of a lot less hair pulling if you know some basics.

SOFTWARE SHORTCUTS

These shortcuts will save you time and make you look like a pro:

ACTION	MAC	PC
Open a File	Command + O	CTRL + O
Save a File	Command + S	CTRL + S
Undo	Command + Z	CTRL + Z
Undo more than the last step	Command + Alt + Z	CTRL + Alt + Z
Fit your art to the screen	Command + 0	CTRL + 0
Select All	Command + A	CTRL + A
Copy	Command + C	CTRL + C
Cut	Command + X	CTRL + X
Paste	Command + V	CTRL + V
Create a New Layer	Command + Shift + N	CTRL + Shift + N

UNDERSTANDING MY NOTATIONS

For every command you see in this book I have written the menu steps with a "/" between them to divide the individual steps. For example, if I want you to flip an image upside down in Photoshop then I have written: Edit/Transform/Flip Vertical. This means that you should go to the top menu bar, find the "Edit" menu, select "Transform" from that menu, and then "Flip Vertical."

When I want you to press two buttons at the same time, I have written a "+" symbol between each selection. For example, to paste an object into a file it's CTRL + V or Command + V. This means that you should hold either the "CTRL" or "Command" key (depending on your operating system) and the "V" key at the same time.

ADOBE PHOTOSHOP

The following does not include all the tools in Photoshop, just the ones that I keep visible. All of the menus can be docked and undocked by clicking on the tabbed top portion with their title and dragging it to a new location.

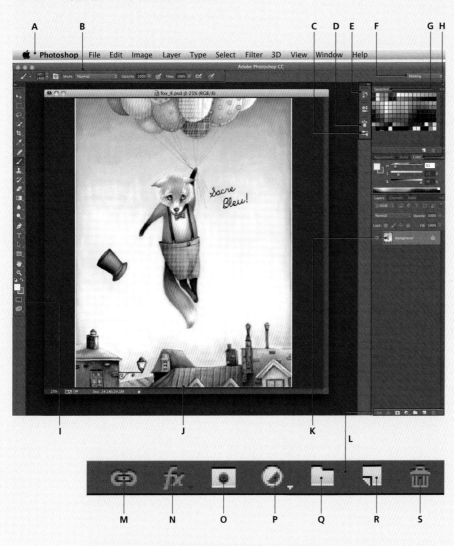

A. Menu Bar
This is the top level bar that contains the drop-down menus under each category. For example, selecting Filter from the menu bar will reveal a list of possible filters.

B. Options Bar
This displays the options for each tool. The options bar will change depending on the tool you have selected. For example, selecting the zoom tool gives you a set of options for zooming.

C. Brush Presets
Contains a scrolling menu that allows you to select a brush.

D. Brush Panel
This allows you to further customize any brush.

E. History Panel
This allows you to go back in time and undo previous steps.

F. Painting Workspace
If you are planning to do mostly painting, then switch to the Painting workspace.

G. Swatch Panel
This allows you to quickly pick colors. Swatch panels can be customized by selecting the small

right arrow and opening up the Preset Manager.

H. Color Panel
Allows you to pick a color based on Hue, Saturation, and Value (HSV). Can be switched to RGB values by clicking on the small right arrow.

I. Toolbar
Discussed on p14.

J. Document Window

K. Layers
Allows you to put art on its own layer and control how it blends with other layers.

L. Layer Shortcuts
I have written out the long way to get to most of the layer options, but these shortcuts will make life easier.

M. Link Layers

N. Create a New Layer Style

O. Create a New Layer Mask

P. New Fill or Adjustment Layer

Q. Create a New Layer Group

R. Create a New Layer

S. Delete a Layer

TIP SAVING WORKSPACES

To save your workspace, click the double arrow at the right of the Painting workspace button. Choose "New Workspace" from the drop-down menu and name your workspace.

THE PHOTOSHOP TOOLBAR

Here is a brief description of the tools I use most commonly when painting. By clicking on the small arrow beneath the icon, you can pull out more options for each of the tools. When selecting any tool, the options bar will change giving you a different set of options.

TIP TOOL TIPS

If you ever forget what a tool icon symbolizes, you can hold your pen over it and it will momentarily bring up "Tool Tips" telling you the name of the tool.

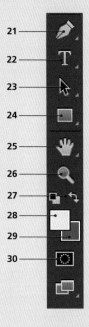

1. Move Tool
Moves a layer, selection, or guide.

2. Rectangular Marquee Tool
Makes a boxed selection. Click the arrow to get other shapes.

3. The Lasso Tool
Creates a freehand selection.

4. Quick Selection Tool
Used to make selections based on color.

5. Magic Wand Tool
Makes selections based on detecting an object's edge

6. Crop Tool

7. Eyedropper Tool
Samples colors from your image. You can access this tool while you have your brush selected by Alt + clicking anywhere on your canvas.

8. Spot Healing Brush Tool
Used for correcting small imperfections on photos. I use this tool to clean up scans.

9. Brush Tool
For more on brushes see the page opposite.

10. Stamp Tool
I use this tool to correct gaps or patterns that need to blend more seamlessly.

11. History Brush Tool
I use this to paint back a filter performed on an earlier step.

12. Eraser
Erases parts of your art. If you are using one, you can flip over your stylus and your brush will switch automatically to an eraser.

13. Gradient Tool
I use this tool to create soft blends between colors for backgrounds.

14. Paint Bucket Tool
I use this tool to fill my background layer or fill selections.

15. Blur Tool
Useful for softening edges.

16. Sharpen Tool
Useful for sharpening edges.

17. Smudge Tool
I never use this tool. It blurs the brush strokes too much and makes them look like goo.

18. Dodge Tool
Lightens pixels.

19. Burn Tool
Darkens pixels.

20. Sponge Tool
Desaturates or saturates.

21. Pen Tool
I use this tool to create vector shapes.

22. Type Tool

23. Path Selection Tool

24. Shape Tool
All of the shape tools under this tool can create vector shapes or paths.

25. Hand Tool
I use this tool to move an image around the document window.

26. Zoom Tool
Magnifies an image. Alt + Click to zoom out.

27. Color Switcher
Switches the foreground and background colors.

28. Foreground Color

29. Background Color

30. Quick Mask Mode

BRUSHES IN PHOTOSHOP

The following menus help you customize your brushes and save brush settings. Every time you choose the brush tool from the toolbar, the options bar changes to the default settings shown below.

1. Tool Presets
Saves the settings for each tool.

2. Brush Selector
Contains a library of your brushes.

3. Open Brush Menu
Contains brush settings.

4. Blending Mode
Alters the way the brush affects existing painted areas.

5. Pressure-for-sensitivity Button
Tells Photoshop to use the pressure sensitivity of your drawing tablet (if you are using one).

6. Airbrush Button
Makes your brush behave like an airbrush. Use this option to soften the edges of a brush.

7. Pressure-for-size
Uses the pressure sensitivity of your drawing tablet to determine the size of your brush. You will want to check this button if you are painting with an image brush.

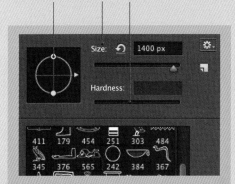

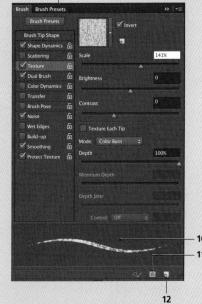

TIP LOADING BRUSHES FROM THE COMPANION SITE

In several of the tutorials, I have provided the Photoshop brush to load into your Brush menu. To load a brush:

1. Download the brush from www.carlynpaints.com and save it to your computer.

2. Open the Preset Manager by clicking on the small gear tool icon at the top right of the Brush Selector window. Select Preset Manager from the drop-down menu.

3. Under Preset Type, select Brushes.

4. Select the Load button and navigate to where your brushes are saved.

5. Select Done.

8. Brush Control
Adjust this to resize and rotate your brush.

9. Hardness
Adjust the hardness of your brush. This is not available for every brush type.

10. Brush Preview
This window gives you a representation of your brush.

11. Preset Manager
Shortcut to launch the Preset Manager.

12. Save Brush
Allows you to save your brush settings.

TIP LOADING PATTERNS

You can load patterns into Photoshop through the Preset Manager:

1. Follow the same steps for Loading Brushes (opposite), but select Patterns under Preset Type (step 3).

FAVORITE BRUSH SETTINGS

Brush Tip Shape: Controls the shape, size, and spacing of your brush tip.

Shape Dynamics: Controls the variance of your brush's tip shape.

Scattering: Scatters your brush shape to get a more confetti look.

Texture: Picks up a "pattern" texture as you paint.

Dual Brush: Combines the settings of two brushes.

Color Dynamics: Varies Saturation, Hue, and Brightness of color.

Noise: Dithers your brush.

Wet Edges: Creates a watercolor effect, pooling the paint at the edges.

COREL PAINTER

These are not all the tools in Painter, but they are the ones that I keep visible. All menus can be docked and undocked by clicking on the tabbed top portion with their title and dragging it to a new location.

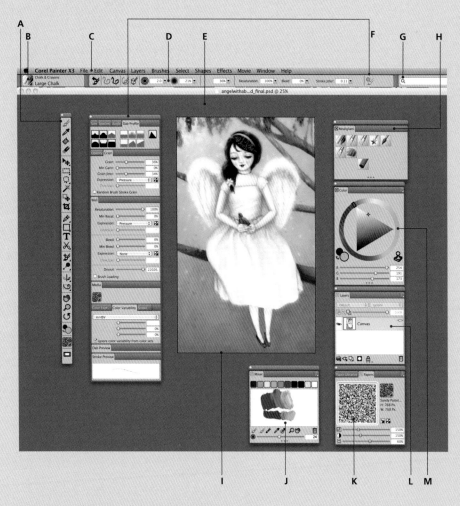

A. Toolbar
When a tool is selected, it is blue.

B. Brush Selector
Clicking on the arrow opens a menu of different brush categories and recent brushes used.

C. Menu Bar
The top level bar that contains all the drop-down menus.

D. Property Bar
Just like Photoshop's Options Bar this panel displays the main options for each tool and changes depending on the tool selected.

E. Document Window
The document window contains the canvas area plus a gray background.

F. Advanced Brush Controls
This blue icon is a shortcut to launch the more advanced brush panels where you can further control your brushes. You can also access these advanced brush panels from the Menu Bar.

G. Search Brushes
Allows you to search for brushes by name.

H. Custom Palettes
By holding down the Shift key while

dragging a favorite brush icon out of the Brush Selector you can create custom toolboxes of favorite brushes for easy access. You can also use this to create favorite palettes of patterns, papers, nozzles, and so on.

I. Canvas
Your canvas is the area that you will paint on.

J. Color Mixer
Allows you to mix colors as if they were traditional paint.

K. Paper and Paper Libraries
Allows you to choose a paper texture and then vary the grain size, brightness, and contrast. I keep this window open, as I like to vary the settings as I paint.

L. Layers
Allows you to put art on layers and thereby control how they blend with each layer.

M. Color
Allows you to choose colors based on RGB values or HSV values. I use HSV. Colors to the right of the triangle are higher in saturation. Colors closest to the bottom are darker in value.

QUICK TIP SAVING YOUR WORKSPACES

Just like Photoshop, you can save workspaces in Painter. To save a workspace, select Window/Workspace/ New Workspace. Name your workspace and it will then appear in the workspace drop-down menu.

THE PAINTER TOOLBAR

Here is a brief description of the Painter tools I most commonly use when painting. Many of these tools work in the same way as Photoshop. Also like Photoshop, clicking on the small arrow beneath the icon, pulls out more options for each of the tools. Also, when selecting any tool, the Property Bar will change giving you a different set of options.

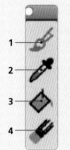

1. Brush Tool
Use to paint.

2. Dropper Tool
Samples colors from your image. You can access this tool while you have your brush selected by Alt + clicking while you paint.

3. Paint Bucket Tool
Used to fill a selection or a layer with color or a pattern.

4. Eraser
Erases parts of a painting. You can also flip over your stylus (if you are using one) to switch to an Eraser.

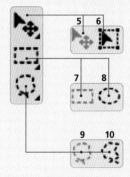

5. Layer Adjuster
Used to select and move a layer. Similar to Photoshop's Move Tool.

6. Transform Tool
Used to move, scale, rotate, distort, or skew a layer.

7. Rectangular Selection Tool

8. Elliptical Selection Tool

9. Lasso Tool
Creates a freehand selection.

10. Polygonal Selection Tool
Allows you to draw your selection using fixed points.

11. Magic Wand
Used to make selections based on color.

12. Selection Adjuster
Scales and moves a selection without affecting the pixels that are contained within the selected area. You can switch to the Layer Adjuster tool by pressing *Command/CTRL* while this tool is selected.

13. Crop Tool

14. Pen Tool
Creates vector objects using curves and straight lines.

15. Rectangle Shape Tool
Creates vector squares and rectangles.

16. Text Tool
Creates text.

17. Scissors
Cuts an open or closed shape path.

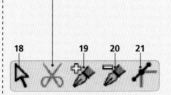

18. Shape Selection Tool
Selects and moves points to adjust a shape path.

19. Add Point Tool
Creates anchor points on a shape path.

20. Remove Point Tool
Removes anchor points on a shape path.

21. Convert Point Tool
Converts smooth points to corner points and vice versa.

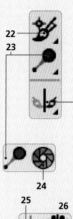

22. Clone Tool
Used to clone patterns and painting. Defaults to the last clone brush used.

23. Burn Tool
Darkens highlights, midtones, and shadows.

24. Dodge Tool
Lightens highlights, midtones, and shadows.

25. Mirror Painting
Paints in symmetrical halves.

26. Kaleidoscope Mode
Paints in symmetrical kaleidoscope.

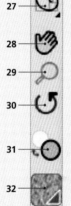

27. Divine Proportion Tool
Guides to help create a composition based on classical measurements.

28. Hand Tool/Grabber
Moves an image around the document window.

29. Magnifier Tool
Zoom in on an image or *Alt + click* to zoom out.

30. Rotate Page
Allows you to rotate your canvas in the same way you would reposition your paper while drawing.

31. Color Selector
The top color shows your main color. The bottom color is your secondary color. You can switch these by clicking on the arrows in between them.

32. Paper Selector
Allows you to choose a paper texture from the Paper Library.

33. View Mode
Toggle between Full Screen and Windowed view.

BRUSHES IN PAINTER

I use the following steps when choosing and customizing my brushes:

STEP 1: PICK A BRUSH FROM THE BRUSH SELECTOR

1. I select my Brush Category from the Brush Selector. The Brush Categories are your different media (Oil, Acrylic, Pastels, Watercolor, and so on) All of these can be found in the column at the left, represented by a brush icon.

2. The right column contains the Brush Variants. These are variants of the medium that you have chosen. For example, if you chose the Oils Brush Category then you must next choose the variant of that category (Real Oil Short, Real Oil Smeary, and so on).

THE BRUSH SELECTOR
This contains numerous brushes, but you will probably find that you use the same 5–10 brushes. To keep things simple, hold down the Shift key while dragging the brush's icon out of the brush library. This will create a custom library containing your brush variant and its settings.

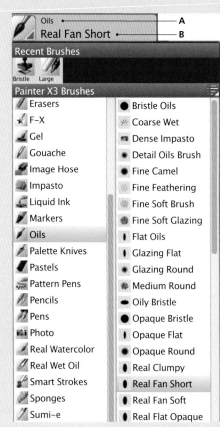

BRUSH TRACKING

You will find that you may paint with different speeds and pressures depending on the type of drawing or painting (or even your mood). For this reason I use Painter's Brush Tracking feature to record the pressure and speed of my hand before I begin a painting. To use Brush Tracking:

1. Select Corel Painter 12/Preferences/ Brush Tracking (Mac OS) or Edit/ Preferences/Brush Tracking (Windows).

2. Make some marks in the scratch pad window using your preferred pressure and speed. Brush Tracking will calibrate your brush based on these marks.

REORDERING YOUR BRUSHES
You can reorder your brushes by dragging them up and down the Brush Library.

STEP 2 CUSTOMIZE YOUR BRUSH

The Property Bar (Window/Property Bar) allows you to further tweak your brush variant. Every time you choose a brush tool variant from the Brush Panel the Property Bar changes to contain different options. You can also access these settings through the Brush Control Panels (Window/Brush Control Panels).

THE PROPERTY BAR
The Property Bar is where you can adjust the main features of your brush variant. The right hand settings will change depending on the brush selected. Here is one example using the Real Flat brush variant from the Oils brush category.

`25.0` ▼ `100%` ▼ Feature: `3.0` ▼ Blend: `7%` ▼

A B C D E F G H I J K

A. Resets the brush
B. Draws freehand
C. Draws straight lines
D. Draws to a path

E. Draws to perspective guides
F. Brush size
G. Brush opacity

H. Controls the amount of bristles: a higher number will have less bristles or act like a very stiff brush.

I. Increases the bristle spacing in direct proportion to the brush size.

J. Controls how much the paint blends with neighboring paint. Similar to adding linseed oil to traditional paint to thin it.

K. Launches the Advanced Brush Control Settings.

STEP 3 CHOOSE YOUR PAPER

After I have selected and customized my brush, I then choose my paper. To change the paper:

1. Select the small thumbnail in the Papers Library (Window/Paper Panels/Paper) and choose a new paper from the drop-down menu. You can then change the Paper Scale, Contrast, and Brightness.

2. You can also select a paper from the Paper Library (Window/Paper Panels/ Paper Libraries) or via the paper icon in the toolbar.

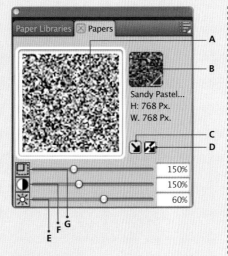

A. Selected paper
B. Paper selector
C. Paper direction
D. Invert paper
E. Paper brightness
F. Paper contrast
G. Paper scaler

TO LOAD A PAPER LIBRARY

Painter allows you to load papers into a paper library. I have provided the paper for several tutorials in this book. To load a paper:

1. Open the Paper Libraries (Window/Paper Panels/Paper Libraries) and then select the small right arrow to reveal the drop-down menu.

2. From the drop-down menu, select Import Paper Library or Import Legacy Paper Library.

3. Navigate to the location of the Papers you wish to load. Select Open. Your new library will now appear in a separated tab beneath your default paper library.

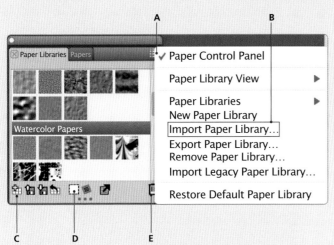

A. Drop-down menu
B. Import Paper Library option
C. New Paper Library
D. Capture Paper
E. Delete Paper

IMPORT PAPER
If you find the Import Paper Library function does not work, use "Import Legacy Paper Library" instead.

ORGANIZING PAPER LIBRARIES

1. Once you load a Paper Library, you can move any paper into a different library. Hold down the Shift key while dragging its icon into a different library.

2. You can create a new library by selecting the New Library Icon. You can add papers to the new library by holding down the Shift key while dragging a paper icon into the new library.

3. You can also create a new custom paper palette by selecting a paper icon and then holding down the Shift key while dragging it out of the Paper Libraries. The new Paper palette will be named Custom + a number. You can rename this palette by selecting Window/Custom Palette/Organizer. In the Organizer menu, select the new custom palette, and then press the Rename button.

4. To delete a paper: Select the paper icon in the library and then click on the trash can icon at the bottom of the Paper Libraries window.

TIP

You do not need to save Paper Libraries in the Applications folder. You can save them anywhere, but it is a good idea to get into the habit of saving all of your papers in the same location.

TIP

You can find more paper libraries through the Corel Painter product page. Click on the Resources tab and download the Extras.

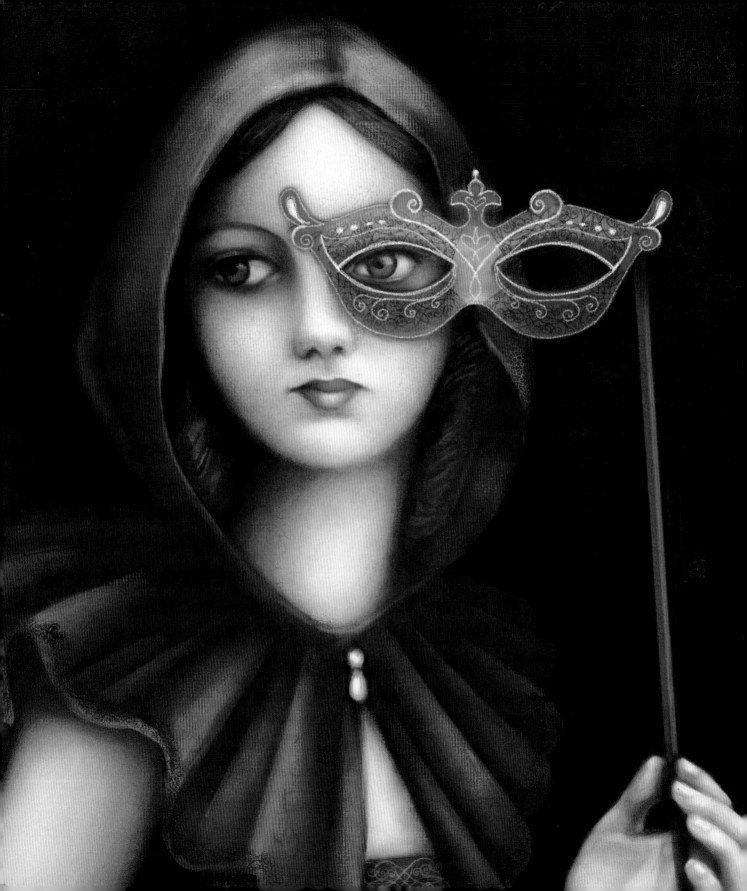

DIGITAL
RENAISSANCE
TUTORIALS

02

01
MICHELANGELO
BUONARROTI 1475–1564
THE PURSUIT OF GENIUS

LEVEL 1 2 3

What you will learn in this section
- Drawing basics
- Getting texture in marks
- Balancing compositions

▶ **Portrait of Michelangelo**
G. P. Lorenzi
Published in Uffizi Gallery of Florence engraving collection, 1841.

Ps Application
PAINTER/PHOTOSHOP

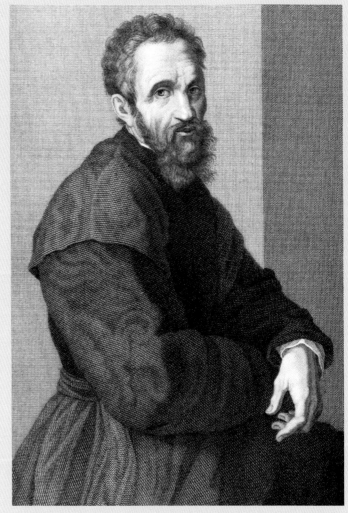

In February, 1564, an 88-year old Michelangelo Buonarroti hobbled outside his small, two-story studio located in Marcello dei Corv on the outskirts of Rome. The place where he created some of his greatest masterpieces was crammed together with rows of dilapidated houses separated by tiny vegetable gardens and overgrown vineyards. Even his studio's beige travertine and tuffa rock façade blended into every other house like a discarded pebble. By the end of his life, Michelangelo had become famous throughout Rome for his work. He could have stayed in a much finer house, but Michelangelo had never cared much for luxuries. He wore the same shabby, black smock every day and rode the same scruffy chestnut pony through Rome's windy streets. He was your typical starving artist.

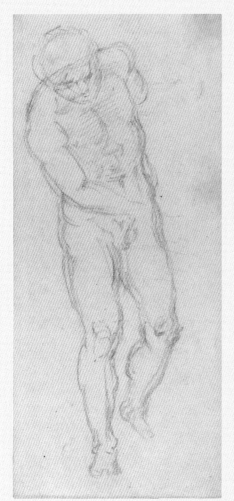 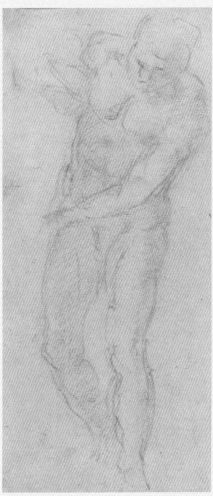

◀◀ Male Nude (verso and recto)
Michelangelo, c. 1560
Michelangelo was very economical with paper, always using both the front and back side. As a result, you will often see a ghostly reversed image coming through the back of his sketches.

written to the prickly artist demanding a sketch. Cosimo would have paid dearly for any one of Michelangelo's preparatory drawings. Unfortunately, Michelangelo thought little of Cosimo's demands, preferring to give his drawings to the flames.

Historians today are left wondering: Why would Michelangelo destroy years of work and arguably some of the most beautiful drawings ever made? Were they not good enough? Or perhaps Michelangelo felt that his drawings revealed too much about his creative process. In his surviving drawings, bodies bulge with strained muscles caught in impossible poses and a simple hand or foot is drawn over and over again until it becomes anatomically perfect. This creative process can be very revealing. He once said, "If you knew how much work went into it, you wouldn't call it genius." Michelangelo may have wanted to conceal the very thing that I plan to show you in the following pages—his drawing process.

"Draw, Antonio; draw, Antonio; draw and don't waste time."
MICHELANGELO BUONARROTI

On this particular cold, winter day, Michelangelo knew he was dying. He had one last task before death knocked upon his crumbling door—to burn all his drawings.

He slowly lit a match and threw one delicately drawn sketch into the flames after another. Red chalk, black chalk, iron gall ink...All fed the conflagration, as decades of work became thick streams of smoke.

This is just the kind of scene that would drive any art collector to heart failure. It also broke the hearts of Michelangelo's patrons. Just weeks earlier, envoys for The Grand Duke Cosimo de Medici had

Unfortunately, we have a hard task ahead of us. Renaissance drawing techniques are not easy to replicate because the materials and paper are very different from modern drawing tools. In fact, many of the materials cannot even be found today. For example, the natural red chalk that Michelangelo used for the drawing of *The Lybian Sybil* no longer exists. Another popular Renaissance medium that is difficult to replicate is lead point. Lead point is a bluish gray, soft metal usually inserted into a stylus. Lead point was preferred because it could be applied to the paper without any ground. If you look at a Michelangelo drawing up close today the lead point is often difficult to detect because lead changes to carbonate over time, eventually becoming invisible. A good indication that lead point was used can be seen where you see surface abrasions in the paper.

One material that you can find today is iron gall ink. Michelangelo would often use iron gall ink over the lead point. Iron gall ink was made by soaking irregular plant growths called oak galls or oak apples in water and then combining them with iron sulfate and gum Arabic. This mixture resulted in a purplish black ink that turned brown over time and could also eat away at the paper if applied too thickly. Michelangelo applied this ink with a sharpened feathered quill. The quill's springiness could be determined by the pressure of the hand and could also produce a thick or thin line depending on the tilt of the hand. Michelangelo used short, cross hatching to model rippling muscles and longer lines to contour the figure. He would sometimes then use a wash over his lines to indicate shadows or white chalk to indicate highlights.

In his later years, he did many drawings in chalk, preferring a black chalk made from a stone found in Piedmont. Black chalk was very dense and could be sharpened to a fine point. With a simple tilt of his hand, he could make any line come to life with a thick or thin mark. Michelangelo used the broad side of the chalk to pick up the texture of the paper. He then created delicate transitions between shading with a "stump"—a piece of leather or cloth rolled to a point. We can see this technique in the way he rendered the skin in *Studies for the Libyan Sybil* contrasted with the sinuous line of the hair (see below).

Many of his surviving drawings can also be found in a red chalk colored with iron oxide. We do not know why he chose one color chalk over the other, but we can suspect that it may have been related to the mood of his work. For example, many of his drawings of Christ are done in a solemn black, while the animated drawings for the Sistine Chapel were done in a more vibrant red.

For his underpaintings, Michelangelo often used a blind stylus—a sharpened iron point that left only an indentation. He also used this drawing tool to copy his drawings onto the wet plaster for the Sistine Chapel frescoes.

In this tutorial, we will complete a sketch of one of Michelangelo's sculptures in red chalk in both Photoshop and Painter. Whatever program you choose, keep in mind that Michelangelo believed the only true secret to becoming a successful artist was to simply draw and draw often. In a tiny corner of one of his surviving drawings, he wrote an admonishing note to one of his students; "Draw Antonio; draw Antonio; draw and don't waste time." Now let's follow Michelangelo's advice and get started.

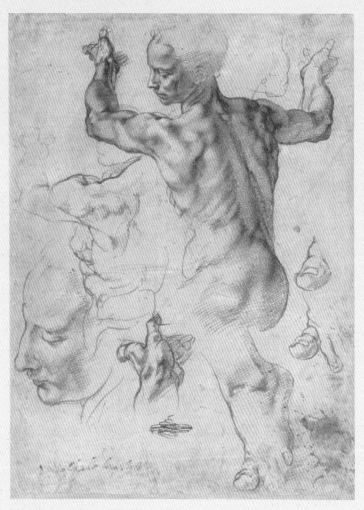

◄ Studies for the Libyan Sybil (recto)
Michelangelo, 1508–12
Although a collection of roughly 60 of Michelangelo's drawings still exist today, far more were destroyed. Michelangelo never signed any of his drawings, but it was a common practice in the nineteenth century for art collectors to sign the artist's name to works.

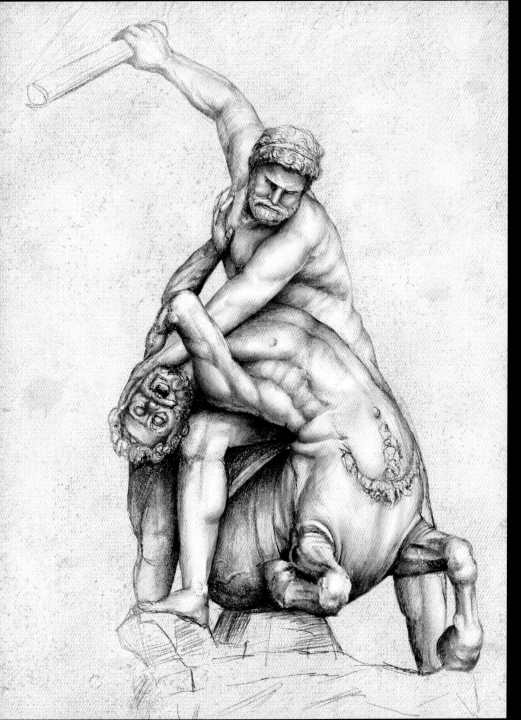

*"If you knew
how much work
went into it, you
wouldn't call
it genius."*

MICHELANGELO
BUONARROTI

◀ **Study of Hercules
Beating Nessus by
Giambologna**
In this sketch I used mostly
tonal shading. To learn about
different shading techniques
see page 28.

STEP 1: MAKE YOUR PAPER

Michelangelo was notoriously conservative with paper, usually using both sides and always filing the entire sheet with figures. The paper he used was made from linen rags and hemp, and was sometimes coated with a layer of "ground" (ground-up bone.) In this step, we'll make an aged paper, similar to hemp, using Photoshop. This will become the basis for your drawing. You could just draw on a blank canvas, but I prefer to start on an aged paper because the paper's imperfections give a drawing a more tactile feel; if you use Painter, your brush can react to the paper's grain and texture.

1. For this image I started by creating a new file (File/New) measuring 8 x 10 inches (you might want to use a different size).

2. Select a pale flesh color from the Color Panel and fill the Background layer using the Paint Bucket Tool.

3. Duplicate the Background layer by pulling it into the new layer icon at the bottom of the Layers palette.

4. Select Filter/Render/Fibers. Here I set the Variance to 64 and the Strength to 1, before clicking on the Randomize button to create the texture.

5. Rename this layer Fibers and lower its Opacity to 50%.

6. Duplicate the Fibers layer and rename the duplicate Paper Wrinkles. Then, select Filter/Render/Clouds.

7. Double-click on the Paper Wrinkles layer to open its Blending Options. Under the Blend If settings, hold down the Alt key and move the Underlying Layer white point to the center. This forces anything below 50% gray in the underlying layer to fade out.

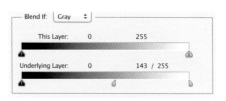

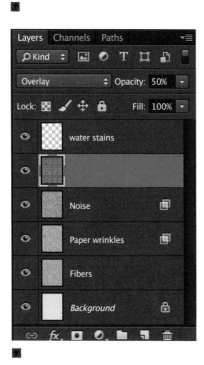

8. Next, duplicate the Paper Wrinkles layer by dragging it onto the New Layer icon. Name this layer Noise and select Filter/Noise/Add Noise. Check the boxes for Gaussian and Monochromatic and then press OK.

9. Create a new layer (Layer/New) and name it Hemp. With the Paint Bucket Tool selected, choose the Coarse Weave pattern from the options bar and fill the Hemp layer with the Coarse Weave pattern (you can download the Coarse Weave pattern from the companion website, www.carlynpaints.com). Set the Hemp layer's blend mode to Overlay. This gives your paper a slight "tooth" that is similar to hemp or linen rags.

10. Finally, give the paper some spotted water staining by selecting the Brush Tool and then the "aged paper maker" brush from the Brush Preset Picker (you can download this brush from the companion site). I selected a darker brown color and used this brush to splatter marks across the paper.

11. I flattened my layers (Layer/Flatten Image).

▲ ROUGH IT UP!
Sometimes I will rough the paper up more when I am done with my final sketch. However, to start with I usually don't want the paper texture to be too distracting: it's easier to add texture than remove it.

STEP 2 SKETCHING

Michelangelo was the master of drawing figures in dramatic *contrapposto*, with poses full of energy. Before he began a more rendered sketch, he often drew quick gesture drawings in pen and ink so that he could find the rhythm of his forms. Here, I have used Painter's Thin Smooth Pen tool, which is found in the Pens brush category. If you prefer to produce your gesture drawings in Photoshop, choose a hard-edged brush. The purpose of this exercise is not to get caught up in shading so you want to use a brush that has very little grain. Here are a few tips for a successful gesture drawing:

1. When drawing figures in motion, Michelangelo always had a line of action. The line of action is the longest line of the pose that captures the energy of that pose. The spine usually conveys the line of action.

2. Michelangelo usually had more than one line of action—a primary line of action and a secondary line of action. This line of action not only conveys the movement, but also the attitude of the subject.

3. Lines should lead into each other unless you want to convey an abrupt stop in the action.

4. IMPORTANT: Straight lines do not exist in nature. If you draw straight lines your figures will appear stiff.

5. It is a good idea to exaggerate the pose, at least at first.

6. If you want a pose to appear "quieter," use a softer curving line of action that flows in either an S shape or a C shape. Backward S shapes will give a figure a sense of balance.

7. Sharp lines administer tension, while curved lines and circles contain that tension. You can create the most drama by using both sharp and curved lines of action together. In the example below I have used sharp lines for the arm that administers the blow (A) and a semi-circle for the centaur that receives and contains that tension within his form (B).

8. Don't look too hard. The job of your eye is to reduce the pose into a continuous rhythm. You can't do that if you are focusing on fingers and eyeballs. Remember to look for the motion, not the contour.

9. When two figures interact there is a point where the forces meet (C). Finding that point of interaction will create a more dramatic pose.

10. Try not to lift your pen too much. You should have a continuous line to show how lines lead into each other.

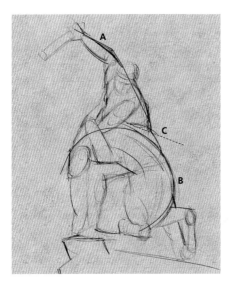

▲ Gesture is in everything, not just the human form. Gesture communicates emotion through the line.

▲ After I have found the line of action, I begin to focus more on the contour and shading.

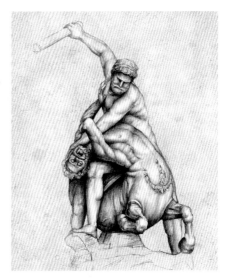

▲ Finally, I build up the tone by applying glazes of color with a heavy texture.

TIP DRAW ANTONIO; DRAW AND DON'T WASTE TIME...

Shortly after Lorenzo de Medici's death, Michelangelo moved into a room in the Santo Spirito church and struck an odd bargain with the prior. He would carve a Jesus Christ for the monastery in exchange for fresh corpses to study and draw. Leonardo da Vinci spent much of his art education dissecting and drawing corpses, sometimes even dissecting young children. If Michelangelo's biggest rival dissected bodies to learn their secrets then he would do the same. So, with scalpel in hand and the smell of rotting flesh turning his stomach, he dissected and drew innards, sometimes even retching from the smells. Michelangelo knew his hard work would pay off, and these lessons in human anatomy would become the foundation for his later works. If you want to draw like Michelangelo and can't afford models, then you will have to do what many female artists in the sixteenth century were forced to do—use a mirror.

UNDERSTANDING SHADING AND CONTOURING

Before we can begin to draw like Michelangelo, we must understand some basic shading concepts:

1. Cast shadow

In a cast shadow, the light is blocked in a straight line by the hard edges of an object. The length of the cast shadow depends on the distance of the light source from the object. The shadow will have crisper edges close to the object, with slight diffusion as the shadow falls further away. They may have a slight color tint depending on the color of the object.

2. Reflected light

Reflected light is light that has been bounced back onto the object, gently lightening the non-illuminated side.

3. Terminator

The terminator is the transition area from light to dark. If the light source is further away or softer than the terminator there will be a gradual transition; if it is a hard or close light then that transition will be much sharper.

4. Highlight

The highlight is the brightest area of your form. If you are painting on a white or light paper then you can choose to let the color of the paper mark out the highlight.

5. Core of the shadow

The core of the shadow is the darkest area of your form. As with a cast shadow, the shadow's core will contain colors from the objects surrounding it.

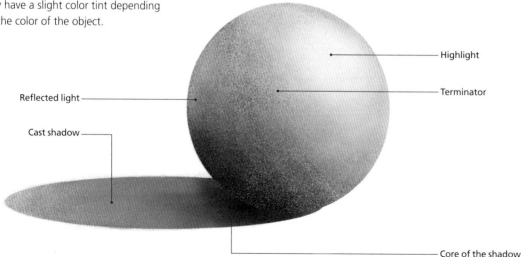

Reflected light

Cast shadow

Highlight

Terminator

Core of the shadow

STEP 3 SHADING

The beauty of Michelangelo's drawings is that he combined more than one shading method. He used cross-hatching with delicate tonal transitions and also strong contour lines to create depth in a very sculptural way. Here is a selection of common shading methods, with details on how you can achieve them digitally.

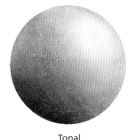
Tonal

Cross-hatching

Hatching

Scumbling

Line

Stippling

QUICK TIP ART OR SCIENCE?

It is important to learn classical techniques toward shading, but I would also advise that you not be too systematic in your approach. Shading should be dealt with on a case-by-case basis and observed through nature.

TONAL SHADING

Tonal shading is created from smooth transitions of light to dark. The key to making objects appear rounder with tonal shading is to create smoother terminators. I call the brushes used for this "Blender Brushes," as they blend colors as you paint. One way to create optical mixing is to make a textured brush with a lot of grain.

1. To create a Blender Brush in Photoshop, start with a suitable picture: I started with a picture of some rotting siding on a house. Use the Rectangular Marquee tool to make a selection around the most interesting area and cut it (Ctrl/Command + X) and then paste it (Ctrl/Command + V) into a new layer.

2. Select Image/Adjust/Threshold and set the levels to about 125 to convert the image to black and white.

3. Next, add a layer mask (Layer/Layer Mask) and paint over the edges using a soft brush with the color black. This gets rid of the regular, straight edges so that you will have a soft, textural brush, rather than a blocky stamp-like one. Making a brush from an image with soft edges will better replicate real media.

4. Using the Rectangular Marquee tool, make a selection around the area that will be your brush and select Edit/Define Brush Preset. Name the brush "Siding."

5. Open the Brush Panel and select Brush Tip Shape. I start by setting the spacing to around 49%: this will spread the marks out so that they are not sitting on top of each other.

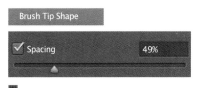

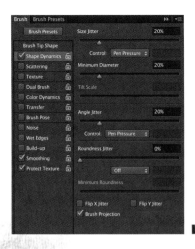

6. Still in the Brush Panel, check the Shape Dynamics box and set the Size Jitter, Minimum Diameter, and Angle Jitter to 20%. Set Control to Pen Pressure so the marks will pick up the pressure of your hand (if using a stylus). I also check Brush Projection so that Photoshop will pick up the tilt and rotation of my hand.

7. Next, select the Mixer Brush tool from the toolbar.

8. In the Options Bar choose Load the Brush After Each Stroke from the drop-down menu to fill the brush with your chosen color. Increase Wet to 100% to create the maximum amount of bleed in your brush and change Load to 50%:

this controls how much paint is loaded into the brush. I set Mix to around 75%. Mix controls how much Photoshop blends neighboring colors or picks up new paint: a higher amount will bleed paint more than it will apply new paint. I never turn on the airbrush option, because I do not like the airbrush look and I also ignore Flow because that pertains to the airbrush setting. I do, however, check Sample all Layers so that my mixing will mix the paint from every layer. Finally, I check the Always use pressure for Size icon so that the size of my brush depends on the pressure of my hand.

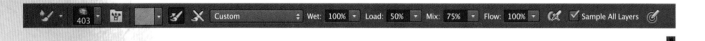

PAINTER

Creating tonal shading in Painter requires far fewer steps because the Grain, Bleed, and Resaturation settings are built into the brushes that you select.

1. Grain: choose a brush that has Grain settings such as pastels, chalk, conte, and some oils. In the Property Bar, reduce the Grain.

2. Bleed and Resaturation: choose a brush that has a setting such as oils, pastels, or acrylics. In the Property Bar, increase the Bleed. Increasing the Bleed causes each layer of paint to blend with neighboring colors. Resaturation controls how much paint is loaded into your brush, so a low Resaturation and a high Bleed will only blend colors, rather than applying color.

3. The wonderful thing about Painter is that you can change the pattern of the

texture on the fly simply by changing your paper. From the Paper Library (Window/Paper Panels/Papers), select a paper and adjust the Paper Scale, Paper Contrast, and Paper Brightness. Unlike Photoshop, you do not have to create a new brush for different textural effects: you can change these settings as you paint, allowing you to create a far more natural look.

▶ Painter allows you to change textural effects on the fly simply by changing your paper. The first example (right) uses the basic paper, while the second (far right) uses a parchment paper that I scanned into my computer.

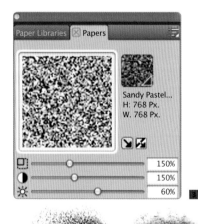

CROSS HATCHING

Cross hatching is created by making a series of crossed lines. These lines should not be vertical but on a diagonal and they should always follow the shape of the form. In Photoshop it is pretty easy to make a cross-hatching brush, which means you don't waste time making a million marks.

1. First, select the Pencil Tool and create a small pattern of cross hatches on a white background.

2. Select Edit/Define Brush Preset and name the brush "Cross Hatching."

3. Open the Brush Panel and click on Brush Tip Shape. Increase the Spacing to around 25% to spread out the marks.

4. Click on Shaped Dynamics and change the Angle Jitter to 20%. I also set the Control to Pen Pressure and Minimum Roundess to 25%.

5. To add more Grain, click on the option for Noise. This creates a cross-hatch pattern brush that will allow you to slowly build up values.

To create the same cross hatching pattern in Painter:

1. With the rectangular selection tool, I make a selection around the cross hatch pattern without selecting any white edges.

2. In the Pattern Library (Window/Media Library Panels/Patterns), select the Capture Pattern button and name it "Cross Hatch." Change the Horizontal Shift and Vertical Shift to 50% and press OK.

3. From the Brush Selector, choose the Pattern Chalk Brush from the Pattern Pens brush category. Change the Dab Type (Window Brush Control Panels/Dab Profile) to the Dull Profile dab so that your new brush will create a softer mark.

SCUMBLING

Scumbling is a technique that I use when I want to create atmospheric distance in a painting. It is similar to glazing except that it uses a very dry brush to almost rub away the paint. In a drawing, scumbling also refers to building up tone with random scribbled lines.

1. To shadow with scumbling in Photoshop, first select the Round Fan Stiff Thin Bristles brush from the Brush Preset Picker. In the Brush Panel, set Size to 100px, Bristles to 65%, Length to 108%, Thickness to 1%, Stiffness to 100%, Angle to -111 degrees, and Spacing to 2%.

2. Click Shape Dynamics and set the Angle Jitter to 20%.

3. Lastly, I checked the option for Scattering and set the Scatter to 728%, the Control to Pen Pressure, the Count to 2, the

Count Jitter to 20% and its Control to Pen Pressure. This creates a very soft brush that is perfect for painting clouds or objects that are in the distance.

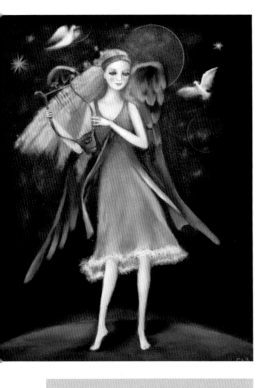

◄ Angel with a Harp

I used the Fx Confusion brush to scumble my paint. This technique creates atmospheric perspective in the background and motion on the birds' wings.

To create Scumbling in Painter, I first apply paint using any of the brushes. I then scumble the edges to create atmospheric perspective.

1. I select the Confusion brush found in the F-X brush category.

2. In the Property Bar, I set the Opacity to 100%, Grain to 100%, and Stroke Jitter to 1.43. The Jitter controls how much the paint is moved around—I vary the Jitter as I paint.

LINE

Line can also create volume in form. Photoshop has a separate grouping of bristle brushes that allow you to control the shape of the tip. I use these brushes to create varying weight in my line. In Photoshop:

1. Select the Round Angle brush from the Brush Preset Picker.

2. You can change the shape of the brush by changing its Shape in the Bristle Qualities. I use different shaped tips to create more energy in my line.

Painter also has many line brushes in the Pen and Pencil brush categories. To create a varied line in Painter:

1. Select the Thin Smooth Pen Brush from the Pen brush category.

2. From the Property Bar, adjust the Stroke Jitter to get the right amount of randomness in your line.

I prefer to use Painter to get more varied marks. Some of the more interesting pen brushes are (from top to bottom) Thin Smooth Pen, Nervous Pen, and Coit Pen.

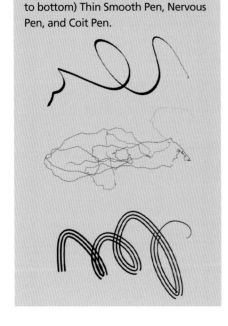

▶ As you change the tip of your brush in Painter you can see an updated visual of your brush tip.

STIPPLING

Stippling is created by building up a series of small dots. I personally would rather chew my arm off then make a million dots. Fortunately, Photoshop allows you to spray the dots, thereby building up the values far quicker then making tiny dots over and over again. To create this effect:

1. Select the basic Hard Round brush from the Brush Preset Picker

2. Launch the Brush Panel and click on Brush Tip Shape. Increase Spacing to around 650%.

3. Check the option for Shape Dynamics and set Angle Jitter to 20%.

4. Check the option for Scattering and set Scatter to 1000%. I set Control to Pen Pressure; Count to 2; and Count Jitter to 20%. I also set its Control to Pen Pressure too. These settings create a brush that sprays tiny dots.

5. You can take this splattered mark and make additional brushes from it to build up denser dots.

6 To do this, make a selection around the area that you want to become your brush using the Rectangular Marquee tool. Select Edit/Define Brush Preset and name your brush. Then, open the Brush Panel and click on the Brush Tip Shape option. Increase the Spacing value to 35% and you will have made a brush that creates a heavier stippling effect.

To create a stippling effect in Painter:

1. Select the Fine Spray Brush from the Airbrush Category. In the Property Bar set the Opacity to 45%, Spread to 60 degrees, Flow to 670, and Feature to 0.2. This creates a very delicate spray of tiny dots and is a great way of building up texture if you are filling a selection.

2. To build up slightly heavier dots, select the Pepper Spray brush (also found in the Airbrush Category). In the Property bar, set the Opacity to 100%, Spread to 40 degrees, Flow to 50, and Feature to 1.8. This produces a much heavier spray of dots.

TIP PHOTOSHOP OR PAINTER?

Which program you use for shading depends heavily on your style of painting. Because I prefer tonal shading, I predominantly use Painter. It simply looks less gooey and more like real paint. However, I prefer to use Photoshop for cross hatching and stippling. Sometimes I mix both.

02
RAPHAEL
PRINCE OF PAINTERS

LEVEL 1 2 **3**

What you will learn in this section
- Imprimatura underpainting
- Divine Proportion and mirror painting
- Sfumato painting techniques
- Painting in tenebrism
- Creating aged texture

Application
PAINTER

▼ **The Alba Madonna**
Raphael, c. 1510

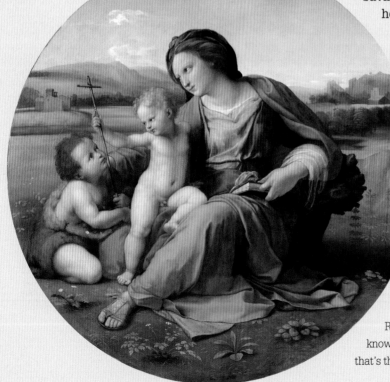

Years before Raffaello Sanzio de Urbino—better known as Raphael—was born, a poor hermit was walking through the forests outside Florence when he was attacked by a pack of wolves. Trying to escape death, the hermit climbed a tall oak tree and stayed high in its branches while the snarling wolves grew hungrier and hungrier. Days passed before a young, beautiful girl from the local village happened to be walking through the forest and found the hermit sitting high up in the oak tree. She immediately scared the wolves away, saving the hermit's life. Grateful to the brave girl, the hermit predicted that both she and the oak tree would one day be famous.

Years later, the girl married, had two children, and lived in a modest house with her father. As for the oak tree, it had been cut down and used to make wine barrels outside the house.

One day, a painter stopped by the house where the two children were playing with their mother. The youngest child scrambled onto his mother's lap while the eldest child nestled to her side, folding his hands upon her knee. The painter was so moved by the scene that he became determined to paint it immediately. Unfortunately, he couldn't find any paper. Thinking fast, he used the bottom of a nearby wine barrel and painted the beautiful mother as the Madonna, her hair the color of an oak tree and her skin in thin glazes of porcelain flesh. The painter's name was Raphael Sanzio and the painting he made that day became known as *Madonna della Seggiola (Madonna of the Chair)*. And that's the legend of how the oak tree and the girl became famous.

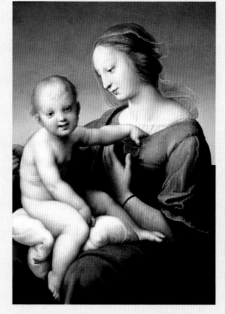 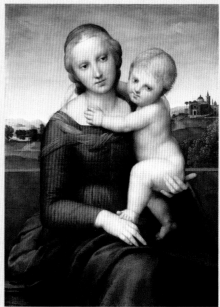

"Let him be my pupil; he will soon become my master."
RAPHAEL'S TEACHER, PERUGINO

▶ **The Niccolini-Cowper Madonna**
Raphael, 1508

▶▶ **The Small Cowper Madonna**
Raphael, c. 1505

If you are feeling like you have been told a tall tale then you should take everything about Raphael with a grain of Renaissance salt. According to his contemporary biographer, Giorgio Vasari, Raphael was so revered that by the time of his early death at age 37, he was called "The Divine Raphael." Vasari was so enamored with Raphael that he even claimed that "Raphael was overflowing with charity and goodness and was beloved by animals as well as men." It takes a certain charm to make animals swoon, but Raphael apparently had the goods. He had the manners and elegance of a spoiled aristocrat, supermodel good looks, and, most importantly, genius talent.

Even today, Raphael makes mere mortals feel like they are in the presence of an art god. But Raphael wasn't born with a paintbrush in his hand. In fact, he sums up the essence of this book—learning from the masters that came before you. Raphael was able to take a style, copy it, and completely make it his own, often going a step beyond the master he copied.

While in Umbria—where he most likely studied under Pietro Perugino—he learned how to create harmonious compositions and paint women with a "sweet air." Perugino was so impressed by the young Raphael's painting ability that he reportedly said, "Let him be my pupil; he will soon become my master."

From the work of Michelangelo, Raphael learned how to draw the body in tense *contrapasto*, so that every muscle in his figures appears as if it was caught with a fast motion camera. Michelangelo was so nervous about the young painter stealing his poses that when he was working on the ceiling of the Sistine Chapel he had the doors barred to prevent Raphael getting in.

From Leonardo da Vinci, Raphael learned *sfumato*, a painting technique that involved creating color with a smoky air. Leonardo shared his drawings with Raphael and from those he learned how to use soft washes of delicate red and black chalk. He also mimicked the smiling lips and more frontal poses of Leonardo's paintings, and in Raphael's later works his portraits became living, breathing women with personality quirks behind their perfect facade.

As his work improved, Raphael's fame skyrocketed, eventually landing him a job with Pope Julius II, where he had a workshop of 50 pupils and assistants, allowing him to concentrate on more personal work. By the age of 30, he was appointed Architect of the new St. Peters—a position equivalent to heading up the entire art world today. By the time of Raphael's death in 1520, he had earned the sobriquet "Prince of Painters" and become the most famous artist that had ever lived. He even died like a rockstar, supposedly sickened by too much sexual exertion.

RENAISSANCE PAINTING TECHNIQUES

Many of the Renaissance painting and drawing techniques used by Raphael were passed down from master to apprentice. These techniques have survived through the *Craftsman's Handbook* by Cennino d'Andrea Cennini (you can still find a copy of this book in many libraries).

Drawings were often made on sheep or kid parchment with vine charcoal made from blackened willow twigs sharpened to a point. Artists then went over the deeper folds of garments and darker shadows with a silver stylus to fix the lines. There were no multiple undos for Raphael: if mistakes were made, the charcoal would be brushed away with a chicken feather.

To transfer these drawings or "cartoons" to a wood panel, wall, or canvas, the master artist's assistants would perforate the drawing with tiny holes. A bag of charcoal was then poured over the holes while the cartoon was held against the canvas.

Much like today, gesso was made from chalk and rabbit skin to form a thin glue that was applied in glazes. It was left to dry and scraped back; the process repeated until the surface became as smooth as ivory. Raphael then brushed the gesso with linseed oil mixed with white lead and finely powdered glass. Some canvases were then tinted with raw sienna or "drab" (a gray/green color), but Raphael preferred tinting his canvases yellow.

Brushes were made from minerva tails and hog's hair: the minerva brushes were a soft brush, while hog hair brushes were more bristly.

Making pigments was a complicated process: white was made from crushing calcium carbonate and then washing it for eight days in spring water; browns, such as raw sienna and umber, were extracted from the hills around Ghibelline city; verdigris was made by grating a copper plate soaked in the urine of newborn babies; Lapis Lazuli blue could only be found in Afghanistan, making it so precious that it was worth almost as much as gold; reds were made from grinding up kermes insects and, worst of all, many colors contained poisonous lead that caused headaches and sickness. Raphael built up these colors in semi-opaque glazes called *velaturas*, using walnut oil to bind the paint.

Scented resin from a small cypress tree, called *sandarac*, was heated and dissolved in solvents to make varnishes. These varnishes were applied after the paint had dried for several weeks (unfortunately, the resins also caused the paint to crack centuries later).

The whole process for creating a Renaissance portrait was extremely time consuming and costly. This tutorial will focus on recreating some of the old master painting techniques, such as sfumato, tenebrism, and glazing (minus the baby urine and crushed insects!). I chose a younger subject matter than Raphael's portraits and one invented in my mind. If you are new to portrait painting I recommend having someone sit for you in a dimly lit room.

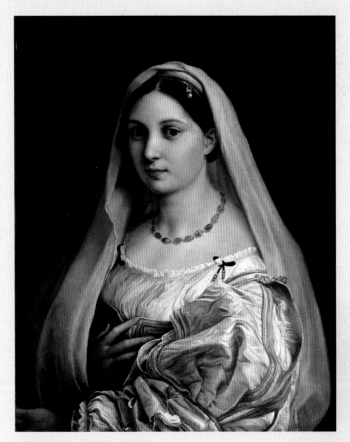

▶ **La Donna Velata**
(The woman with the veil) Raphael, c. 1516
Historians are still divided on the identity of the woman in *La Donna Velata*, but most agree she was probably Raphael's mistress, Margherita Luti, a baker's daughter from Siena. Raphael became so enamored with Margherita that he could not get any work done. Eager to keep his passionate artist focused on completing his frescoes, his patron, Agostino Chigi arranged for Margherita to live with Raphael at Chigi's villa in Rome. *La Donna Velata* shows Raphael's mastery of the sfumato techniques that he learned from Leonardo.

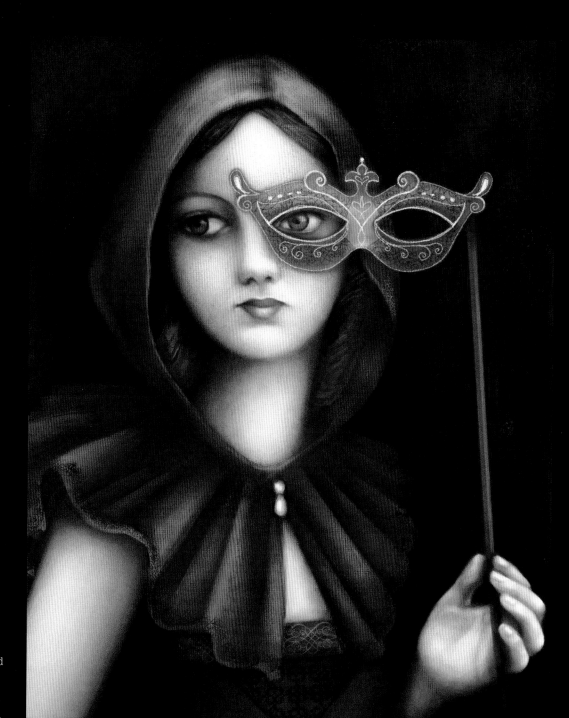

▶ Lady with a Green Mask
This painting was created using Corel Painter's Oil, Pastel, and Conte brushes. In this tutorial we will learn the old master painting technique of tenebrism

STEP 1 SKETCH WITH MATHEMATICAL PERFECTION

Every Raphael composition was arranged in a mathematically pleasing pattern using the Fibonacci sequence, otherwise known as the Divine Proportion or Golden Ratio. Divine Proportion is an irrational number that equals 1.618 and you can find this number in everything from the Pantheon and the *Vitruvian Man*, to objects in nature such as sea shells, leaves, or your own hands.

1. Create a new canvas and open the Divine Proportion panel (Window/Composition Panel/Divine Proportion). Check the box to Enable Divine Proportion.

2. For this example I selected Portrait orientation, curving to the left. The Divine Proportion tool helps organize a composition so that the most interesting portion falls into the inner curve of the spiral. As you sketch, you can check and uncheck the Enable Divine Proportion box.

3. Using the Real Hard Pencil tool, I lightly mapped out how the figure would fill the page. I was careful to keep her mask in the spiral so that it relates to her eyes. At this point, I am not interested in doing a tight sketch—I just want to get the movement of the form.

TIP PROPORTION

You can select the Divine Proportion tool from Painter's toolbar, and move it anywhere on your page. You can control its size and rotation from the Divine Proportion panel, and you can also change its Color and Opacity.

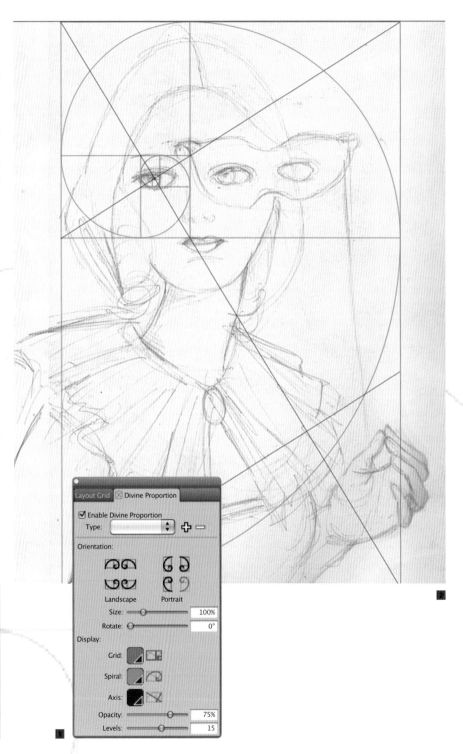

IS YOUR PORTRAIT IN DIVINE PROPORTION?

You can find the Divine Proportion or Golden Ratio (roughly 1.6) in almost any part of your body, but faces that are in the correct proportion will automatically appear more beautiful to our eye. Scientists believe that this is partly scientific: harmony is an indicator of good health and humans are biologically programed to choose healthy mates. Studies even show that babies will actually stare longer at faces in perfect proportion. To try to reach this beauty ideal, plastic surgeons have also developed a "golden ratio mask" that they use to reconstruct faces using the perfect proportion. Here a few tips to drawing faces in divine proportion:

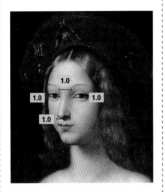

On a perfect face the length of the eyes should equal the length of the nose's base, and also the distance between the eyes. Raphael tended to draw heavy lidded, almond-shaped eyes with thin brows because it was considered the beauty ideal in Renaissance Italy.

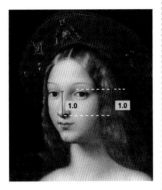

The length of the ears should be equal to the length of the nose. The top of the ears should align with the top of the eyelid and the bottom of the earlobe should align with the nostril (when the face is seen from a frontal position).

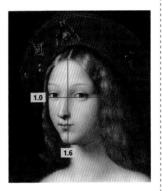

A face in perfect harmony should be about 1.6 times longer than it is wide. To measure your proportions, take the length of the face from the tip of the head to the chin and divide it by the widest part of the face. You should get a number equaling roughly 1.6

Next, measure from the forehead hairline to a spot between the eyes; from between the eyes to the bottom of the nose; and from the bottom of the nose to the bottom of the chin. If a face is in divine proportion then these measurements will be equal.

A face can be distorted and still remain in perfect harmony: in *Nude on a Blue Cushion*, by Amedeo Modigliani, the face is in divine proportion even though it is distorted.

TIP PRETTY CHILD

When drawing a child's face in perfect proportion you can follow the same rules, with the exception that the cranium is much larger. To allocate for the larger cranium, I usually double the size of the forehead in relation to the other parts (depending on the age of the child). In this tutorial I have drawn a young girl, so her forehead is going to be longer.

STEALING RAPHAEL: **COMPOSITION TRICKS**

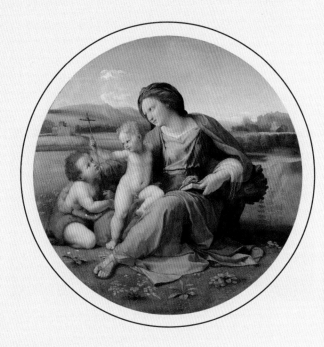

◀ **The Alba Madonna**
Raphael, c. 1510
A Perfect Circle
Raphael painted many *tondu* ("in the round")
paintings. Even when not composing his
figures in a circle, Raphael repeated circular
elements throughout his compositions.

▼ **Young Woman with Unicorn**
Raphael, 1506
A Perfect Frame
In *Young Woman with Unicorn*, Raphael
used the vertical columns to frame the
face and keep the eye on the page.

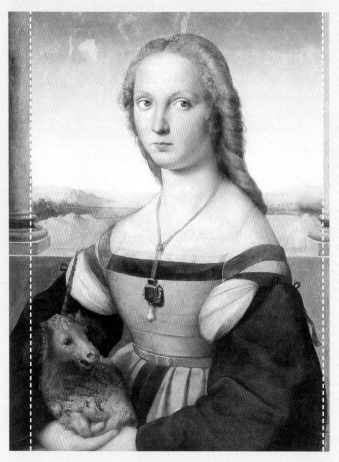

FIBONACCI: A REAL BONEHEAD

In the year 1200, in Pisa, Italy, a father decided to send his
son, Leonardo Pisano Bigollo, across the Mediterranean to
learn math. While there, Leonardo (also known as Fibonacci)
learned Arabic numerals and the symbols 0 through 9.

When he came back to Pisa he dared to suggest there was a
system of numbers more efficient than the old Roman
numerals. He wrote a book on his findings called *Liber Abaci
("The Book of Calculating")*, in which he also suggested a
sequence of numbers where each number is the sum of the
two proceeding numbers (1, 1, 2, 3, 5, 8, 13, 21...). He
proposed that this sequence occurred in nature and even
with the way rabbits multiplied.

Italians thought the child was crazy—they called his father
Bonaccio ("bonehead") and called the son *filius Bonaccio*
("son of a bonehead"). It wasn't until the 19th century that
a French mathematician named Edouard Lucas, named this
sequence of numbers the Fibonacci Sequence, after Leonardo.

▼ The Triumph of Galatea
Raphael, 1511–13
Rhythm in Beauty
Raphael always creates a continuous rhythm in his art and a sense that his figures are related to each other. In *The Triumph of Galatea*, the figures are arranged in such a manner that your eye is lead up the painting to the cherubs in the sky and then back down again as a result of the direction their bows and arrows are pointing.

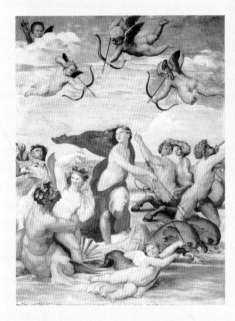

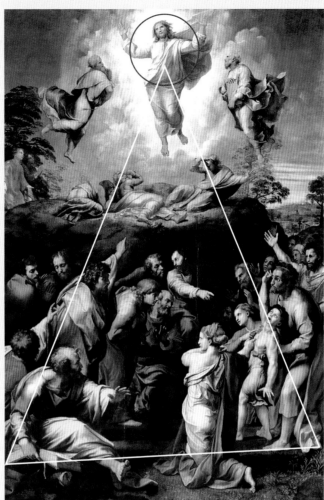

◄ The Transfiguration
Raphael, 1518–20
The Beautiful Triangle
Triangular composition reached the height of its popularity in the High Renaissance. Much like the dramatic crescendo in a piece of music, the top point of the triangle becomes the focal point, allowing the artist to create a hierarchical build-up of tension, as well as adding visual unity between elements. *The Transfiguration* is a very good example of this compositional device.

TIP FRAME YOUR COMPOSITION

Stealing a composition trick from Raphael, I used the diagonal line of the mask to keep the eye from leading off the right side of the page (right). Whenever you have a centered composition, always add elements that keep the eye on the center. These container devices work better if they are on the right, as we read from left to right. If you look at the image flipped (far right), the eye tends to wander off the page.

STEALING RAPHAEL: **UNDERPAINTING TECHNIQUES OF THE MASTERS**

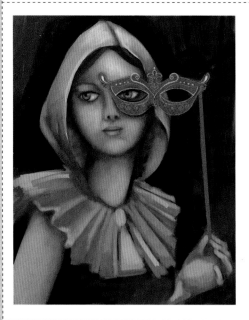

Grisaille

A true Grisaille underpainting contains completely neutral grays. I often use this method with tricky compositions where I want a dramatic range of light to darks and form is more important than color. Often called a "dead layer," the Grisaille method lives up to its name, sometimes making subjects appear as though they escaped the local cemetery. Still, the effect can be striking if you are going for a Gothic look or if the dead layer is eventually enlivened with warm or cool tones. Jean-Auguste-Dominique Ingres created underpaintings in Grisaille.

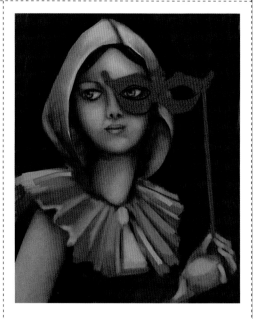

Imprimatura

When Old Masters painted in Imprimatura they used a single layer of sepia tones washed thinly onto the canvas. They would then rub down the underpainting with linseed oil and a piece of bread. Leonardo and Raphael created underpaintings using Imprimatura.

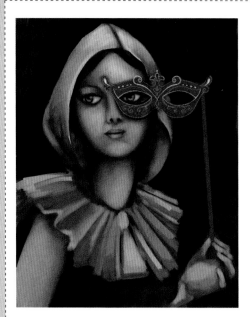

Verdacchio

In a Verdacchio underpainting, flat layers of gray/green color mark out the highlights, while a warmer sepia tone is used in the shadows. Old masters had a very scientific reason for painting in Verdacchio. When light hits Caucasian skin, the red wavelengths created from our blood are blocked and we are left with its opposite color—green. Although Renaissance underpaintings often appear green, the colors mixed do not contain any green, but instead yellow ocher, a bit of black, white, and a hint of a red color called *cinabrese*. The Flemish masters and Italian painters such as Michelangelo created underpaintings using Verdacchio.

STEP 2 CREATE AN UNDERPAINTING

Most Renaissance artists first did an underpainting in Verdacchio or Imprimatura (see opposite). The exact mixture of an underpainting varied from artist to artist, but most were created in grayish tones with a slight sepia or olive tone. The underpainting is very important as it establishes a range of values. Paintings that lack depth are usually suffering from the incorrect tonal values. Keep in mind that unless you apply paint with 100% Opacity, your underpainting will show through subsequent layers of color. For this reason, your underpainting method is important not only for solving tonal value problems, but also for communicating the right mood—get your underpainting right and you have 90% of your painting solved.

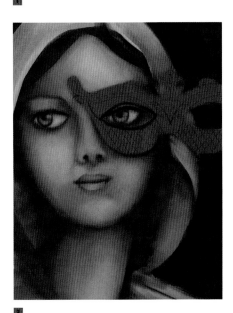

1. Once you have a rough pencil sketch mapped out, apply the underpainting using the Square Conte Brush. I usually set the Opacity to 100%, Grain to 8%, Resaturation to 75%, Bleed to 100%, and Jitter to 0.14.

2. Select the Sandy Pastel Paper from the Paper Library. The Sandy Pastel Paper is one of Painter's default papers and gives a fine tooth to the Conte Brush, which is similar to painting on old Parchment paper. This brush will allow the paint to go on in thin, watery glazes.

3. Using a large brush, block in the color to create an underpainting in Imprimatura. This makes it easier to get your tonal values right before you add color.

UNDERSTANDING GRAIN, RESATURATION, BLEED, AND JITTER.

 31.0 ▼ ⬤ 17% ▼ Grain: 8% ▼ Resaturation: 75% ▼ Bleed: 51% ▼ Stroke Jitter: 0.00 ▼

Grain: As you build up paint on each layer, the grain becomes less prominent, as the paint seeps into the paper. It may sound counterintuitive, but with most brushes, if you want more of the paper's grain to show through, decrease the Grain value in the Property Bar; if you want *less* paper grain, increase the Grain amount.

Resaturation: A higher Resaturation value will load your brush with more paint, while a lower Resaturation will pick up the paint on the layer and blend it as you apply your brush strokes. If you paint on an empty layer with Resaturation set at 0, then no paint will be applied, as there is nothing to pick up and blend. This would be similar to running medium through your paint. I use a low Resaturation value when blending colors and a higher value when applying thin glazes.

Bleed: A higher Bleed will blend neighboring colors within a layer creating a wet-on-wet look. A lower Bleed will apply paint thickly, without blending—similar to using paint without any medium.

Stroke Jitter: Jitter controls the variance in the brush stroke. A lower Jitter value will create a smoother line, while a higher Jitter value will create a brush stroke that "jitters" at the end.

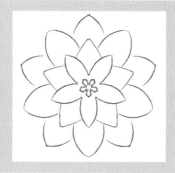

STEP 3 MIRROR PAINTING

In this next step, I want to add a pattern to the girl's mask, but being intrinsically lazy I need an easy way to make the pattern symmetrical. Thankfully, Painter has a tool that will allow you to quickly create symmetrical patterns.

1. Select the Mirror Painting icon from the toolbar. This immediately activates the mirror painting guides, with a green line and a circle in the middle. The default position will be going through the exact middle of the canvas.

2. Hover over the circle icon and your cursor turns into a crosshair. The crosshair allows you to move the mirror painting guide to any point on your canvas. Here, I dragged the guide to the center of the mask.

3. Once your guide is in the right place you can turn Toggle Planes off, so the guide isn't shown as you paint.

4. In this example, I selected white from the Color Panel. Using the Conte Crayon with a small brush size, I painted in a pattern on the left side of the mask. The pattern is repeated automatically at the right side.

TIP MIRRORED REPEAT

If you want to have your mirror painting repeat from top to bottom, select the Horizontal Plane option from the Property Bar after you have activated the Mirror Painting tool. You can also change the angle of the mirror plane by adjusting the Rotation value.

PERFECTION IN NATURE

Nature and mathematics intersect in most flowers. Leonardo da Vinci observed that the petals around a stem occur in patterns that follow the Fibonacci sequence. If you take the number of petals in each row and divide them by the number of petals in the next row (for example, 2/1, 3/2, 5/3, 8/5, 13/8, and so on), You will get a number that is approximately 1.6180339887—otherwise known as the Golden Ratio. You can create your own mathematically perfect flower by selecting Painter's Kaleidoscope tool.

STEP 4 THINNING IMPRIMATURA

Raphael's Imprimatura underpainting was applied using very thin paint and was often rubbed back in places, allowing the texture of the wood panel to show through. In the next step, I want my paper to show through the paint, giving the appearance of thinner washes. Renaissance artists often used stale bread to thin out the paint, but we don't have to grow mold to get the same look!

1. Select the Canvas Layer (CTRL/Command + A) and copy it (CTRL/Command + C).

2. Paste the Canvas Layer into a new layer above the original (CTRL/Command + V). Name this layer "Texture" by double clicking on the layer's name.

3. Download the Renaissance Canvas paper from the companion website and import it into your library (see p19).

4. Select the Renaissance Canvas paper in your Paper Library (Window/Paper Panels/Paper Library).

5. Select Effects/Surface Control/Apply Surface Texture. In the pop-up menu, keep the default lighting setting and set the light direction to the upper left.

6. Lower the Opacity of the Texture layer to 40% and you will see a slight texture over your canvas layer.

HOW TO CREATE YOUR OWN RENAISSANCE TEXTURE

You can find a lot of interesting textures by looking at the end papers inside covers of vintage book. In this example, I took an old library book and scanned the cloth binding. The texture of the linen used to bind old books is very similar to the material stretched over Renaissance canvases, and once scanned it can be transformed into a paper.

1. Use the Square Selection tool to make a selection around the area that you want to be your paper.

2. In the Paper Library (Window/Paper Panels/Paper Library), click on the Capture Paper button.

3. Name your new paper and set the Crossfade to 0 before pressing OK.

STEP 5 PAINTING IN TENEBRISM

For the next step, I am going to steal an old Renaissance painting technique known as *tenebrism*. The word comes from the Italian *tenebroso* (meaning "murky") and is a painting technique that utilizes dramatic lights and darks to make a subject emerge from darkness.

It is often confused with *chiaroscuro*, which is another technique for contrasting lights to darks. Academics may have a more specific definition, but the main difference is that tenebrism uses more darkness in the light-to-dark ratio, often keeping part of the painting completely black.

In this example, the Imprimatura layer has established my midtones, so now I'm going to deepen the shadows and bring in more dramatic highlights.

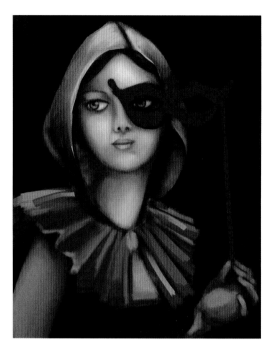

1. Create a new layer (Layer/New Layer) and name it "Tenebrism." Set its Composite Method to Luminosity and uncheck the Pick Up Underlying Color box. These settings only make changes to the tonal values.

2. Choose a light gray color and the same Square Conte Brush used in Step 2 (see page 43). Here I mapped out the lightest portions of the girl's face; her forehead, chin, and the rise of her cheekbones below her eye.

3. Switch to a dark gray color and make the background shadows deeper; I've applied this darkness to the dress, the folds of her ruff, and the sides of her arms and hands.

4. I then dropped the tenebrism layer (Layer/Drop).

TENEBRIST PORTRAITS

The difference between chiaroscuro and tenebrism often comes down to intent. If your intent is to use light to bring focus to an area for dramatic effect then tenebrism is being used. If, however, you are using light and shadow to better convey the three dimensionality of a form then chiaroscuro is being used. All of these examples use light and shadow to spotlight the drama, allowing the figures to emerge from complete darkness.

▲ **Portrait of the Artist's Mother**
Jan Lievens, 1629

▲ **David and Goliath**
Michelangelo Merisi da Caravaggio, c. 1600

▲ **Portrait of a Gentleman with a Tall Hat and Gloves**
Rembrandt van Rijn, c. 1658–1660

STEP 6 ADD GLAZE

Raphael used very thin, semi-opaque glazes for skin and slightly thicker paint for robes and drapery. His glazes were so thin that you can barely see his brush strokes in his finished works. With my tonal values in place, it's now time to add thin glazes of color.

1. Create a new layer (Layer/New Layer) and set its Composite Method to Color.

2. Select the Real Round Brush from the Oils brush category. In the Property Bar set its Opacity to 10%, Resaturation to 10%, Bleed to 25%, and Feature to 1.6. These settings will create a brush that applies paint thinly for a true "glazed" look with only a hint of the brush mark.

3. Here I chose a deep red to apply to the garments, then selected a flesh color to wash in a thin layer of color on the skin

before dropping the Color layer down (Layer Drop)

4. Next, create a new layer (Layer/New Layer) and leave its Composite Method set to Default. Check the box for Pick Up Underlying Color.

5. This time, I increased the Bleed of my brush to 75% so I could start to blend color into my tenebrism layer. I then dropped this layer to the canvas.

TIP RECEDING COLOR

Remember to use less color in the shadows, as this makes those areas recede. I removed the color on the sides of the face to let the Verdacchio show through. Renaissance artists would scrub back the paint with a rag or piece of bread in the shadowed areas.

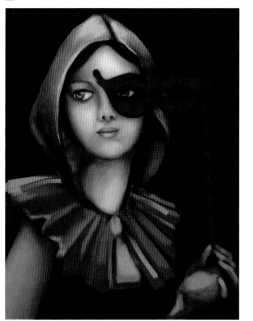

COMPOSITE METHOD

This is an example of how the initial layer appears when its Composite Method is set to Normal. When you switch the Composite Method to Color, it keeps the luminosity of the underlying layer and only changes the color. You can also use this Composite Method for tinting drawings.

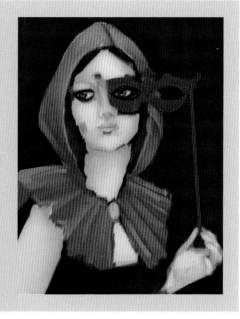

STEP 7 DIGITAL SFUMATO

Sfumato, meaning "smoky," was an oil painting technique invented by Leonardo da Vinci to create edges that blended into the background. Raphael probably first saw Leonardo's sfumato technique when he saw *La Gioconda* (the *Mona Lisa*), a painting that Raphael greatly admired. Sfumato was a breakthrough in Italian art after the sharp edges of medieval painting: paintings no longer appeared "cut out" and pasted on, but instead became part of their surroundings. Raphael painted the edges of flesh in warm sfumato using redder tones, so in this step, I'll add red to the edges of the girl's flesh to blend the shadows into the background. I am using the Hard Pastel brush because it applies paint with a diffused grain, which is perfect for creating smoky layers.

WHEN TO USE SFUMATO

1. **To create distance** Leonardo used sfumato techniques on the distant landscape in the *Mona Lisa*. I often use the same principal of diffused blues to create aerial perspective. For example, when looking at a mountain scene you will notice that more distant mountains appear bluish gray, blending into the sky.

2. **Edge lighting** When the sun is behind an object and low in the sky you get edge lighting. I use bright yellow or white to diffuse the edge.

3. **Motion** Objects in motion never have smooth, sharp edges. I use sfumato to indicate how motion distorts an object in space.

1. Start by creating a New Layer (Layer/New Layer) and name it "Sfumato." Check the Pick Up Underlying Color box.

2. Select the Square Hard Pastel brush from the Pastel Brush category. In the Property Bar set the Opacity to 10%, Grain to 7%, Resaturation to 75%, Bleed to 100%, and Jitter to 0.

3. You need a paper with a tight grain, so from the Paper Library (Window/Paper Panels/Paper Library), switch to the Sandy Pastel Paper. This paper is part of the default library.

4. In the Paper Panel (Window/Paper Panels/Paper) set the Scale to 30%, Contrast to 50%, and Brightness to 50%. This creates a brush with a tightly diffused grain that will blend with the underlying color.

5. I selected red from the Color panel (Window/Color Panels/Color) and lightly brushed this into the edges of the flesh, slowly blending the colors into the background. As you paint you may want to switch the direction of the grain occasionally so that your strokes appear more natural. I used sfumato along the edges that recede, such as the edge of the figure's cheeks. I kept the folds of her red hood sharp to frame the face and make the hood pop forward. I always kept her eyes sharp as well.

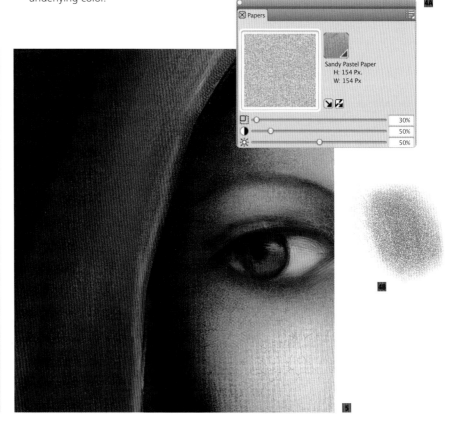

Sandy Pastel Paper
H: 154 Px.
W: 154 Px

STEP 8 AGED TO PERFECTION

Thicker layers of oil paint will shrink as they dry, sometimes causing cracks over the surface. Raphael painted using very thin, fast-drying glazes because they were less likely to crack as he built them up. Still, the resin in the final varnish layer caused the paint to expand and would eventually crack the underlying layers. It is very hard today to find a Raphael painting without a few cracks. Personally, I think these cracks give the paint character, so in this last step I created a crackle paper from an antique turquoise necklace. I then added this to the surface of my painting to give it an aged appearance.

1. I started by scanning a turquoise necklaces that had dark cracks on the stone's surface and used the Crop tool to isolate the cracked area.

2. Then, I turned the scan into a grayscale image by choosing Effects/Tonal Control/ Adjust Color and moving the Saturation slider all the way to the left. This meant that I could better see the contrast between the cracks.

4. Next, I made a selection around the area that I wanted to be my crackle paper and from the Paper Libraries Panel (Window/Paper Panels/Paper Library). I selected the Capture Paper button. I named my paper "Crackle Turquoise," set Crossfade to 0, and selected OK.

5. I now chose the Square Hard Pastel brush from the Pastel Brush category, and from the Paper Library I selected my new Crackle Turquoise paper.

6. From the Property Bar, I set the Square Hard Pastel brush's Opacity to 10%, Grain to 10%, Resaturation to 75%, Bleed to 50%, and Jitter to 0.

7. I then selected black from the Color Panel (Window/Color Panels/Color).

8. Finally, I painted over some of the brightest red areas. I made sure to vary the scale of my paper as I painted so that the cracks did not appear tiled. If you want the paint to seep into the cracks more, you can reduce the Grain of the brush in the Property Bar.

1A

1B

2A

2B

1B

03
VINCENT VAN GOGH 1853–1890
REACHING FOR THE STARS

LEVEL 1 2 **3**

What you will learn in this section
- Harmonizing complementary colors
- Building up impasto effects
- Alla-prima painting technique

 Application
PAINTER

"I dream of painting, and then I paint my dream."
VINCENT VAN GOGH

It began as the painting full of yellow hope. Van Gogh's dream of an artistic collaboration was finally coming true: his idol, Paul Gauguin, was coming to live with him in his small countryside abode, nestled in the hills of Arles, France.

▼ **Bedroom in Arles**
Vincent Van Gogh, 1888
Van Gogh's bedroom, known today as the "Yellow House."

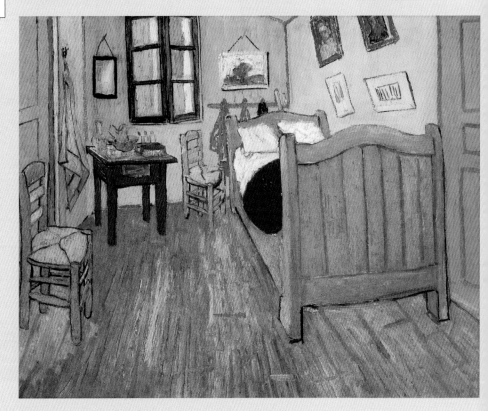

Known today as the "Yellow House," Van Gogh quickly set about buying furniture and making Gauguin's room comfortable. To complement the blue walls and red tiled floors, he chose to paint sunflowers—the symbol of loyalty and friendship in Dutch literature. In one of his usual artistic fervors, Van Gogh dashed off four sunflower paintings, finishing most of them in under an hour.

He created the sunflowers by building up bright yellows, greens, and blues, sometimes squeezing paint directly onto the canvas. For the flower's centers he used *pointilism*, a technique developed by his friend George Seurat that used tiny dabs of complementary colors (although Van Gogh's paint dabs were applied larger and less scientifically). Then, he painted the furling petals and leaves with paint applied so thickly that it took weeks to dry.

For his backgrounds, he mixed complementary colors, sometimes blues and yellows to get a less saturated, grayer tone. Van Gogh was certainly a master colorist, but he also knew the power of gray. In a letter to his brother, Theo, he wrote, "the colorist is he who on seeing a color in nature is able to analyze it coolly and say, for example, that green-gray is yellow with black and almost no blue. In short, knowing how to make up the grays of nature on the palette." If you look at one of his sunflower paintings stripped of color (below right), you can see Van Gogh's grays at work: Van Gogh's sunflowers are in a perfect range of dark to light values.

When Gauguin first laid eyes on the sunflowers he liked them so much that he said they were even better than Monet's sunflowers. Since Monet is hardly remembered for sunflowers, I would have to agree. The sunflowers were Van Gogh's masterpiece, but to the general public they were as strange and unsettling as the artist who painted them.

For a start, no artist had ever used such garish, fully saturated colors in one painting. He also used complementary colors juxtaposed in an effect called simultaneous contrast, which draws the viewer's eye by placing opposing warm and cool tones near each other. Although used to some degree in his sunflower paintings, it is more obvious in *Bedroom in Arles*: the bright yellow-orange bed almost vibrates off the blue walls. In a letter to his brother, Van Gogh wrote, "There are colors which cause others to shine brilliantly, which form a couple which complete each other like man and woman." By applying these high chroma, complementary colors, Van Gogh created a greater sense of visual depth.

The sunflower painting also marked a point of confidence for Van Gogh. For the first time, he realized that he had painted something wonderful. To his brother, Theo, he wrote: "It is a kind of a painting that rather changes in character, and takes on a richness the longer you look at it. You know the peony is Jeannin's, the hollyhock belongs to Quost, but the sunflower is somewhat my own."

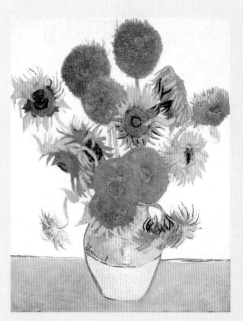

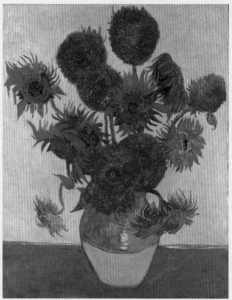

◄◄ Color
Van Gogh was not using artistic license when he painted the smaller centers for his *Sunflowers*, 1888 (far left). The flowers that he painted were a mutated version that lacked the large brown centers found in today's sunflowers.

◄ Gray
If you get your tonal values right you have won half the battle: Van Gogh's *Sunflowers* still pop forward even when reduced to shades of gray (left).

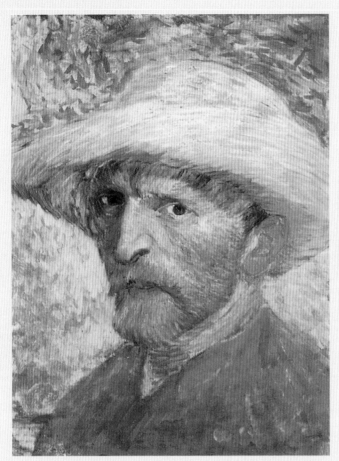

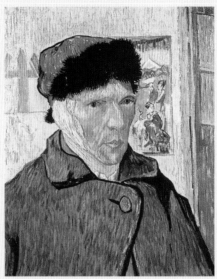

◄ **Self-portrait with Bandaged Ear**
Vincent Van Gogh, 1889
Van Gogh created several self-portraits throughout his life. In this painting you can see a Japanese print on the wall in the background. Van Gogh collected Japanese prints and was influenced by how their layout broke up positive and negative space.

◄ **Self-Portrait with Straw Hat**
Vincent Van Gogh, 1887
In his earlier work, Van Gogh was influenced by the impressionists and applied paint with dabs of color. Yellow dominated his painting—in fact, Van Gogh loved the color yellow so much that he sometimes ate it. If only he had chosen blue or green, he might have been only half-crazy, but yellow paint contained highly poisonous lead!

But here is the thing about sunflowers: Sure, they are very pretty when those bright, yellow petals first open to the sun, but once they start to die…they can get pretty creepy looking. In art, sunflowers also represent the opposing sides of birth and death—full of yellow promise at birth, but quickly blackened by death. Van Gogh's sunflowers were inspired by his new friendship with Gauguin, but by the time the paint had dried on his canvas, that friendship would start to resemble a brown, crusty, droopy, and very dead sunflower.

Their polar opposite personalities were bound to cause problems. Gauguin was the passionate savage from the tropics with a bawdy sense of humor and a penchant for painting the macabre. Van Gogh was awkward, sensitive, introverted, and always quick to take offense. They couldn't even agree on art: Gauguin admired Ingres and Raphael, while Van Gogh found their work soulless. Van Gogh idolized Adolphe Monticelli while Gauguin felt Monticelli's impasto

brushwork left too much to "chance effects." Their career paths also diverged as rapidly as their friendship: Gauguin had sold several paintings (one to even the great impressionist master, Edgar Degas), while Van Gogh had yet to sell a single painting.

Van Gogh also had some seriously bad habits that caused him, at times, to not act like the most courteous of roommates. His most destructive vice was his fondness for absinthe. It was once believed some hidden ingredient in absinthe caused hallucinations, but we know today that this hidden ingredient was simply good old fashion alcohol…148 proof alcohol. Vincent began to rely heavily on absinthe, telling his brother Theo, "If the storm within gets too loud, I take a glass too much to stun myself." He became more than a bit stunned: one night, he even threw a glass of absinthe at Gauguin's head. It missed, but Gauguin got the message and began to threaten to leave the yellow house if things did not improve.

◀ Madame Cahen
Adolphe Monticelli, 1869
Van Gogh greatly admired Monticelli's thick brush strokes and used a similar muddy brown color palette in his earlier works. Monticelli is either loved or hated. In 2005, Sir Timothy Clifford, Director General of the National Galleries of Edinburgh stated: "We have been bequeathed eight paintings by Monticelli, each one more hideous than the last."

"If you hear a voice within you say 'you cannot paint,' then by all means paint, and that voice will be silenced."

VINCENT VAN GOGH

▼ L'Absinthe
Edgar Degas, 1876
Much like today's "happy hour," bars in 19th century France had "the hour of absinthe." This colorless (or sometimes green) drink was up to 148 proof alcohol and was typically dribbled over sugar into a glass of water. Absinthe drinkers included Gauguin, Toulouse Lautrec, and Degas.

The story that follows is a familiar one, but is still steeped in mystery. A couple of days before Christmas, Vincent stumbled through the winding streets of Arles to visit his favorite prostitute, Rachel. In his hands he had carefully wrapped a present in newspaper, tucking the corners in to resemble an envelope. Rachel unwrapped the parcel and found Vincent's blood soaked ear (or earlobe—accounts differ). She quickly did what any sensible person would do with a chunk of flesh staining her fingers and fainted to the floor. Vincent then hobbled back to the yellow house and was later found in his bed with his head wrapped up, bleeding to death.

As for Gauguin, did he run to his friend's bedside? Not exactly. He packed up his bag and headed back to Paris. Some historians have suggested that Gauguin may be responsible for the ear-cutting debacle. Doctors couldn't figure out how the ear was cut off so cleanly and Gauguin just happened to be a talented fencer who kept his sword on him at all times.

But whether Van Gogh or Gauguin made that infamous slice, most people today cannot think of Van Gogh without picturing his missing ear. We are left wondering whether the craziness fueled his painting or his painting fueled his craziness. To Theo, he confessed his greatest desire: "What I want to express, in both figure and landscape, isn't anything sentimental or melancholy, but deep anguish. In short, I want to get to the point where people say of my work: that man feels deeply, that man feels keenly."

In Van Gogh's final days, his true anguish became obvious. The year before he died, he painted my personal favorite—*Starry Night*. Van Gogh was disappointed with the painting and wrote to Theo: "Once again, I allowed myself to be led astray into reaching for the stars that are too big," he said. "Another failure—and I have had my fill of that."

On July 29, 1890, Vincent Van Gogh tucked his easel under his threadbare smock and headed out to the fields for a day of landscape painting. There, surrounded by his favorite shades of yellow, he put a bullet in his chest. His brother Theo rushed to his side to hear Vincent's last words—"the sadness will last forever."

In this tutorial, I chose to paint the flower that should truly honor Vincent Van Gogh—Artemisia Absinthium, the main ingredient in absinthe. This tutorial will focus on Van Gogh's use of complementary colors and impasto effects. I chose a still life because although Van Gogh's painting technique may look easy, it is anything but simple. I recommend mastering his color and brushwork techniques before moving on to more complicated subjects. This tutorial is not for the timid. It is intended to be completed in under an hour with paint slapped on quickly and applied Alla-prima (wet-on-wet). So abandon all your color inhibitions and channel your inner Van Gogh!

◄ Starry Night

Vincent Van Gogh, 1889
Starry Night shows Van Gogh's view outside his sanitarium at Saint-Remy-de-Provence. He used some artistic license with it, most likely painting it from his imagination: the church in the background is not a church that one would find in France, but in Holland, for example. The cypress tree in the foreground is also more abstracted, giving a more foreboding feel. Van Gogh felt this painting was a failure. He painted it in less than 45 minutes.

► The Hour of Absinthe

This painting was created to honor Van Gogh's favorite drink —absinthe. In this tutorial you will learn how to apply thick, highly saturated colors using Corel Painter's Oil and Impasto brushes.

TIP STEALING VAN GOGH? READ HIS LETTERS

Van Gogh wrote over 800 letters, mostly to his brother Theo. These letters allow us to read his painting technique in graphic detail.

STEP 1 PREPARE YOUR CANVAS

Partly in an effort to save money, and partly to try something different, Van Gogh painted many of his pictures over jute. Instead of gessoing the jute, he applied a liquid barium sulfate as his base and then applied a "fond brun" underpainting in a mixture of white, carmine, and yellow. This gave his canvas a light reddish brown color and allowed some of the jute texture to show through in places. Before you begin painting your still life, prepare a similar canvas. To follow along, you will need to download and open the Jute.jpg file from the companion website.

1. In Painter, open the Jute.jpg file.

2. Next, open the Paper Library (Window/ Paper Panels/Paper Library).

3. Select the entire canvas (Select/All or Command/CTRL + A)

4. Next, select the Capture Paper icon. In the Save As dialog box, name your paper "Jute" and set the Crossfade to 100. You can now see a new paper thumbnail in your paper library.

5. Open a New Canvas (File/New) and set the dimensions to roughly 8.5 x 11in.

6. Select a light, warm brown color from the color wheel (Window/Color Panels/

Color), click on the Paint Bucket tool, and in the Property Bar set Fill to Current Color. Click inside the canvas area to fill it with the light brown color.

7. Duplicate this layer by selecting all (Select/All) and copying and pasting it above the Canvas layer. Name this layer "Jute texture." You should have two identical layers with a brown fill.

8. Select Effects/Surface Control/Apply Surface Texture and change the light source. I moved mine to the right side, as that is where my light will be coming from. This tiled the jute texture across the canvas.

9. Finally, lower the opacity of this layer to mimic the effect of a thin layer of barium sulphate across the canvas.

> **TIP** CHOOSING A BASE COLOR
>
> A brown base color will give the whole painting a warm tone. If you would prefer a cooler base then fill the canvas area with a blue or green.

◀◀Flowers
Van Gogh usually worked from nature, but I found Artemisia Absinthium a little hard to come by. Instead, I used marigolds, as they have similar tight yellow petals.

◀Initial drawing
I usually draw in pencil and scan it in, but for this composition I drew directly on my Cintiq screen. The goal of your drawing should be to map out the negative and positive spaces; try not to focus on any details.

STEP 2 SKETCH YOUR COMPOSITION

Before venturing into painting, Van Gogh constantly honed his drawing skills, believing that it was the "root of everything." He used a variety of drawing mediums, but generally preferred pencil, conte crayon, or a reed pen with sepia India ink. In a letter to Theo he wrote: "I have learned to measure and to see and to look for the broad outlines, so that, thank God, what seemed utterly impossible to me before is slowly becoming possible now." For this sketch, you are going to use Corel Painter's reed pen over the jute texture created in step 1. You are not making a detailed sketch, but should simplify your still life into simple shapes.

1. Create a new layer (Layers/New Layer) and name it "Sketch."

2. From the Pens Brush category, select the Reed Pen and choose a deep brown color from the Color Panel (Window/Color Panels/Color).

3. In the Dab Profile (Window/Brush Control Panels/Dab Profile), change the Dab to Pointed Profile.

4. In the Size panel (Window/Brush Control Panels/Size), set Min Size to 10%, Size Jitter to 5%, and Expression to Pressure. These settings will give you a reed brush that has a stronger variance between thick and thinness depending on the pressure of your hand.

5. Begin sketching using quick brush strokes, varying the pressure of your hand to get a thick mark on the shadow side and a thin mark where the light hits.

6. When you're done, drop the sketch layer down to the Canvas (Layers/Drop).

Size | Spacing | Angle | **Dab Profile**

3

Size | Spacing | Angle | Dab Profile

Size:	11.0
Min Size:	10%
Size Jitter:	5%
Expression:	Pressure
Direction:	0°
Size Step:	5%

4

STEP 3 CHOOSE YOUR COLORS

In the early stages, Van Gogh wasn't much for mixing colors. He would often apply paint straight from the tube and was a very messy painter. He believed there are three fundamental colors—red, yellow, and blue; "composites" are orange, green, and purple. By adding black and some white one gets the endless varieties of grays—red-gray, yellow-gray, blue-gray, green-gray, orange-gray, and violet-gray. For this step we will mix up a limited palette of yellows, oranges, blues, greens, and browns.

1. To start with, choose the highest saturated colors from the Color Panel (Window/Color Panels/Color).

2. Open the Color Mixer (Window/Color Panels/Mixer) and choose Apply Color Brush. Repeat this process for a range of blues, yellows, and greens.

3. Next, choose shades of brown, ranging from red to yellow, to define your mid-tones. Then turn on the Dirty Brush mode and blend the browns together.

4. Finally, choose the Sample Color tool so you can "pick up" the colors from the Mixer Panel.

> *"Great things are done by a series of small things brought together."*
>
> VINCENT VAN GOGH

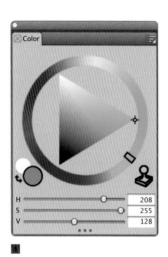

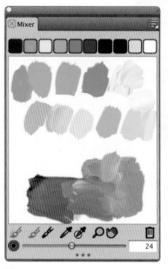

STEP 4 LOOSEN YOUR HAND

To emulate Van Gogh, you should use paint thickly and at a very fast pace. This means you need to adjust the Brush Tracking. Brush Tracking records the pressure of your hand to determine the width and density of your brush strokes. To use Brush Tracking:

1. Open Brush Tracking by going to Corel Painter 12/Preferences/Brush Tracking (Mac OS) or Edit/Preferences/Brush Tracking (Windows).

2. Make a few quick marks in the Scratch Pad window.

3. Select OK and Brush Tracking calculates the appropriate speed and pressure settings based on your hand.

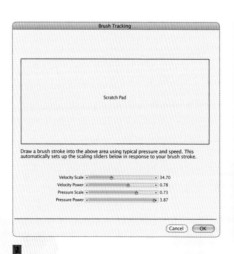

VAN GOGH'S ADVICE
A BLANK CANVAS

"Just slap anything on when you see a blank canvas staring you in the face like some imbecile. You don't know how paralyzing that is, that stare of a blank canvas is, which says to the painter, 'You can't do a thing'."

(Letter to Theo Van Gogh, October 1884)

STEALING VAN GOGH: **COLOR TIPS OF THE MASTER**

Blues
Van Gogh understood atmospheric perspective; objects become less saturated in the distance and blend into the background blue of the sky. He often used blues to help objects recede. His most famous use of Cobalt is in his painting, *Starry Night.*

"Cobalt is a divine color, and there is nothing as fine for putting an atmosphere round things."

Black and White
When Van Gogh painted the stars in *Starry Night*, he didn't just slap white dots on a black background. He did mix black into his paint, but he never used pure black: he always used black and white to neutralize his colors.

"Black and white, they have their reason and significance, and anyone who suppresses them won't get it right. The most logical, certainly, is to regard them both as—neutral."

Reds
Van Gogh used carmine sparingly, but with dramatic results. He would add dabs of the rich, red color to draw the viewer's eye to the focal elements. For example, in *Bedroom in Arles*, he placed a blood-red blanket upon the bed.

"Carmine is the red of wine and is warm and lively like wine."

Grey
Van Gogh understood that even if he used the brightest colors, he still had to get his tonal values right. As such, gray was at the heart of every painting.

"Black...forms the endless variety of grays—different in tone and strength. So that in nature one really sees nothing else but those tones or shades."

Greens
Look at any Van Gogh painting with red in it, and you will always find greens to balance it. Van Gogh used greens to complement red. He also often used green in portraits to define shadowed areas and balance the warm, red tones of the skin.

"I've tried to express the terrible human passions with the red and the green"

Violet
Van Gogh usually depicted earth colors not in browns, but browns warmed by the sun—deep violet hues.

"From time to time there are moments when nature is superb, autumn effects glorious in color...earth in all the violets."

Yellows
Van Gogh saw yellow in almost every object. He used yellow instead of white to define the lightest points in his work.

"Sunshine, a light which, for want of a better word I can only call yellow—pale sulphur yellow, pale lemon, gold. How beautiful yellow is!"

Orange
You will have a hard time finding a Van Gogh painting that contains blue and not orange. He mixed orange into his blues to neutralize them, or he used more saturated orange to complement the blues.

"There is no blue without yellow and without orange, and if you put in blue, then you must put in yellow, and orange too..."

STEP 5 APPLY BASE COLORS

Van Gogh never tried to paint exactly what was in front of him. Instead, he saw every color as having a meaning and an energy of its own. That energy could be amplified by placing complementary colors next to each other, so when painting red apples he would place them against a background of greens. In this step we will be applying highly saturated, complementary colors.

1. Add a new layer (Layers/New Layer) and uncheck the box for Pick Up Underlying Color. Unchecking this option will prevent your colors from blending with the colors below it.

2. Select the Real Flat Opaque brush found in the Oils brush category. In the Property Bar set the Feature to 4 and the Opacity to 100%. Set the Bleed at 0 because you wanted the paint to go on thickly, without blending into neighboring colors.

VAN GOGH'S ADVICE
THE POWER OF COLOR

Van Gogh always used colors with a specific intention. When describing *The Night Cafe,* he said:

"I have tried to express the idea that the café is a place where one can destroy oneself, go mad, or commit a crime. In short, I have tried, by contrasting soft pink with blood-red and wine-red, soft Louis XV-green and Veronese green with yellow-greens and harsh blue-greens, all this in an atmosphere of an infernal furnace in pale sulphur, to express the powers of darkness in a common tavern."

3. Next, select the Impasto Panel (Window/Brush Control Panel/Impasto) and change the Draw To method to Color and Depth. Change the Depth slider to 4% with a Depth Jitter of 15% and set Expression to Pressure. These settings will apply thick paint with a depth that varies with the pressure of your hand.

4. Apply your first layer of paint, slapping it on quickly and not worrying if you cover the whole canvas. These colors may look over saturated now, but in the later stages you will tone them down. Be aware of the direction of your brush strokes: Van Gogh's strokes always contained a very deliberate direction.

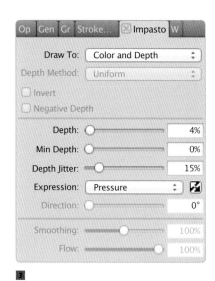

TIP
It's good to remember that any oil brush can be turned into an impasto brush.

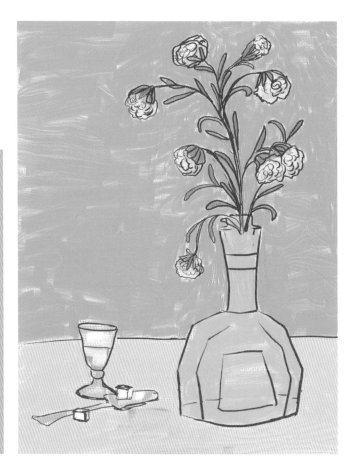

Van Gogh understood that colors changed their hue and saturation depending on the color adjacent to them: our eyes will combine the colors to create a third color. This is called *optical mixing*. In the example below the yellows are the same color, but the second yellow appears more saturated against it's opposite color of purple.

"I've heard of an experiment with a sheet of neutral colored paper that became greenish on a red background, reddish on a green one, bluish on orange, orangeish on blue, yellowish on violet, and violetish on yellow."

(Letter to Theo Van Gogh 20 October, 1885)

BLENDING VS. OPTICAL MIXING IN PAINTER

To truly paint like Van Gogh, you want to avoid a lot of heavy blending between colors. Normally, I always paint with Pick Up Underlying Color checked, but here you want to keep your colors as opaque as possible. This would be equivalent to painting with very little medium or turpentine. Here are the steps to take to prevent your colors from blending:

1. It is a good idea to add a new layer to build up color, instead of painting directly on the Canvas layer. When you paint on the Canvas layer the colors will naturally bleed into each other.

2. In the Layers palette, uncheck the option for Pick Up Underlying Color and set the Composite Method to Default. Set the Composite Depth to Add to make the paint build on top of each subsequent brush stroke. You will only be able to see changes in the Composite Depth if you are using a brush with Impasto settings.

3. If a brush has a Blend option in the Property bar, set the Blend to 0%: a low blend will prevent neighboring colors from mixing with each other.

TIP

There are two places where you can control the depth of your paint: the Impasto Panel (Window/Brush Control Panels/Impasto) and the Composite Depth settings in the Layers panel. I use both, but I prefer to control my brush's impasto depth in the Impasto Brush panel as it allows me to vary positive and negative brush strokes as I paint. The Composite Depth options create a universal change that applies to every brush stroke on that layer, which can make it appear more repetitive.

▲ I usually paint with high bleeds because I like to paint in thin washes. For this painting in the style of Van Gogh painting, I had to resist the urge to increase my bleed and paint with dry, thick paint.

STEP 6 BUILD UP COLOR

In further stages of his art, Van Gogh used colors to connect objects to each other in greater harmony. He called these colors the "broken color." He would "break" his colors by combining two complementary colors together to get a grayer tone. For example, if he was painting apples, he would add shades of grayish pink by mixing red and green. The pink would be the broken color, or the color that connects the red and green in the painting. In this next step, we're going to build up paint while using Van Gogh's color theory.

1. Add a new layer (Layers/New Layer) and uncheck Pick Up Underlying Color.

2. Switch to the Dr Clumpy Impasto Brush found in the Impasto brush category. Increase the depth slider to 250% and checked the box for Negative Depth. Model the flowers using tiny dabs of thick paint.

3. Switch to the Soft Grainy Impasto Brush found in the Impasto brush category. Use this brush to blend colors and soften the edges that you want to recede. Check the box for Negative Depth if you want the paint to seep into the canvas.

4. For the background, use the Soft Grainy Impasto brush set to Negative Depth. The Negative Depth will allow the background to recede in relation to the still life. To get more variance in how the paint color is applied, alter the Color Variability (Window/Brush Control Panel/Color Variability): increase the Hue, Saturation, and Value to over 10%. As you paint, vary the amounts.

5. Van Gogh was often so passionate about his paintings that he put down his brushes and applied paint directly from the tube, smearing it with his palette knife. For the bottle, I switched to the Loaded Palette Knife and set the Impasto Depth to 25%. I then used the palette knife to cut in paint and mark where the light plays off the bottle.

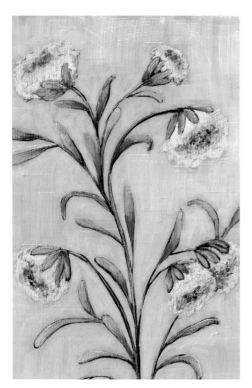

◄◄**TECHNIQUE**
Van Gogh was influenced by the Impressionist painting technique of using dabs of paint to convey light. As his art matured, he moved further away from impressionism, but never fully abandoned it. Today, his art is defined as Post-Impressionism because he continued to use dabs of thick paint, but also distorted forms in space and used more unnatural color. To make sure your dabs of thick paint do not look too mechanical, vary the option for Negative Depth in the Impasto panel and also the Depth as you paint.

◄**CREATING HARD ANGLES**
The Loaded Palette Knife brush has a sculpted feel due to the sharp, blocky way it applies paint. I used this brush to create hard angles in the bottle.

STEP 7 DEFINE EDGES

If Van Gogh wanted an area to have a sharper edge, he increased the contrast of where complimentary colors touched. In the final stages of this painting, I increased the saturation of my colors where I wanted the edge to be more defined and painted in a dull red to define the shadowed edge that I wanted to recede. Here's how it's done:

1. Add a new layer (Layers/New Layer) and uncheck Pick Up Underlying Color.

2. To define the edges, use the Loaded Palette Knife. In this example I used the brightest blues at the point where the yellow/orange of the flowers hit the background. Using a random, crisscross motion, I went over the entire background, building up the texture.

3. I also used the Loaded Palette Knife for the table, using larger blocks of color to show where the light played off its surface. Dabbing in areas of green and blue pulls the colors from the bottle into the background.

4. Next, I used the Graphic Paintbrush from the impasto brush category to outline the edges where the darkest shadows hit. In the Impasto panel (Window/Brush Control Panel/Impasto) I changed the Draw To method to Color and Depth, then checked the box for Negative Depth and set the Depth slider to 50%. I used this brush to outline the edges of the bottle.

5. I also used the Graphic Paintbrush to define the stems of the flowers in deep blues and browns. For the stems, I unchecked the option for Negative Depth because I wanted this area to be raised above the canvas.

TIPS

• The Loaded Palette Knife is the perfect tool for creating sharp energetic brush strokes. Use this tool sparingly: Van Gogh had many hard edges, but he also had areas painted in flatter, softer colors.

• Van Gogh was more interested in showing how light danced around an object than in painting actual shadows. Try to resist painting in shadows, but suggest them with blocks of color.

• Van Gogh knew the power of red and used it only in small amounts to draw the viewer's attention to the area. I used the deep red color sparingly—in the centers of the flowers and to define the edge of the bottle.

• The stems of the flowers are important to show the direction of the paint. The leaves, flowers, and to some degree the background should flow from the direction created by the stems.

VAN GOGH'S ADVICE A STRONG BACKGROUND

Van Gogh understood the importance of getting his background right. In a letter to his brother Theo, he wrote:

"I make a plain background of the richest, intensest blue that I can contrive, and by this simple combination of the bright head against the rich blue background, I get a mysterious effect, like a star in the depths of an azure sky."

STEP 8 SIGN LIKE A MASTER

It may seem slightly obnoxious to sign a painting like Van Gogh, but since I have got this far I may as well finish in true homage to the master! Van Gogh never signed his work with his last name because he felt people could not pronounce it, but his signature was a mark of his confidence—it was always placed in a prominent position on the canvas. On works he felt were less successful, (for example, *Starry Night*) he chose to leave it off completely. In this final step, I am signing my still life using my first name to honor Vincent Van Gogh. You can do this as well, in one simple step.

1. Using the Graphic Paintbrush, set the Depth to 25% and choose a color that compliments the colors used in the painting. Put your signature in a prominent location on your picture.

VAN GOGH'S ADVICE
CARRY ON

Van Gogh went through periods where he felt that he would never realize public success. Still, he never wavered in his conviction that his art was progressing. In a letter to Theo, he wrote:

"As practice makes perfect, I cannot but make progress; each drawing one makes, each study one paints, is a step forward."

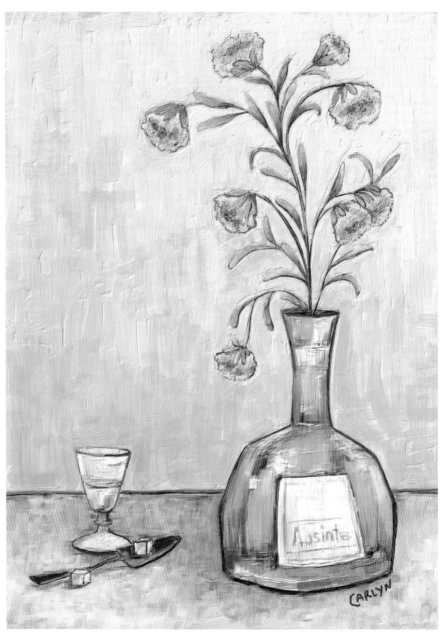

▲ **FINAL STEP**
The final task is to step back and see if your colors are balanced with each other (squinting your eyes can help). In this painting I echoed the yellow of the flowers in the table and I also repeated the blues and greens used in the background and bottle.

FEATURED ARTIST JOHN MALCOLM: DIVIDED COLORS

"I was introduced to Van Gogh's work at a young age, but I didn't appreciate it until I was much older. Today, I admire his strong, confident brush strokes and the way he used optical mixing to make his colors appear more vibrant. I use Corel Painter to emulate a great number of traditional media and enjoy experimenting with different brushes that work well for Van Gogh's style. For *Reminders of the Past* I used Painter's Thick Wet Oils brush from the Oils brush category to create swirling dabs that pick up the underlying colors as I paint. I then selected the Artists Canvas paper from the Paper Library (Window/Paper Panels/Paper Libraries) and applied it as a surface texture (Effects/Surface Control/Apply Surface Texture). Finally, I contoured my foreground objects using darker lines with a smaller brush size."

▲ **Girl with a Green Top**
© *Imagine Publishing Ltd.*

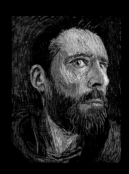

John Malcolm
johnmalcolm1970@gmail.com
www.johnmalcolm1970.co.uk
www.youtube.com/user/JohnMalcolm1970

John works full-time for a newspaper group designing adverts, but his passion is digital art. He's happiest when drawing and painting in Corel Painter, or using good old-fashioned pencil and paper, sketching in his local pub. He has contributed tutorials to *Digital Artist* magazine and also shares his art process on his YouTube page. In 2012, he joined Corel's Painter Advisory Council to help shape the program's future.

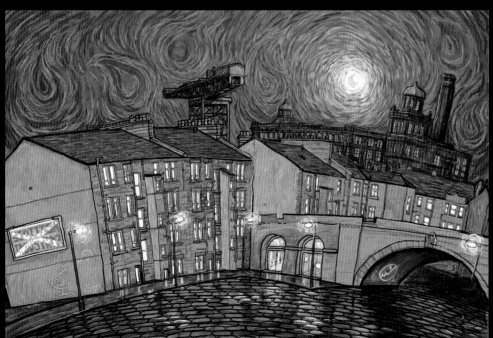

▲ **Reminders of the Past** © *Imagine Publishing Ltd.*

04
AUGUSTE RENOIR 1841–1919
AN IMPRESSION OF BEAUTY

LEVEL 1 2 3

What you will learn in this section
- Capturing color harmony and light
- Painting soft edges
- Blending colors directly on the canvas

Application
PAINTER

There was a lot of nail biting in Paris on April 15th, 1874, as five hopeful artists paced the floors of the modern-looking studio at 35 Boulevard des Capucine: Claude Monet, Edgar Degas, Pierre-Auguste Renoir, Camille Pissarro, and Berthe Morisot were to exhibit a collection of their art to the general public for the first time. Months earlier, they had broken away from the Académie des Beaux-Arts (School of Fine Arts) and formed their own group—*The Anonymous Society of Painters, Sculptors, Engravers, etc.*

At the time, they were just a bunch of rag-tag painters trying to shake up the art world with their new style of painting light *en plein air* (in the open air). Their show would allow them to exhibit the paintings that had been rejected previously by the government-sponsored annual exhibition known as "the Salon." Up until this point, the Salon controlled everything in the art world, prompting Renoir to complain that, "There are hardly fifteen connoisseurs in Paris capable of liking a painting without the Salon."

Unfortunately, the show was an absolute flop. The premier art critic of the day, Louis Leroy, took particular offence to Monet's painting *Impression, soleil levant*. In a review entitled *The Exhibition of the Impressionists*, Leroy wrote, "impression—I was certain of it. I was just telling myself that, since I was impressed, there had to be some impression in it… Wallpaper in its embryonic state is more finished than that seascape." Little did Leroy know that he would not only be remembered for being wrong about the works, but also for giving the Anonymous Society of Painters its new name: *The Impressionists*.

Renoir had his share of setbacks before that devastating first show. The son of a tailor and a dressmaker, his life as an artist was never an easy road. He got an early start in painting, working as a porcelain painter at the age of thirteen, but his first real success with the Salon was a painting entitled *Esmeralda Dancing with her Goat around a Fire Illuminating the Entire Crowd of Vagabonds* (a work that Renoir later destroyed).

Although he continued to have his supporters, critics more familiar with classical methods of painting derided his work as "a mass of

"Why shouldn't art be pretty? There are enough unpleasant things in the world."

RENOIR

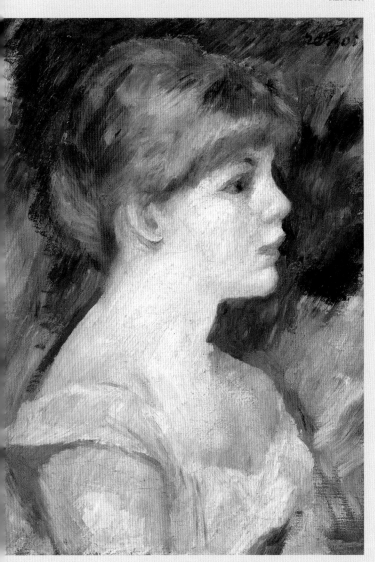

▲ **Suzanne Valadon**
Auguste Renoir, c. 1885

decomposing flesh with green and purple spots that indicate the state of total putrefaction in a corpse!" As the critics got more and more cantankerous, Renoir's debts mounted.

The turning point occurred in 1886 when the Impressionists had their most successful show ever in America. The art dealer, Paul Durand-Ruel, pointed out the difference between European and American markets when he said, "the American public does not laugh, it buys." The success of the Impressionists soared after that fateful show. Renoir's work stood out amongst the other Impressionists because he was more concerned in developing the solidity of form, preferring people to haystacks. Renoir also had a stronger appreciation for Renaissance artists, such as Raphael, and his style is more reminiscent of the Rococo era.

In his earlier works Renoir used a palette knife, but later switched to soft, fan-shaped brushes. These softer brushes allowed him to apply dabs of paint that delicately merged one color into another. His paint strokes dance around his forms, varying between broad and short to long and feathery. The flickering light makes his figures feel as if they are not just in nature, but part of nature.

As his work matured, so did his use of color. Influenced by Monet, Renoir used simultaneous contrast—applying small dabs of complementary colors next to each other. Renoir especially excelled at creating the porcelain skins of French women. His figures feel tactile and rounded through his use of light, and his subject's eyes always have a degree of soulfulness. Like the other Impressionists, he blurred details, but not so much that the viewer feels disconnected with his subjects.

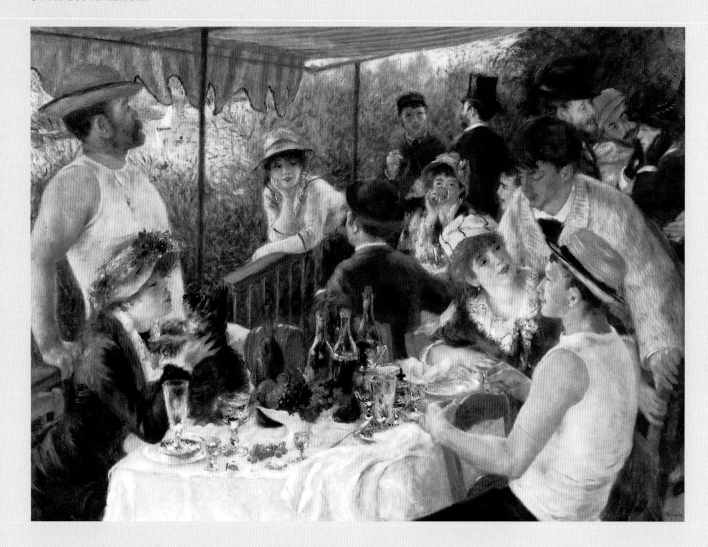

Renoir wasn't interested in just capturing the way light played off the water—he wanted to show the gaiety and pleasure-seeking side of Parisian society. His scenes often have a high vantage point, making the viewer feel like they could swoop in and join the party. He painted fashionable women, frolicking children, and even resorted to an occasional fluffy puppy. While others may have found his art saccharine, Renoir said, "Why shouldn't art be pretty? There are enough unpleasant things in the world."

Ironically, life could be more than just a little unpleasant. France declared war on Germany on July 19, 1870. During the time *Dance at Le Moulin de la Galette* was painted, starvation, disease, and a lack of coal were part of daily lives. Amongst the hardships, Renoir and the

▲ **Luncheon of the Boating Party**
Auguste Renoir, 1881
Renoir liked to use the same models in his painting: the artist's future wife, Aline Charigot, is at the left, playing with a small dog.

▼ **Dance at Le Moulin de la Galette**
Auguste Renoir, 1876
In 1980, *Dance at Le Moulin de la Galette* sold for $78 million. It is considered one of the most beautiful paintings ever created. Renoir got to know all the women in his paintings very intimately (some were his lovers), and it is perhaps for this reason that he was able to capture their intrinsic beauty. One of his models, Jeanne Samary, once said "Renoir… marries all the women he paints… but with his brush."

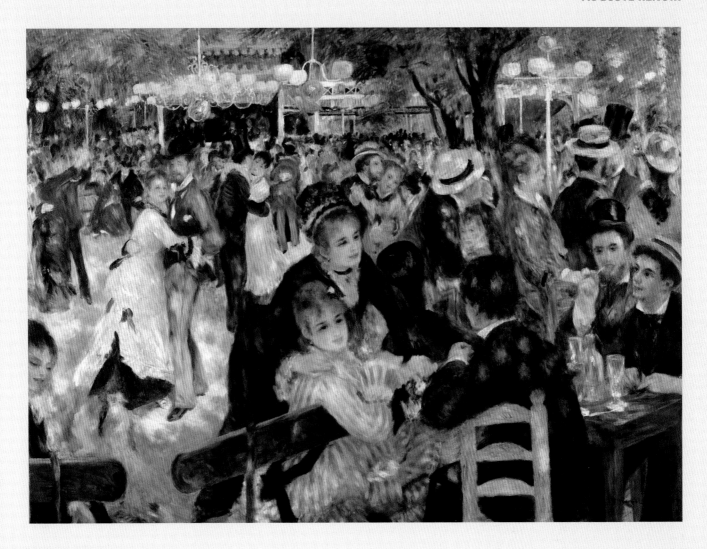

rest of Paris still turned out ever Sunday to dance at Le Moulin de la Galette, situated high on the hills of Montemarte.

Renoir knew many of the subjects in this painting. The two girls in the foreground were sisters: the standing one was a seamstress named Jean (who was reluctant to pose for Renoir, but needed the money), and the girl sitting in the foreground with the striped dress is the other sister, Estelle. The girl in the pink, dancing in the background was Marguerite Legrand (Renoir was extremely fond of "Margot" and even paid for her funeral after she died of typhoid fever). Renoir did several oil studies to complete the painting, and was even rumored to drag his gigantic canvases to the dance hall to capture the whirling dancers.

For *The Strawberry Picker* (see next page), I painted a bright outdoor study using Renoir's color techniques. Since I couldn't drag my computer out in the sun, I tried to only work on this painting on sunny days. Renoir was a master of painting light, but even he might have struggled translating light to the digital medium—the way we see color on screen is very different from what we see outside. I recommend doing several traditional color studies outside before attempting one digitally.

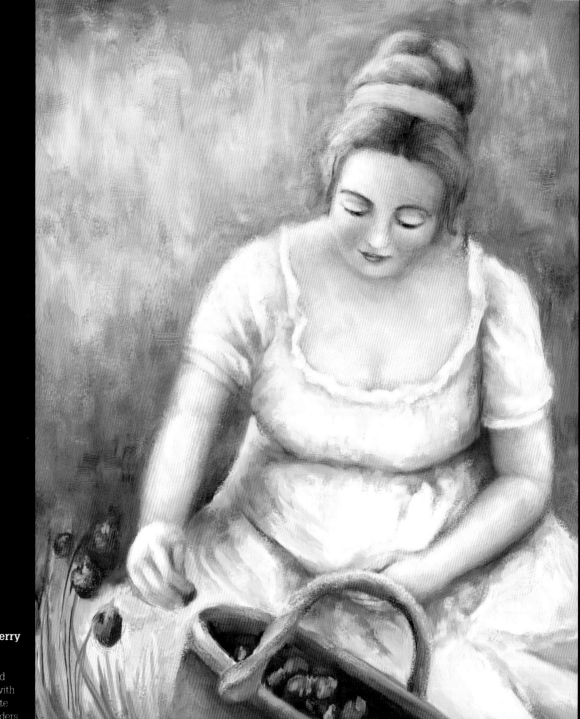

▶ The Strawberry Picker
My Renoir-esque study was created in Corel Painter with Oils, Pastels, Conte Crayon, and Blenders

STEP 1 BASIC SKETCH

I find doing tons of preparatory sketches very painful. Renoir did not spend a lot of time doing complicated underdrawings either, which may have been how he retained such freshness in his finished paintings. To sketch, Renoir would often use a fine soft sable brush and raw Sienna thinned with turpentine. Before I began my painting I sketched out my drawing using similar thin washes of paint. Here's how:

1. In Painter, create a New Document (File/New) and set the canvas size.

2. From the Color Panel (Window/Color/ Panels/Color) choose a yellowish brown color. Fill the Canvas layer with your color by clicking on the document with the Paint Bucket tool.

3. From the Paper Library (Window/Paper Panels/ Paper Library), select the Worn Pavement paper. This paper is part of the Painter 12 Default Paper Library. In the Paper Panel (Window/Paper Panels/ Paper), set the Scale to 80%, Contrast to 150%, and the Brightness to 50%.

4. Add some surface texture to the Canvas by selecting Effects/Surface Control/ Apply Surface Texture. Set the Amount to 70% and set the Light Direction to the upper left. These settings create a paper with a slightly uneven texture to it.

5. From the Property Bar, select the Charcoal Pencil brush found in the Charcoal & Conte brush category. In the Property Bar set the Size to 1, Opacity to 8%, Grain to 20%, Resaturation to 30%, Bleed to 30%, and Jitter to 0.24. These settings create a textured brush with a bit of randomness to its stroke.

6. Sketch your figure using rapid marks. Renoir tended to draw his female figures with small heads. In homage, I have done the same here.

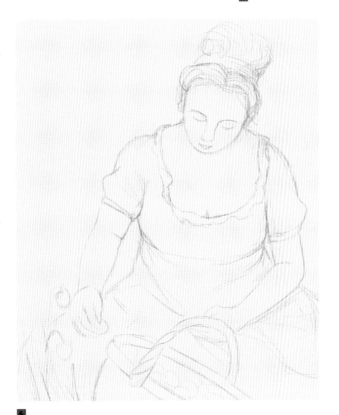

STEP 2 THE EBAUCHE LAYER

The *ebauche layer* was the term used by the Impressionists to describe a preliminary sketch. Renoir usually painted his in brown tones, so in this next step we will work up light and dark values in sepia tones. This study will map out the values of my form.

1. From the Color Panel (Window/Color Panels/Color), select a dark sepia color.

2. Choose the Square Conte Crayon from the Charcoal & Conte brush category. From the Property Bar, set the Size to 15, Opacity to 25%, Grain to 10%, Resaturation to 50%, Bleed to 50%, and the Jitter to 0.14. These settings create a grainy brush that slowly builds up color with each stroke. Use this brush to paint in your dark to light values.

3. Next, select the Real Hard Conte brush from the Charcoal Conte brush category. Set its Opacity to 30%, Grain to 40%, Resaturation to 10%, Bleed to 10%, and Jitter to 0. From the Paper Library (Window/Paper Panels/Paper Library) switch to the Fine Hard Grain Paper and use this brush to block in the most dramatic highlights.

4. Choose the Square Hard Pastel Brush from the Pastel brush category. From the Property Bar set the Size to 25, Opacity to 10%, Grain to 10%, Resaturation to 75%, Bleed to 100%, and Jitter to 0.

5. From the Paper Library (Window/Paper Panels/ Paper Library), change the paper's Scale to 35%. With a high Bleed and a smaller sized grain in the paper texture, this brush will act as a blender brush to further soften transitions from dark to light.

6. Sketch in your pastel study, switching back and forth between the Square Conte Crayon and Square Hard Pastel. Renoir's paintings always had a delicate softness to them, so I blend the edges into the background using the Square Pastel Brush.

TIP EVERYDAY BEAUTY

Renoir was one of the first artists to capture Parisians in their informal surroundings. At the time, the only work being accepted in the Salon was figures shown in classical poses or art that depicted historical themes. Therefore, when choosing a subject try to capture someone performing an everyday action.

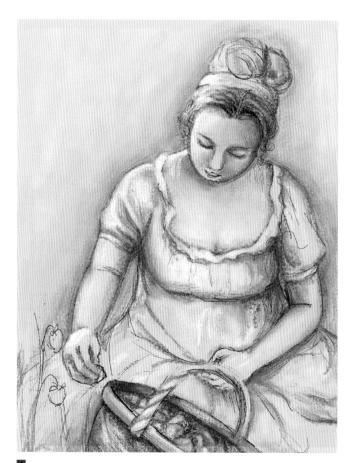

STEP 3 PREPARING CANVAS

Renoir prepared his grounds using lead white mixed with one third linseed oil and two thirds turpentine. Using a palette knife, he would then brush a thin layer of the white ground over his canvas. This preparation could take several days to dry. Fortunately, you do not have to watch paint dry. In this step, I will show you how to paint over a pastel study with thin washes of white paint.

1. Create a new layer (Layers/New Layer) and name it "White Wash."

2. Select the Loaded Palette Knife from the Impasto brush category. Set its Size to 78, Opacity to 100%, Resaturation to 80%, Bleed to 100%, and Feature to 1.

TIP THE BLACK AND WHITE OF PAINTING

▲ **The Theater Box,**
Auguste Renoir, 1874
Black will always make colors appear more saturated.

Renoir achieved stronger contrasts of light by starting his paintings with a ground of white lead. A smooth, opaque white ground allows light to better reflect off its surface, so colors will be brighter and more translucent.

Renoir was also not afraid to use black. He once said, "the queen of all colors is black." While he preferred not to use black in shadows, he did use it as a compositional element. He believed that without black there was no light because it created a higher degree of contrast: in *The Theater Box* the skin appears brighter against the black used in the clothing, for example. Renoir exhibited *The Theater Box* in the first Impressionism show, where it was his only painting to sell, earning him a dismal 425 Francs (barely enough to pay his rent).

3. In the Impasto menu (Window/Brush Control Panels/Impasto), lower the Depth to 8% and set Expression to Pressure.

4. Select pure white from the Color Panel (Window/Color Panels/Color).

5. Choose the White Wash layer and, using a light touch, wash in a layer of white using vertical brush strokes. Make sure to brush over the white in one direction—Renoir's brush strokes tended to go in one direction, almost caressing the form.

6. Lower the Opacity of the White Wash Layer so you can still make out a ghost of your pastel study.

7. Drop this layer down (Layers/Drop).

STEP 4 CREATING A RENOIR COLOR PALETTE

Renoir was a very neat painter. He never mixed colors on his palette, but instead preferred to mix them on the canvas. To keep his colors clean and at the highest saturation, he kept a jar of turpentine next to him and constantly dipped his brushes into the turpentine to clean them. When choosing colors, Renoir's favorites were lead white, chrome yellow, vermilion, red lake, emerald green, viridian green, and ultramarine blue. In later works, he also used earth green and yellow ochre. In this next step, we will create a custom color set that we will later use to select our colors.

1. Open Painter's Color panel (Window/ Color Panels/Color) and select a color similar to red lake.

2. Open the Color Set panel (Window/ Color Panels/Color Sets.). Click on the small right arrow and choose Create New Color Set from the drop-down menu (I named my set "Renoir"). Your red color appears in the new color set.

3. Select a chrome yellow color from the Color panel and click on the "Add Color to Color Set" button.

4. Repeat this process until you have all the colors you want in your set. In addition to my Renoir color set, I also use a set called "flesh tones" which helps me create more realistic skin.

5. You can select any of these colors quickly. If you accidentally add a color that you do not need, select the "Delete Color from Color Set" button.

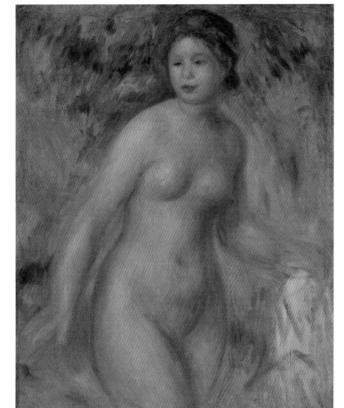

◀ **Nude**
Auguste Renoir, c. 1895
Renoir used a rainbow palette of colors, often mixing them directly on the canvas. He kept his colors in harmony by carefully balancing complementary colors with one another. In this painting you can see how Renoir used greens and reds to great effect.

TIP ORGANIZE COLOR

It's a good idea to export your Color Set so you can have it in a safe place. I keep all my color sets saved in one place on my hard drive. To export a color set:

1. I selected the "Export Color Set" button and saved it in my Renoir folder.

2. Alternately, you can import the Renoir color set from the companion web site by selecting the Import Color Set button.

STEP 5 ADDING COLOR

Renoir favored soft, sable-haired brushes from Russia called *de Melloncille*. In this next step, we'll begin to lay in color using a similar soft brush. I started with the background, as it will determine the colors of the girl's flesh and clothing.

1. From the Oils brush category, select the Real Fan Short brush. In the Property bar, set the Opacity to 100%, Feature to 3.5, and Bleed to 0.

2. Apply greens, yellows, and dabs of orange into the background using long brush strokes.

3. As you paint, slowly increase the Bleed and lower the Opacity to allow the colors to blend into each other.

4. Next, select the Square Hard Pastel Brush found in the Pastel brush category. Set the Opacity to 10%, Grain to 10%, Resaturation to 75%, and Bleed to 100%.This brush acts like a dry brush —loaded with paint it will introduce some texture that will optically blend colors together.

STEP 6 BLOCK IN FORM

When Renoir painted figures, his brush strokes always followed the form of his subject. Here, I used a combination of hard- and soft-edged brushes to model my form.

1. From the Oils brush category, select the Real Flat brush. In the Property bar, set the Opacity to 100%, Feature to 3.5, and Bleed to 0.

2. Block in the colors of the flesh using white, light pink, and yellow, and greens to define the shadows. To blend colors, increase the Bleed of your brush and lower the Opacity.

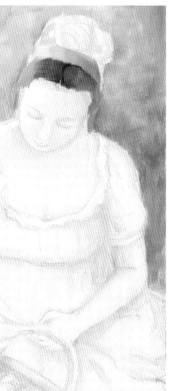

◄ As I work up the background, I slowly add more and more yellow. I always paint in hair first because it is the background to the skin color. As I paint, I sample colors from the hair into the skin and vice versa.

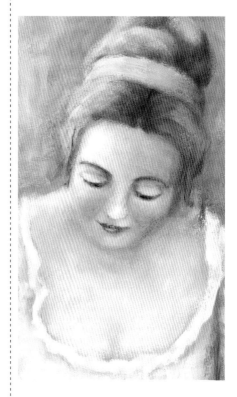

▲ Remember to echo the colors used in the background in the flesh so they appear related to each other.

3. To add thicker paint, open the Impasto panel (Window/Brush Control Panel/Impasto) and set the Draw To method to Color and Depth. Reduce Depth to 5%, set Expression to Direction, and check Invert Depth Expression.

4. These settings make the paint thicker if you move your brush up and down across the form, and blend it more when you move your brush horizontally.

"I am just learning how to paint."

RENOIR AT AGE 72

STEP 7 BLENDING THE FORM

Renoir used pure linseed oil to make his colors go on smoother. To blend colors, Renoir preferred the *blaireau* brush (a fan-shaped brush made with long, springy badger hair). This brush blended colors while obscuring the mark of the brush itself. In this next step, we'll use a similar brush to soften the edges and blend colors.

1. Select the Real Oils Smeary Brush found in the Oils brush category. In the Property bar set the Opacity to 25%, Feature to 1.2, and Bleed to 7%. Open the Color Variability panel (Window/Brush Control Panels/Color Variability) and increase the Saturation and Value to 10%. These settings will alter the value and saturation of your colors as you paint. Use this brush along the edges of the form, blurring more where the figure should recede into the background.

2. Next, blend colors with the Course Smear brush found in the Blenders brush category. Set the brush's Jitter to over 0.3, Grain to 20, and Opacity to 100%

3. Select the Water Rake (also found in the Blenders brush category). This brush will apply color as it blends depending on the Resaturation. In the Property Bar set the Opacity to 35%, Resaturation to 11, Bleed to 15, and Jitter to 4.

4. Finally, pick out edges to blur even further using the F-X Confusion brush found in the F-X brush category. In the Property Bar set the Opacity to 100%, Grain to 100%, and Jitter to 1.43. By blending the brightest colors into the background you will be able to diffuse the light in the same way that sunlight scatters when it hits an object. This is called subsurface scattering.

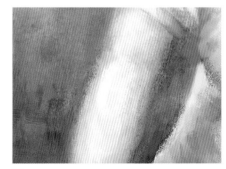

STEP 8 APPLY THICKER PAINT

Renoir used the greatest variety of yellows, sometimes using chrome yellow, Naples yellow, and yellow ocher in the same painting. He also built his yellow up thickly, using dabs of yellow to show how the sun played off his figures. In this final step we will add a final layer of yellow and white impasto to create more depth in the paint.

1. Choose the Real Oils Smeary brush from the Oils brush category. Open up the Impasto menu (Window/Brush Control Panel/Impasto) and set the Draw To method to Color and Depth. Set the Depth slider to 10% and Expression to Direction.

2. Sample colors from the background with the Color Wand and use these colors to make shorter dabs in the garment. After you lay down the dabs, smear them with the F-X Confusion brush to blend them into the underlying paint.

3. Next, we'll add another layer of thicker paint. Create a new layer (Layer/New Layer and name this "thick paint."

4. From the Color Panel (Window/Color/ Color Panel), choose a yellow hue.

5. From the Paper Library (Window/Paper Panels/Paper Libraries), select the Worn Pavement paper (you can download this from the companion site.) Under the Papers Panel (Window/Paper Panels/ Papers) set the Scale to 80%, Contrast to 150%, and Brightness to 50%.

6. Select the Square Hard Pastel brush. In the Property Bar set the Grain to 7%, the Bleed to 100%, and the Resaturation to 75%.

7. As you paint, change the Grain. Remember, the higher the Grain, the less grain that will show through. Use this brush to add mottled texture and blend underlying colors, especially at the edges. I used mostly yellow to blend light into the colors of my picture.

8. Finally, select the Depth Eraser found in the Impasto brush category. Set the Opacity to 1%, Resaturation to 15%, Bleed to 50%, and Jitter to 0. This brush will strip out the impasto effects, allowing you to pull back any impasto that interferes with the lighting.

◀▲ With Impasto added to the Real Oils Smeary brush and a low bleed, you can slowly build up thicker layers of paint.

TIP SUPER BLENDERS

Any brush that has Resaturation and Bleed settings in the Property bar can be changed into a blender brush. To make a blender brush:

1. Set Resaturation to 0. This setting means your brush is not loaded with any paint. If you want a brush that has some paint, increase the Resaturation to 15%

2. Set the Bleed to 100%. Reduce this if you don't want neighboring colors to blend together.

3. Create a new layer (Layer/New Layer). In the Layers panel, make sure the box is checked for Pick up underlying Color. This option will take the color in the layers beneath it and blend it with whatever you apply on the new layer.

ORGANIZING YOUR BRUSHES

Unlike Photoshop, Painter will keep the settings of your brush from the last time you used it. If you really like a brush's setting, you can also save the brush as a Brush Variant. To save a Brush Variant:

1. Select the brush that you would like to save from the Brush Selector.

2. Select Brushes/Save Variant.

3. Name your brush and select which Brush Category to place it in.

4. Select Save.

CUSTOM PALETTES

You can organize your brushes into custom palettes. For example, I created a palette containing the brushes used for each artist from this book. To create custom palettes:

1. Select the Brush's icon in the Brush Selector, hold down the Shift key, and drag the brush out of the Brush Selector. This will create a custom Brush Palette with the name Custom, followed by a number.

2. Repeat the process for any other brushes and pull them into the new custom palette.

3. You can now name this custom palette by selecting Window/Custom Palette/Organizer. Click on the name of the palette that you would like to rename and hit the button for Rename.

SHARING FAVORITE BRUSHES

You can share your favorite brushes with other users. To export a custom palette:

1. Select Window/Custom Palette/Organizer. Click on the name of the Palette that you would like to share.

2. Press the Export button.

3. Name your custom brush palette and select a location to save it to.

4. Press Done.

IMPORTING BRUSHES

To import another user's brushes:

1. Select Window/Custom Palette/Organizer.

2. Press the Import button.

3. Navigate to the location of the custom brush palette.

4. Select Open.

TIP KEEP BRUSH VARIANTS TO A LIMIT

Having too many brush variants can slow down Painter's performance. I try not to add more than two or three new variants per category.

STEALING RENOIR: **ORDERED CHAOS**

At first glance it may seem that Renoir has thrown his figures into the scene without any structure. Although there is some chaos, there are also many elements that organize his compositions, as we can see here.

Renoir uses blues in the background to create a sense of distance.

Renoir creates a dynamic triangle to unify the foreground figures.

The orange canopy frames the composition and balances the peachy skin tones.

Renoir always crops some figures out of the frame. This may be a common cinematic technique to draw the viewer into the scene but it was revolutionary in Renoir's day.

The artist uses darker colors at the edge of the canvas to keep the eye on the center—the lively table.

The vertical lines of the canopy create a rhythm into the distance and a grid-like structure.

The gaze of the girl in the background diverts our attention back to the foreground figures.

The two arcs of the left and right figures contain the rest of the action seen in the painting.

05
JOHN SINGER
SARGENT 1856–1925
SCANDALOUS PAINTER

LEVEL 1 2 **3**

What you will learn in this section
- Light and atmospheric perspective
- Transforming selections to fix composition problems
- Painting edges
- Painting skin, fur, and fire

Application
PAINTER

▶ **Madame X**
John Singer Sargent, 1884
Sargent's heavily powdered, defiant beauty in cameo-like profile was originally painted with one strap falling from her deeply cut black dress. The artist had no regrets regarding the painting itself, but later repainted the fallen strap. He kept the portrait in his personal collection until 1917 when he sold it to the Metropolitan Museum of Art. He requested that the sitter remain anonymous and that the painting only be known as "Madame X." Mme. Gautreau died that same year.

On a warm May day in 1884, Mme. Avegno, "bathed in tears," burst unannounced into John Singer Sargent's cluttered studio apartment overlooking the River Seine. Catching the 28 year old artist off guard, she let loose a tirade: "All Paris if making fun of my daughter. She is ruined." She then demanded Sargent remove his portrait of her daughter from the Paris Salon.

Always uncomfortable around women, the young artist suddenly found the courage to defend his painting. "Nothing said about Madame Gautreau at the Salon was any worse than what the fashionable world had said of her already." Sargent did have a point. A longtime target of scandal sheets and rumored affairs, Virginie Amelie Avegno Gautreau was no wallflower. As a celebrated socialite, Sargent pursued her for over a year trying to get his "unpaintable

beauty" to sit for him. The resulting uncommissioned portrait, entitled *Madame X*, was finished in 1884 and entered into the most prestigious art show, the Paris Salon.

Unfortunately, Mme. Avegno was not the only Parisian disappointed by Sargent's portrait. Critics called it "beastly" and "a sort of caricature," while one went as far as to claim it was "offensive in its insolent ugliness and defiance of every rule of art."

Heartbroken, Sargent moved to London to paint society portraits and never dared to break rules again. After the firestorm had passed, he admitted that the painting was, "the best thing I have done." Most art critics today agree, and the woman that caused such a scandal has become a recognizable icon.

This tutorial will cover Sargent's bold application of paint and explore how this can be created digitally. His brush strokes are so unique there is even a brush named after him in Painter.

"Every time I paint a portrait I lose a friend."

JOHN SINGER SARGENT

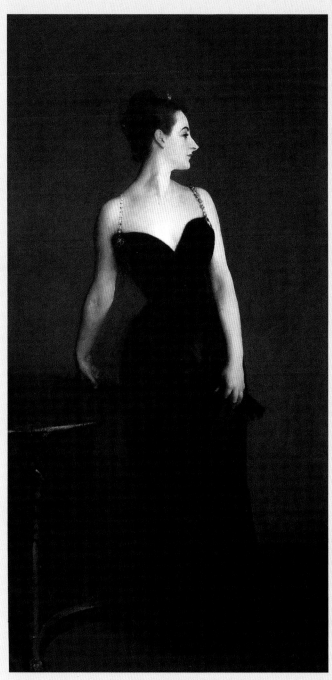

▲▲ **Lady Agnew of Lochnaw**
John Singer Sargent, 1892–3
Here you can see the limited palette Sargent preferred to work with.

▲ **Palette**
Sargent's real color palette. Notice the contrast of warm and cool shades.

Sargent's portraits started with a limited palette and took shape with dramatic planes of color, much like a sculptor forming a mass of clay. Especially in clothing, he used long, quick brush strokes that gave a spontaneous feel and a sense of movement. Up close, his brush strokes look like a tangle mass of abstract art, but when the viewer stands back, the wild brush strokes reveal his intentions.

As an ode to Sargent, I have chosen a subject he loved—Greek mythology. My painting is of the equally scandalous Arachne who bragged of her weaving talents to the gods. My painting depicts her final tapestry before Athena turns her into a spider to punish her for her hubris.

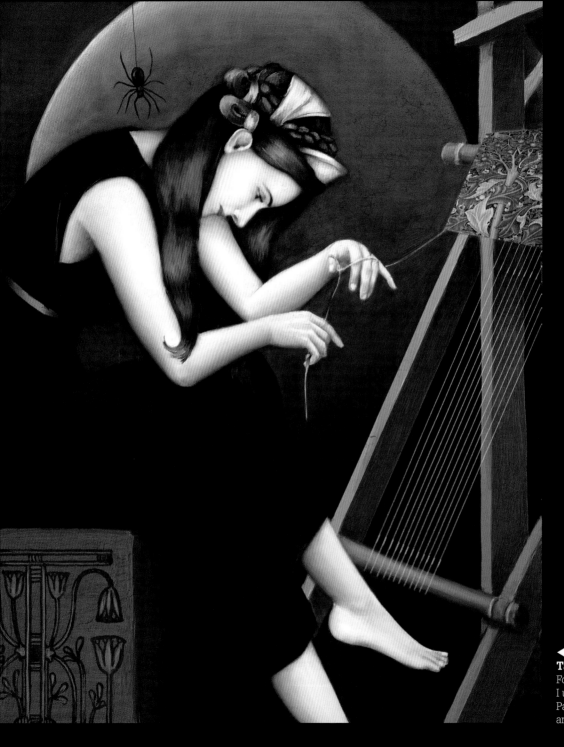

◀ **Arachne's Final Tapestry**
For this painting, I used Corel Painter's Sargent and Oil brushes.

STEP 1 100 SKETCHES

Before beginning a painting, Sargent was said to do "a hundred studies." He advised his students that "you can't do sketches enough. Sketch everything." I don't have Sargent's patience to do 100 sketches, so I did a few quick ones and decided which one captured my story's essence. I then scanned my sketch into Painter.

1. Scan your sketch and clean it up in either Photoshop or Painter.
2. Reduce the sketch to simple black and white shapes. This step forces you to see what areas should recede and what areas will come forward.

STEP 2 MIXING A SARGENT PALETTE

Sargent began every painting with a limited palette of lead white, rose madder, Mars brown, Mars yellow, cadmium yellow, viridian, emerald green, and bone black. In the initial stages his goal was to block in values in the same way that a sculptor defines the initial planes of his figure. To create a similar palette:

1. Open Painter's Mixer panel (Window/ Color Panels/Mixer) and select the Apply Color tool.
2. Create a string of tones using warm grays, reds, and browns.
3. To mix colors, use the Mixer Brush.
4. To pick up color, use the Sample Color tool.

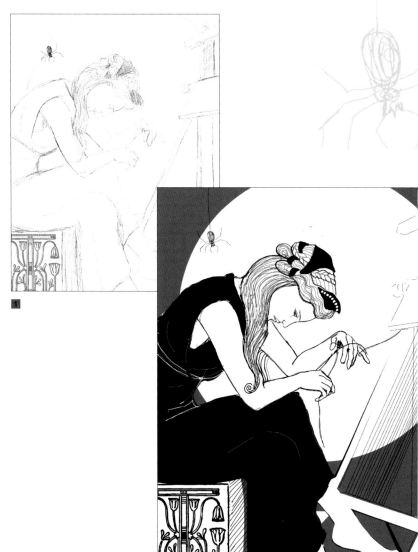

▲ Before adding color, I mix a color string of dark to light values. This scale of dark to light will help me get the values in my painting correct.

STEP 3 PRIME YOUR CANVAS

Sargent sometimes primed his canvases in white, but he usually used a gray tone composed of ivory black, lead white, and linseed oil. This gray primer served as his midtones and gave a cool appearance to his subject's skin tones. To create a similar base for your painting:

1. Put the sketch layer on a separate layer by selecting Command/CTRL + A and then clicking anywhere on the canvas with the Layer Adjuster tool. Set this layer's blend mode to Multiply.

2. Select a light gray/green color from the color wheel similar to Chromium Green oxide mixed with white.

3. Select the Paint Bucket tool and fill the Canvas layer with the gray color by clicking anywhere on the canvas.

STEP 4 PAINT YOUR MIDTONES

Sargent believed that artists should get their midtones correct and then build up the shadows and highlights. He always began his midtones in a grayish color study with very little turpentine. He applied his paint thickly and passionately, dabbing his brush with enough vigor to leave hog-hair bristles trapped in the paint. To paint with similar thick paint:

1. Select the appropriately named Sargent Brush from the Artists brush category. The Sargent Brush is a blocky shaped brush that blends as it paints. This brush is perfect for fast, thin brush strokes, but it needs a little tweaking to get the paint on thicker.

2. Open the Impasto panel (Window/Brush Control Panel/Impasto). For the Draw To method select Color and Depth." Increase the Depth slider to 200%, set Min Depth to 25%, and Depth Jitter to 25%. Change Expression to Pressure.

3. Block in the color, focusing on the tonal values and letting the initial form take shape. Keep your palette limited to grays and greens.

4. For the background and fabric, increase the Jitter (Window/Brush Control Panels, Jitter) to 0.15. Jitter will make the brush stagger in places, giving more energy to your brush strokes.

IMPORTANT!

The Sargent Brush uses the underlying paint and mixes it with your chosen color. Because of the nature of this brush you must paint on either the Canvas layer or a layer containing paint. If there is nothing on the layer (a transparent layer) then you will not see color being applied.

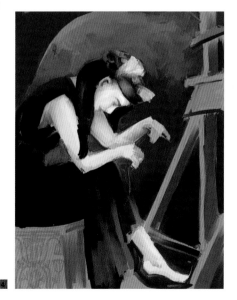

STEP 5 SHADOWS AND HIGHLIGHTS

Once the midtones are established you can start to tighten up where the figure emerges from the background and where the sharpest highlights come forward. To add further modeling to the figure:

1. Select the Real Flat Oils Brush found under the Oils category. Increase the Bleed to 50%: this will allow the paint to blend with the underlying paint, letting you paint "wet-on-wet."

2. Start to add brown tones into the hair. The reason why I do the hair before working color into the face is because the hair will change the appearance of the skin tones of the face.

3. Sargent had an amazing ability to paint smooth, almost translucent skin. To apply paint in glazes, go back to the Sargent Brush, but customize it to apply paint in smoother glazes. Change Method to Cover and the Subcategory to Soft Cover.

4. In the Property Bar set Resaturation and Bleed to 100%, and keep the Opacity below 15%.

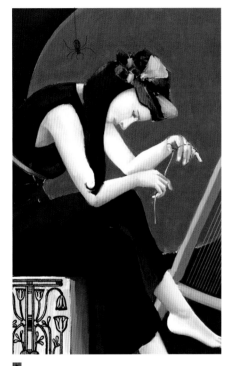

1

"The thicker you paint, the more color flows."

JOHN SINGER SARGENT

▶ As I paint, I often vary the Resaturation and Bleed. I rarely touch the opacity.

A

13% ▼ Resaturation: 100% ▼ Bleed: 100% ▼

2

3

General	
Dab Type:	Captured
Stroke Type:	Single
Method:	Cover
Subcategory:	Soft Cover
Source:	Color

TIP SARGENT BRUSH

Sargent painted very quickly, using thick brushes loaded with paint. The Sargent Brush applies paint in a similar style, applying color with a little bit of trail at the end to give it the look of paint applied quickly (1). You can change the shape of this trail by adjusting the Dab Profile (Window/Brush Control Panels/Dab Profile). To add more variance in this trail and the appearance of scraped paint, increase the Stroke Jitter (2). I prefer to keep the grain at 100% to keep the paint thick. To paint in glazes (3), create a thinner version of the Sargent Brush.

1 2 3

STEP 6 PAINTING IN COLOR

With the midtones in place, it's time to build color into your value study.

1. Add a new layer and set its Composite Depth to Add. Check the option for Pick up Underlying Color. This will allow the color you apply to blend into the underlying value study.

2. Select the Real Flat Oils Brush and set its Bleed in the property bar to 100% so the paint will be thinner and blend more.

3. Select shades of rose, bluish purple, and yellow ocher and paint a thin glaze of color into the skin. Remember to keep the thinnest areas of the skin (the eyes and around the mouth) the bluest.

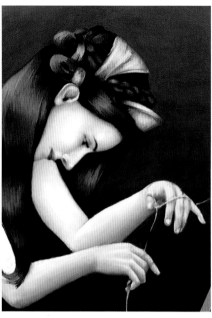

STEP 7 ADDING WEIGHT TO THE PAINT

In the later stages of his painting, Sargent built up thick paint with very little medium. To create this heavy impasto effect:

1. Select the Real Flat Oils Brush from the Oils brush category. In the Impasto settings (Window/Brush Control Panel/ Impasto) change the Draw To method to Color and Depth.

2. The impasto effects can sometimes remove too much canvas texture. To bring some back, select the Fine Feathering Oils Brush from the Pastel brush category and set the Grain to less than 10%. Selected different crackle relief papers from the Paper Library (Window/Paper Panels/Paper) and paint on a separate layer to add texture back.

TIP TEXTURED BRUSHES

Any brush with a Grain setting in the Property bar can be used to pick up the grain of your chosen paper.

STEP 8 ADDING BACKGROUND DETAILS

Next, you need some background details to bring the painting to life.

1. For my painting, I referred to a William Morris tapestry design and used it as a reference for Arachne's unfinished tapestry. I selected the Transform Tool (hidden underneath the Layer Adjuster tool) and selected the Distort option in the Property Bar. I dragged the corner handles until it matched the angle of her tapestry and pressed Enter.

2. To make the decorative pattern on her chair appear less "stuck on," I selected the Detail Oil Brush found in the Oils brush category and painted over the pattern to make it look more like a wood relief carving.

STEP 9 SOFTENING EDGES INTO THE BACKGROUND

Sargent always knew which parts of his painting to bring into sharper focus. For areas like the moon's edge and her skin, I needed a softer gradual blending and not the sharp harsh strokes of the Sargent Brush. In this next step I'll show you how I blend the edges into the background so there is not such a harsh light on Arachne.

1. Select the Real Flat Oils Brush found under the Oils brush category. Keep the Bleed at 100%, but reduce the Opacity to 20% or less.

2. As you paint, pick up colors from the background and paint it into the edges of the foreground figure.

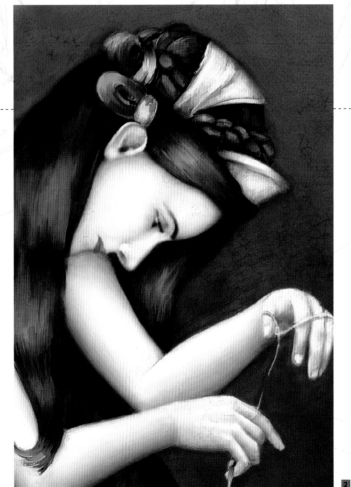

STEP 10 PAINTING IN COLOR

Sargent's paintings exhibit a perfect balance between warm and cool tones. When he painted flesh he used lead white and vermilion, but he would also work bone black into the shadows and use a combination of rose madder and green viridian to balance the warm and cool tones of the flesh. In this final step, I have warmed the skintones in places by adding red and yellow glazes using the Sargent Brush that I created on page 85.

1. Select the brush created in step 5.3 (page 85). Keep the Stroke Method set to Cover, but change the Subcategory to Grainy Soft Cover. In the Property Bar set the Opacity to 12%, Resaturation to 50%, and Bleed to 70%. This brush applies softer glazes with a slight diffusion at the edges.

2. Use a warm red color and apply it to the background and the edges of her skin. Then, select yellow and use this color on the halftones.

TIP ESTABLISHING THE FOCUS
Sargent deliberately darkened the ears, hair, mouth, and nose of his subjects, but lightened the values around the eye to draw the viewers focus to them.

▼ **EMBRACING DARK COLORS**
For his dark backgrounds, Sargent used a mixture of ivory black, Mars brown, and paint medium to make his brush strokes bleed into each other. In the final step, I made the background warmer, so it is closer to the colors of a Van Dyke Brown to complement the warmer skintones.

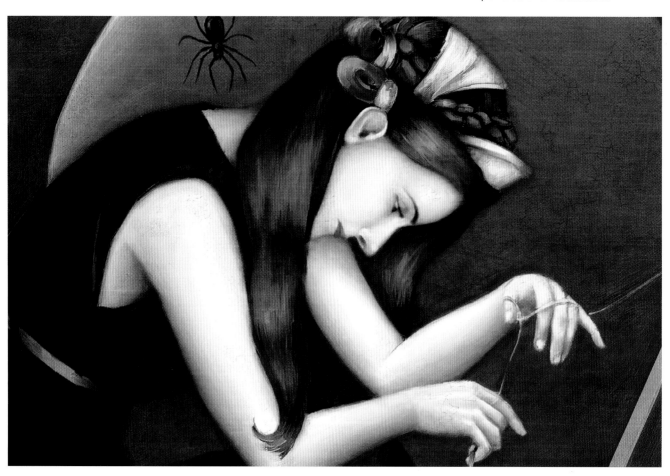

FEATURED ARTIST NANCY STAHL: LUMINOUS SKINTONES

"Who doesn't love John Singer Sargent's work? The quick, assured brush strokes, luminous skintones, beautiful manipulation of light and color, and wonderfully designed arrangement of the elements on his canvases all combine to take your breath away when you see one in person. One look and I find myself thinking I want to be him. But of course I'm not, I'm me and it is now, and as disappointing as that may be, I'm sure that adoration of a superb artist's work can only influence for the good."

▲ Glidden

Nancy Stahl
http://nancystahl.com
Nancy@nancystahl.com

For most of Nancy Stahl's career, she has been creating art used to illustrate everything from postage stamps to corporate identity, editorial pages, book covers, advertising and more. Her renown in the field recently led to induction in the Society of Illustrators Hall of Fame.

▲ Braid

▲ Tennis woman

▲ Sax

06
GIOVANNI BOLDINI 1842–1931
MASTER OF SWISH

LEVEL 1 2 **3**

What you will learn in this section
- Create a study in charcoal
- Creating movement with brush strokes
- Collage and overlay techniques

Application
PAINTER

Miss de Florian paced the floors of her Paris apartment, aware that time was running out. It was 1940, and in London, residents slept under blackened windows to the sounds of air raids shaking the foundation of their homes. France had yet to see much of Hitler's devastation, but that was about to change.

She had two choices: she could flee the city and abandon her opulent lifestyle, or wait for the German forces to invade and hope that her home was left standing. She looked up at the painting of her grandmother bathed in swirls of pale pink mousseline with her devil-may-care smile and wondered what

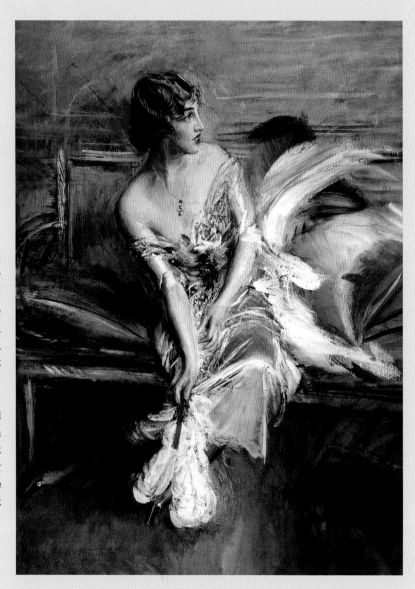

▶ **Gladys Deacon**
Giovanni Boldini,
1901

▼ **Portrait of Cleo de Mérode**
Giovanni Boldini, 1901
Much like classical music, Boldini's art
builds with a steady merging of color into
a fast tempo explosion of brush work.

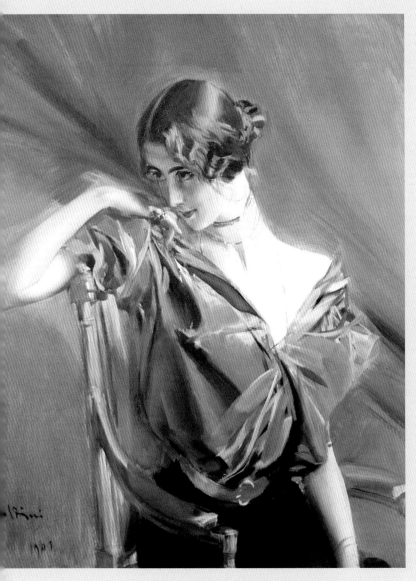

her grandmother would do? In the nineteenth century, her grandmother, Marthe de Florian, had been an actress and reigning *demimondaine*, accumulating a treasure trove of opulence and an impressive list of lovers including the prime minister of France, George Clemenceau. Would her grandmother have stayed or fled?

Miss de Florian decided that she had enough of her grandmother's moxie to not end up in a government-issued cardboard coffin, so she stuffed a few precious belongings into her suitcase and fled.

Seventy years later, an auctioneer, Monsieur Olivier Choppin-Janvry, got a call about an apartment that had been abandoned during WWII. The owner had continued to pay the rent, but had passed away at the age of 91. His job was to make an inventory of the contents of the apartment. He could not have been expecting much: the apartment may have survived the German invasion, but it could not have survived marauding thieves. Plus, little old ladies who abandon apartments often do not leave behind many treasures.

Janvry stepped into the decadent foyer, his feet kicking up clouds of dust from the priceless, oriental carpets. In one corner he spied a stuffed ostrich staring back at him, the bird's quizzical stare demanding to know who dared to disturb his slumber.

The walls were covered with floral wallpaper and paintings in gold gilt frames. One painting of a woman in profile wearing a pink dress caught Janvry's eye. He recognized the painter immediately as Giovanni Boldini, the "Master of Swish." He had never been aware of this painting's existence, nor did he recognize the sitter. A clue lay in another corner of the room where the thick, damask drapery let in a sliver of light upon an ornate, wooden

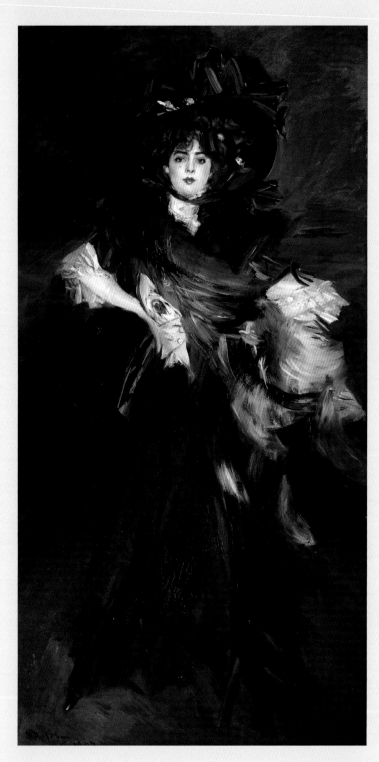

dressing table. Beneath layers of dust and cobwebs were glass perfume bottles, silver hair combs, and small books, but inside the vanity's drawers lay the true treasure. Upon opening the creaky drawers, Janvry found love letters "in little packages wrapped up with ribbons of different colors."

One of those letters contained a visiting card with a scribbled love note from Giovanni Boldini to Marthe de Florian. Further digging revealed a reference to the work in a book by the artist's widow stating it was painted in 1898 when Miss de Florian was 24. Janvry had hit pay dirt: the painting later sold at auction for 2.1 million dollars.

If you have a Boldini collecting dust in your basement, you probably could safely retire. Boldini paintings are not always easy to come by: the artist traveled so extensively that his paintings became scattered throughout Europe.

He was born in Ferrara and later moved to Florence to study painting. In Florence, he became a member of the *Macchiaioli*, a coalition of realistic painters who did much of their painting in the outdoors, predating the Impressionists.

In 1867 he visited Paris and met Manet, Degas, and Courbet. Influenced by their painting techniques, he moved to Paris in 1871 and became a top portraitist of the *belle époque*. Heiresses, authors, and actresses found themselves sitting for him at the Boulevard Berhier—the Paris studio he claimed after John Singer Sargent moved to London. Always fond of the ladies, he married for the first time when he was 86 years old to journalist Emilia Cardona, who was several decades his junior. Much like his paintings, Boldini was hard to pin down.

◀ **Portrait of Mademoiselle Lanthelme**
Giovanni Boldini, 1907
Boldini often used his brush strokes to create perspective lines that focus the viewer's eye on the subject. In this painting, the brush strokes on the floor move in a diagonal direction, pointing toward the figure.

I first saw Boldini's work while traveling through Italy and I was immediately carried back to the never-ending hustle and bustle of turn of the century Paris. Nothing sits still in his art. His women are always placed in strong, seductive poses where you can feel the weight of their bodies cutting through space. Much like Sargent, he was also a master of painting the edge. In his portraits—and especially his landscapes—he knew exactly when to use a bold, dashing stroke and when to use a sharp, quiet edge to focus the viewer's attention to a part of an image. For the eyes and cheekbones of his portraits, he made the focus sharp and almost photographic. For the luxurious fabrics, he used long, slashing brush strokes by thinning his paint.

Boldini died in 1931 and his work lost some of its commercial appeal as art collectors gravitated toward Art Deco aesthetics. Today, his art is appreciated much more, with an entire museum dedicated to his work in his birthplace of Ferrara, Italy. You can also see some of his work at the Sterling and Francine Clark Art Institute in Williamstown, MA.

In this tutorial, I will show you how to create some of the brush strokes that Boldini used to convey movement, incorporating some classical painting techniques. We will finish by thinning out the paint with one of my favorite collage techniques.

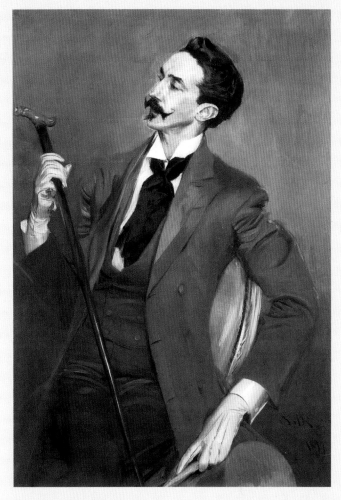

▲ **Count Robert de Montesquiou-Fezensac**
Giovanni Boldini, 1897

"When times have established values at their correct places, Boldini will be recognized as the greatest painter of the last century."

GERTRUDE STEIN

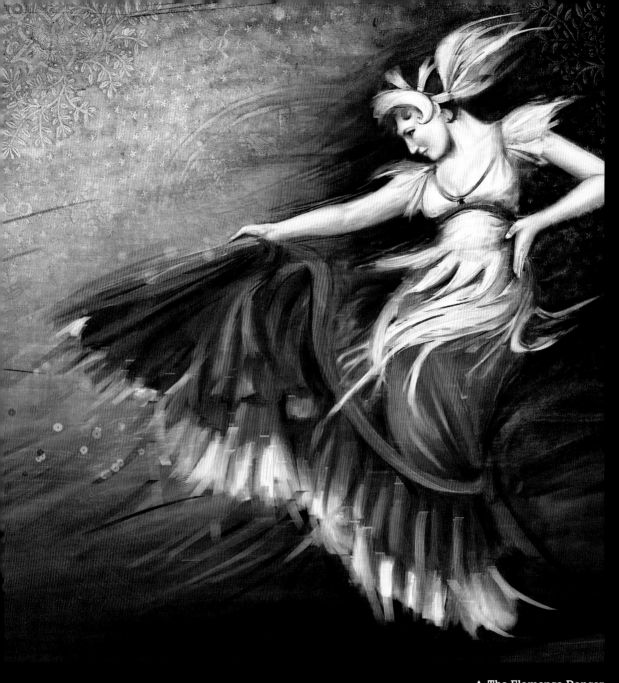

▲ **The Flamenco Dancer**
Created in the style of Boldini
using Corel Painter's Oil,
Impasto, and Pattern brushes

STEP 1 GESTURE STUDY

Boldini began his studies using charcoal and long, expressive lines. Before he began on a portrait he often did several sketches of his sitters and would then work from these. In this step we will create a charcoal study using Painter's Charcoal and Conte Crayon brushes.

1. First, use the Paint Bucket tool to fill the Canvas layer with a light flesh color.

2. From the Paper Library (Window/Paper Panels/Paper Library) select the Sandy Pastel Paper. This paper is part of your default library.

3. Duplicate the Canvas by first choosing Select/All and then Copy (Ctrl/Command + C) and Paste (Ctrl/Command + V). Name the duplicate layer "Texture."

4. Select Effects/Surface Control/Apply Texture. Use the default surface texture options with the Light Direction coming from the left and press OK.

5. In the Layers Panel, lower the Opacity of the Texture layer to 50% and then select Drop (Layers/Drop).

6. Next, choose the Charcoal brush from the Charcoal & Conte brush category. In the Property Bar set the Opacity to 100%, the Grain to 25%, Resaturation to 100%, Bleed to 40%, and Jitter to 0. This brush will pick up the grain of the paper while still applying enough charcoal pigment to get a dark line.

7. Roughly sketch the figure, paying attention to the direction of your lines.

8. Still using the Charcoal brush, increase the Grain to 35% in the Property Bar. Use this brush to create long, sweeping lines in the background. This brush creates deeper lines, allowing the charcoal pigment to seep into the paper.

9. Finally, introduce some softer modeling along the edges. For this, switch to the Square Conte brush found in the Charcoal & Conte brush category. In the Property Bar set the Opacity to 15%, Grain to 15%, Resaturation to 100%, Bleed to 100%, and Jitter to 0.08. These settings create a much softer brush that sits on top of the paper grain.

10. Use this brush to create transitions from dark to light that will map out your shadows and highlights. You can create a simple gesture study or a more detailed study. The purpose of the charcoal study is to find the movement of your lines and map out how lines connect. This drawing has an obvious, fast, slanted motion to the lines.

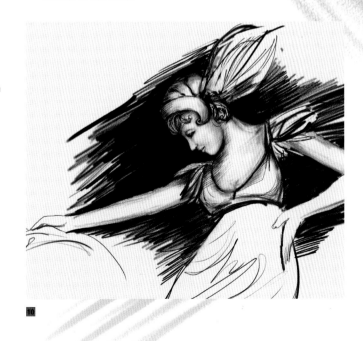

STEP 2 CLEAN UP LINES

Once the gesture study is complete you can use it as a guide to trace over. I am going to paint in reverse, from dark to light, so I will lightly trace out the figure using a light beige color on a dark background.

1. Duplicate the Canvas layer containing the charcoal study by choosing Select/All and then Copy (Ctrl/Command +C) and then Paste (Ctrl/Command + V). Name this layer "Study."

2. Reduce the Study layer's Opacity to 50% so you can still see it, but without it getting in the way of you tracing over the lines.

3. Select the Canvas layer, and using the Paint Bucket tool, fill it with a dark sienna color. I chose this color because it is dark, but still has warmth to it: as I'm planning to use reds, oranges, and magenta for the figure I want the background to become the base for my warm colors.

4. Create a new layer (Layer/New) and name it "Pen Lines."

5. Select the Thin Smooth Calligraphy pen found in the Pen brush category. The thick/thin nature of the brush allows you to retain motion in your line as you trace over your study.

6. Once you've traced over your study, delete the Study layer (Layers/Delete) and drop the Pen Lines layer down to the Canvas (Layers/Drop).

▶ **TRACE**
When tracing over your study it is important not to lose the energy in your line. I will use this trace as a guide to apply paint, but I will not let it dictate the picture.

QUICK TIP COLOR HUNTER

One of my favorite sites for coming up with quick color combinations is Colorhunter.com. You can enter any artist's name into the search box and it will spit out a color palette based on their paintings. When I entered Boldini I got the following color palette. This color palette is based on a portrait he did of Toulouse Lautrec.

266742
add to favorites

#5D392D #B73B06 #B02200 #FFDEB1 #DB9D3F

6

STEP 3 CREATE UNDERPAINTING

Boldini began his paintings with cool skin tones and then slowly warmed them up with a largely monochromatic palette. In this step you will learn how to create an underpainting using green undertones in the skin and then slowly build up the warmth in the paint.

1. Create a new layer (Layer/New) and check the Pick up Underlying Color box. Name this layer "Underpainting."

2. Select the Real Tapered Flat brush from the Oils brush category. In the Property Bar set Resaturation to 100%, Bleed to 60%, and Feature to 4.5.

3. In the Opacity panel (Window/Brush Control Panels/Opacity) set the Opacity to 100%, Min Opacity to 45%, Opacity Jitter to 100%, and Expression to Velocity. These settings will vary the Opacity of the brush depending on the speed of your hand.

4. In the Dab Profile panel, change the Dab to Flat Rake Profile. However, as I paint, I will often switch between the Flat Rake Profile and the Dull Profile Dab to get different marks.

5. In the Color Variability panel (Window/ Brush Control Panels/Color Variability), increase the Hue to 6%, Saturation to 14%, and Value to 20%. These settings will randomize the Hue, Saturation, and Value as you lay down paint.

6. With these brush settings in place, build up the skin tones in green, and the drapes of the fabric and background in reds and browns. The figure's skin tones may look very "alien," but the green underpainting helps create more realistic skin tones. When you're done, drop the layer down (Layer/Drop).

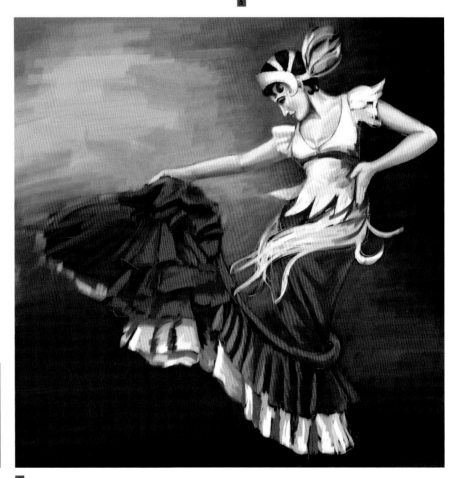

STEP 4 BUILD UP PAINT

Unlike Sargent, Boldini used much thinner paint for the initial stages and then slowly built up the thickness in the drapes of the fabrics. In this step, I will begin to warm up the skin tones and apply thicker paint to the drapes of the fabric.

1. Create a new layer (Layer/New) and check the Pick up Underlying Color box. Name this layer "Underpainting" and set the Composite Depth to Add (instead of Ignore). These settings are important as they enable you to build up impasto effects in each layer.

2. Next, select the Loaded Palette Knife brush from the Impasto brush category. In the Impasto panel (Window/Brush Control Panels/Impasto) change the Draw To method to Color and Depth. Set the Depth to 100%, Min Depth to 0%, Depth Jitter to 50%, Expression to Velocity, and uncheck the option for Invert Velocity. These settings will unload less paint if you make a fast mark, and build up more paint if you make a slow mark—I used this brush in the dancer's skirt to create more spontaneous marks.

3. Next, select the Real Oils Smeary brush from the Oils brush category. In the

Property Bar set Feature to 2.5 and Bleed to 20%. In the Real Bristles Panel (Window/Control Panels/Real Bristle) increase the Bristle rigidity to 100% and the Fanning to 35%. These settings will cause the brush to fan out without bending—I used this brush in the shadows and highlights of the figures skirt, to spread the paint applied with the Loaded Palette Knife.

4. Use the Real Oils Smeary brush for the skin tones, but reduce its Opacity to 35%. This allows you to glaze in color washes that warm up the skin tones.

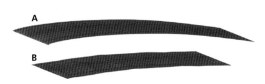

▲ With these settings, if you make a fast mark the impasto is not raised (A). If you make a slow and steady mark, the paint is applied thickly (B). The difference is very subtle, but you will see it when painting.

▲ The Loaded Palette Knife cuts into the paper with thick paint (A). To soften this effect in places, use the Real Oils Smeary Brush to spread the paint more thinly (B).

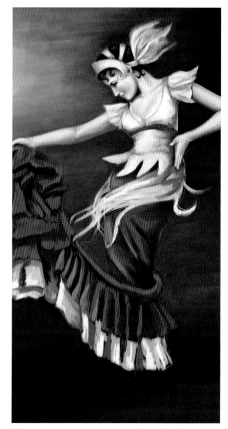

STEP 5 DRAMATIC LIGHT

Boldini used dramatic light and bright whites to make the eye move around his figures. In this step we will use different Layer Composite Methods to create dramatic lighting and punch up the color intensity.

1. Create a new Layer (Layer/New) and set the Composite Method to Hard Light. Check the Pick up Underlying Color box.

2. Select the Real Tapered Flat brush from the Oils brush category. In the Well panel (Window/Brush Control Panel/Well) set Resaturation to 30%, Bleed to 80%, Min Bleed to 100%, and Expression to Pressure. The Resaturation controls the amount of paint loaded onto the brush, while the high bleed settings will cause the brush to bleed colors into each other, depending on the pressure of your hand (the Min Bleed forces that bleed amount to never drop below 80%).

3. Select a magenta color and use long strokes to paint in where the light would hit the figure's skirt. Switch the paint color to white and increase the Resaturation to paint more dramatic highlights on the skirt. Drop this layer down once you are happy with it (Layer/Drop).

4. Create a new Layer (Layer/New). Set the Composite Method to Multiply, checking the Pick up Underlying Color box.

5. Select black as your paint color and use long strokes to paint darkened shadows around her face. Drop this layer down once you are happy with it.

TIP FIND YOUR EDGE

It is important to vary the sharpness of your edge to keep the eye moving around the image and vary the movement in the figure. For the folds of her dress use the Real Oils Smeary brush to create soft, sweeping brush strokes. For her arm and face, create a cleaner, tighter edge by using the Real Tapered Flat brush. The sharper edge creates a "pause" or a moment of stillness from the surrounding motion.

1

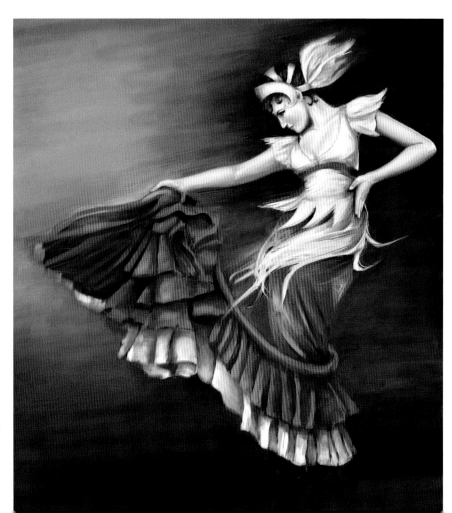

3

5

STEP 6 SMEAR PAINT THROUGH CLONING

Boldini didn't get called the "Master of Swish" for nothing. His painting used long lines of paint that swirled around his figures, forcing the eye to be lead in a specific direction. In this step we will see how we can use the quick clone function to smear the paint further. The quick clone function allows you to take your original image and use it as a template to create more painterly brush strokes, while still retaining the color and values of the original.

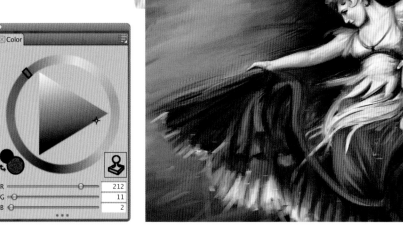

1. To create a quick clone, select File/Quick Clone. This function opens a copy of your image with a "tracing paper" effect over it.

2. The default setting allows you to see 50% of the original image, but I prefer to increase it to at least 80% so that I cannot see as much of the original. To do this, change Set Tracing Paper Opacity in the Clone Source panel, (Window/Clone Source). Here I've set it to 85%.

3. Next, create a New Layer (Layer/New Layer). This will be the layer that contains your smeared paint.

4. Select the Loaded Palette Knife and turn on the Clone Color option in the Color panel. This will cause your Color panel to turn gray.

5. Using the Loaded Palette Knife as a clone brush, paint into the new layer using long strokes that follow the direction of the action. The accompanying illustration shows the Clone layer on

its own: using the clone function allows you to smear the paint, but still retain its original color and values.

6. When you've finished smearing the paint, select it (Select/All), copy it (Ctrl/Command + C), and then open your original image. Use Ctrl/Command + V to paste your smeared layer into the original. In the Layers panel, reduce the Opacity of the smeared layer to around 80% and drop it down (Layer/Drop).

7. Select the Sargent Brush from the Artists brush category. In the Property Bar increase the Stroke Jitter to 1.25. In the Size panel (Windows/Brush Control Panels/Size) increase the Size Jitter to 25%, set Expression to Pressure, and adjust Size Step to 60%. The paint will be more jagged looking because the size is being varied. Use this brush to blend the red of the figure's dress into the white underlayer.

8. Finally, select the Sargent Super Jitter brush from the Artists brush category. From the Property Bar, set the Stroke Jitter to 0.45. Use this brush on the edges of the figure's dress to create the appearance of dragged paint.

STEP 7 THIN PAINT

If you look at a Boldini oil painting up close, the paint is so thin that you can see the canvas. At this point, you will have lost most of the canvas and will need to bring it back in places. In this step we will overlay the image with a paper texture to give the appearance of thinner paint.

1. From the companion website download and open ScratchedCanvas.psd. This texture was created by scanning in an old canvas book cover and then scratching it up further with the Gritty Charcoal Brush found in the Charcoal and Conte brush category.

2. Select all of the Scratched Canvas image (Select/All) and copy it using Ctrl/ Command + C.

3. Paste the texture into your Boldini painting by using Ctrl/Command + V.

4. Set the layer's Composite Method to Overlay and set the Opacity to 60%.

5. Add a layer mask (Layers/Create Layer Mask) and select the Digital Soft Pressure brush found in the Airbrush brush category. Set the Opacity to 50%.

7. Choose black from the Color panel and paint out the areas that you want less texture in. Painting with black will mask out parts of a layer, while painting with white will make them visible again.

8. With this picture I repeated the process using an image of a scanned vintage book. The collage elements add visual interest and help contain my image.

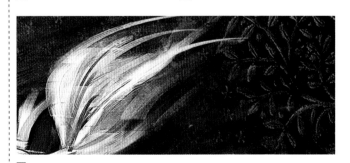

07
ARTHUR RACKHAM 1867–1939
THE GOBLIN MASTER

LEVEL 1 2 3

What you will learn in this section
- Painting in translucent washes
- Expressive pen and ink lines
- Adding aged effect

▶ **The Old Woman in the Wood**
Arthur Rackham, 1917
From *Little Brother and Little Sister and Other Tales* by the Brothers Grimm.

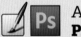 **Ps** Application
PAINTER/PHOTOSHOP

Ask any fantasy artist today whose work they admire and Arthur Rackham will most likely be at the top of the list. Unfortunately, the artist would turn in his grave if he saw a tutorial recreating his style on the computer. Rackham hated new technologies, fearing and criticizing photography as a poor substitution for illustrated book art. He believed cars, telephones, typewriters, and other modern inventions were the root of all evil, once declaring, "I would rather have a page of handwriting I couldn't read than a typewritten manuscript."

Yet despite his aversion to new technologies, Rackham's illustrations grew out of a period of technological advances in the printing process. Previously, illustrations had to rely on an engraver to cut lines on wood or a metal plate. This method of printing not only meant that the art was only as good as the engraver, but also that the delicate flowing pen and ink lines that Rackham became so famous for were impossible to reproduce.

◀ **The Book of Pictures**
Arthur Rackham, 1913
Rackham often included caricatured self-portraits of himself in his paintings as he did here.

"Suddenly the branches twined round her and turned into two arms."

THE OLD WOMAN IN THE WOOD,
FROM *GRIMM'S FAIRY TALES*

This process changed with the birth of new photographic and printing techniques that allowed printers to print a four-color image by separating it into three images. Rackham's illustrations were then "tipped in"—printed on coated card stock and pasted onto larger, thicker card stock. Often, Rackham's books were produced on delicate vellum and signed, resulting in a thriving gift book market.

Rackham's subdued, tea-stained tones were a perfect match for this new printing process. Rackham first sketched an outline of his drawings in soft pencil, but he did not do many preliminary sketches. Instead, he preferred to, "build as I go on, and the idea develops as I work." He then drew over his pencil lines with pen and ink and blocked in color with thin, transparent layers of watercolor. The result displayed flowing ink lines with dramatic sharpness that contrasted against the soft washes of color.

His painting technique of airy washes confined by dark, sometimes ominous lines was also well suited to an age that was torn between Victorian values and the cold, hard edge of the Industrial Revolution. Rackham was born in London in 1867, as one of 12 children. At the age of 18 he worked as a clerk, studying in his spare time at the Lambeth School of Art. However, Rackham's first big achievement didn't come until the age of 38 with his illustrations for Washington Irving's *Rip Van Winkle*. From then on, his popularity soared as the master illustrator of impish goblins, talking trees, and fairy beauties.

But Rackham didn't become the "Goblin Master" overnight. His illustrations for *Alice in Wonderland* were met with less than stellar reviews. The Times wrote: "His humor is forced and derivative, and his work shows but few signs of true imaginative instinct..." Thankfully, the general public thought differently and sales reached 14,322 copies in just the first six months.

Rackham was not one to sit and gloat over his success. He had a boundless energy for his art, often resembling the mischievous gnomes from his fairytales. Bent over his drafting table with his round-rimmed glasses, he would often mimic the facial expressions of his characters as he drew. When stuck, he would take a break to jump on his trapeze or comb his cat Jimmie (named after his partner in crime and creator of Peter Pan, Sir James Barrie.) Undeniably, he had a playful side that came through in his characters' exaggerated poses and wry smiles.

Rackham was influenced by early 16th century artists, such as Dürer, and this is seen especially in his later work for *Undine* and *Siegfried and the Twilight of the Gods*. Toward the end of his life, Rackham worried that some of his illustrations were too dark for young people. He wrote to one attentive fan that his illustrations for *The Ring of the Nibelung* were "not very well suited for those lucky people who haven't yet finished the delightful adventure of growing

▲ Rackham's color palette
Rackham's muted color palette meant his soft washes did not compete with his pen lines. The result is light and airy, with dark undertones.

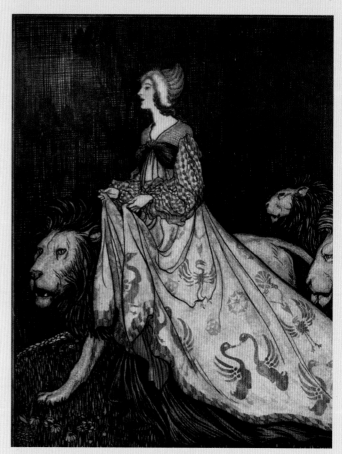

▶ The Lady and the Lion
Arthur Rackham, 1909
In this image we can see how Rackham's palette translates into his work.

up..." Even after cancer claimed him at the age of 72, one could say that Arthur Rackham still had not finished the "delightful adventure of growing up." His art has a childlike delicacy that continues to appeal to art collectors and children alike.

▼ Front plate from Alice in Wonderland

Arthur Rackham, 1907
Rackham always used models in his work. The model for *Alice in Wonderland* was Dorris Jane Dommet, who later became a painter in her own right. Jane modeled for Rackham in a dress that she had designed herself and thick wool stockings. Rackham copied the exact dress and stockings for all of his *Alice in Wonderland* illustrations.

▼ Hades Kidnaps Persephone

In this painting I used Painter's Pen and Ink brushes along with soft washes applied with the Real Watercolor and Sponges brushes. To add grit to the background, I used Photoshop brushes to layer in texture.

STEP 1 AGE YOUR PAPER

Rackham preferred to work on a slightly yellowed paper, so you need to paint on the right paper to keep the texture in each wash of color. Painter comes with many watercolor papers, but I prefer to make my own aged paper using this technique:

1. Start by scanning an old book that is riddled with water stains.

2. Increase the contrast by selecting Effects/Tonal Control/Brightness/Contrast and pulling the Contrast slider to the right.

3. Using the Rectangular Selection tool, draw a selection around the area that you want to become your paper.

4. Open the Paper Libraries panel (Window/Paper Panels/Paper Libraries) and click on Capture Paper.

5. Name this paper "Old Book" and set the Crossfade to 100% to prevent it from looking tiled. Your new paper will appear in your Paper Library.

STEP 2 EXPRESSIVE LINES

Rackham would first sketch his illustration with a soft pencil and then ink over it using pen and ink. He would then erase his pencil lines, leaving the hard edge of the pen marks.

1. You can create your pencil sketch digitally or scan in a rough sketch of your composition, as I have done here. This is only a guide and will be deleted once you have inked in your drawing.

2. From the Color panel (Window/Color Panels/Color) select a light yellow color and fill your canvas layer using the Fill tool.

TIP WHEN PAPER MATTERS

Remember that your paper surface will only alter brushes that have a Grain setting in the Property Bar. All other brushes will not change with the paper.

3. Select the Thin Smooth Calligraphy Pen from the Pens brush category. Under the General panel (Window/Brush Control Panel/General), change the Subcategory to Flat Cover. This pen will alter its thickness based on the rotation of your hand.

4. Create a new layer (Layers/New Layer) and double-click on the layer to rename in "Ink lines."

5. From the Color panel (Window/Color Panels/Color), select a deep brown color similar to a 50/50 mixture of India and sepia inks. Then ink in your lines.

6. For less sharp lines, switch to the Calligraphy brush tool, which is also found in the Pens brush category. In the Property Bar, lower the Opacity to 25% and increase the Grain to 100%. In the Dab Profile panel (Window/Brush Control Panel/Dab Profile) change Dab to Medium Profile Dab. The Calligraphy brush will now have a rougher feel to it.

STEP 3 WASH IN COLOR

Rackham was able to create richness in his illustrations by applying very thin washes, and building them up slowly in layers. We will recreate this using a series of brushes.

1. Choose the Rough Edges brush found in the Real Watercolor brush category. In the Property Bar, increase the Grain to 100% to pick up the grain in the Old Book paper that you created in Step 1.

2. Block in washes of color, allowing the paint to drip in a downward motion.

3. Switch to the Sponge Brush found in the Sponges brush category in the property bar. Increase the Grain to 100% and use the Sponge Brush to apply another layer of color.

4. Select the Real Wet Sponge found in the Real Watercolor brush category and block in a darker tone to give the background more texture. Try to resist adding color at this point: Rackham worked with a very limited palette, allowing him to get his values correct.

TIP CINTIQ USERS

Trying to tilt your wrist while applying the appropriate pressure can be difficult if you have your Cintiq at an angle perpendicular to your desk. Instead, try tilting your Cintiq downward so you can draw at the same angle as a piece of paper placed on a drafting table.

TIP

Arthur Rackham always blocked in his background first before beginning his figures. This is a good habit to get into because your background values will alter the foreground figures.

5

2

4

5. Switch to the Smeary Wet Sponge, which is found in the Sponge brush category. In the Property Bar, increase the Grain, Resaturation, and Bleed to 100%. This brush applies a softer glaze of color while still retaining some of the paper grain.

6. To blend color, especially in the folds of the clothing, lower the Smeary Wet Sponge brush's Resaturation to less than 10, but keep the Bleed at 100%. A low Resaturation and high Bleed create a "blender brush" that allows you to get a softer gradation between colors.

7. Select the Burn tool from the Toolbar and use it along the edges of the figures. The burn tool will darken the edges, giving them a smokier feel.

8. Next, create a new layer (Layers/New Layer) and name it "Color." Change this layer's Composite Method to Color, and using the Sponge brush set at a low Opacity, wash over your sepia illustration with yellower tones.

9. Use the Sponge brush to wash over a layer of red to keep the two female figures connected through color.

10. After adding the red, use the Sponge brush to wash in a layer of brown to unite the newly colored areas with the background.

"When I have finished a book, I wish I could do it all over again, quite different."
ARTHUR RACKHAM

TIP

To paint like Rackham, you must let the shadow and highlights define the figures. Rackham was very selective as to where his pen and ink delineated foreground and background objects. Interior shadows are always blended. Only outside edges are smooth.

STEP 4 MASTER THE STORY

At this point, I realized that I had not captured the right emotions for the story. In the famous Greek myth, Hades steals Persephone away from her mother, Demeter, and drags her down into the Underworld. Demeter refuses to let anything grow until her daughter returns. Rackham's illustrations never lacked dark undertones, so this illustration needs a more ominous feel. We will achieve this by adding twisting vines rising up from the Underworld.

1. Using the Thin Smooth Calligraphy brush on a new layer, create a thorny branch in black. Repeat this to create a number of different branches.

2. On the branch layer, make a selection around a branch with the Rectangular Selection tool. Be sure to keep enough space at the top and bottom to avoid feathering the black portion of your masked pattern.

3. In the Patterns Library (Window/Media Library Panel/Patterns), select the Capture Pattern button. Name the brush you are creating "Vine Branch 1" and set the Horizontal Tile, Rectangular Shift, and Vertical Shift to 0. Repeat steps 2 and 3 with your other branches to create a range of brush patterns.

4. Select the Pattern Pen Masked brush from the Patterns brush category and then choose one of your new Vine Branch patterns from the Patterns Library. Paint in a swirling motion to add a vine twisting upward from the bottom of the canvas. Repeat this with each of the different vine brush patterns.

TIP WHAT DID I DO WRONG?

If your masked pattern does not turn out right, here are some of the most common mistakes:

1. Make sure that you are making your brush from left to right and not from top to bottom.

2. Your branch must be on a transparent layer before you hit the Capture Pattern button. Do not use the Canvas layer.

3. Select enough space from top to bottom to get a clean edge.

4. Remember to select the Pattern Pen Masked brush and not the Pattern Pen brush.

STEP 5 ADDING TEXTURE

To finish the illustration, add some more texture to the background. For this step, I have switched over to Photoshop because I like the way it captures textured brushes.

1. To create my texture I scanned in some scraped back paint, but you could also use photographs of textured surfaces such as rough concrete, a weathered door, or peeling paint. Select Image/Adjustments/Threshold and set the levels to 135 to make the image black and white.

2. Next, select Edit/Define Brush Preset and name your new brush.

3. Open the Brush Presets menu and check Shape Dynamics. Set Size Jitter to 0 and its Control method to Fade at 25. Set the Minimum Diameter to 20%. Finally, set Angle Jitter to 0% and its Control method to Direction.

4. Create a new layer above your illustration, select a dark brown color, and paint in texture over the background using your new brush.

TIP SOFTENING EDGES

It's easy for your pen and ink lines to appear too sharp in places, especially in areas that should recede. Rackham softened his lines' edges by applying a grainy ghosting behind his figures and at the edges. To get the same look, use the Sponge brush at a low Opacity along the edges of your figures.

FEATURED ARTIST KIMBERLY KINCAID: LAYERING

"Arthur Rackham is one of the major influences in my art. His beautiful, lyrical line work as well as his muted earth tones has captured my attention since childhood. With *Detour*, I began with a detailed graphite sketch that was scanned and then darkened, and tinted warm, sepia brown. This gives the sketch a similar ink look without redrawing all the lines. If lines need darkening, I use a low setting color burn. Working on multiplied layers, I apply my colors, building up the tones as I would watercolor. I often 'lift' color with the eraser tool when I want to expose the sketch beneath the layers. Sometimes I use a texture layer, as in *The Minstrel* to give the piece a more organic feel. Any highlights are applied opaquely on a normal layer."

▲ Fade Within the Silence

▲ Detour

▲ Detour Sketch

▲ The Minstrel

Kimberly Kincaid
kimkincaidart@msn.com
www.artbykimkincaid.com

Kimberly is a freelance artist who has returned to art after raising her family. She has attended IMC at Amherst, MA four times and just finished two semesters with Rebecca Guay's SmART School mentorship program. She's been in *Imagine FX* and *Spectrum 14*. Recently, three of her pieces were accepted in *Society of Illustrators 50* and she was selected as one of Muddy Color's Rising Stars for SFAL II.

08
GUSTAV KLIMT 1860–1939
THE MIDAS TOUCH

LEVEL 1 2 3

What you will learn in this section
- Creating an underpainting using cool and warm tones
- Creating pattern fills in Painter
- Using pattern and nozzle brushes in Painter
- Creating customized texture brushes in Photoshop

Application
PAINTER/PHOTOSHOP

"Now I know what a kiss is," wrote Alma Schindler in 1899 from Vienna. The young socialite had fallen for the dashing bohemian artist and notorious seducer, Gustav Klimt. At the time, the Viennese artist was engaged in affairs with at least three other women (two of whom were carrying his children). He simply loved women, and they loved him. His list of sexual conquests was so long that one starts to wonder when he had time to paint, but paint he did, in his small cottage studio, wearing a long blue smock (with nothing underneath), surrounded by cats and beautiful female models. Indeed, he became so infamous for sleeping with his subjects that just sitting for the painter could ruin a woman's reputation. For most women, it was worth the risk, though: one sitter recalled, "Klimt was exceptionally animal-like." What we know of Klimt is mostly through the women that loved him; he wrote very few letters, leaving behind a trail of riddles and dark secrets. Shy and moody, he once wrote, "Whoever wants to know something about me ought to look carefully at my pictures, and try to see in them what I am and what I want to do."

Unfortunately, his paramours also left few clues about his art and far too many about his sexual prowess. Consequently, art historians are left to guess what secrets his paintings hide: we still do not even know the identity of the woman in the iconic painting *The Kiss*. Theories abound that it may have been the one woman he never fully conquered—his life long friend and sister-in-law, Emile Flöge. Other theories suggest that the sitter may have been Jewish heiress, Adele Bloch-Bauer. The woman in *The Kiss* certainly bares a remarkable resemblance to Bloch-Bauer down to even her crooked finger.

During this period, Klimt became one of the most sought after portraitists with the cost of his paintings equaling the purchase of a small villa. It seemed the shy and brooding artist had the Midas touch and every woman in Vienna wanted to be captured in gold.

"There is nothing that special to see when looking at me. I'm a painter who paints day in day out, from morning till evening—figure pictures and landscapes, more rarely portraits."

GUSTAV KLIMT

Born in 1882, Klimt had humble origins. His father was a gold engraver and aspiring musician, and Klimt trained at the Vienna School of Arts and Crafts, rather than Vienna's fine art academy. Disenchanted with criticism that his work was too profane, he became the leader of the Secession movement—a group of Viennese artists who were challenging the conservative nature of traditional Austrian painting.

Klimt's styles changed throughout his life and he demonstrated a tireless energy for his art. He posed his models on swings to make them look like they were floating, and worked with very loose lines to find the gesture of the model. He made over 100 pencil sketches on manila paper before starting his painting in oils, which typically began by giving the flesh blue undertones to give the skin a delicate thinness and contrast against the warmth of his backgrounds. His compositions were usually square to suggest a sense of stillness.

During his Golden Period, he was influenced by Byzantine mosaics, Celtic design, and Egyptian art. Consequently he frequently used symbols such as the Eye of Horus to convey a sense of divinity in his subjects and in the final stages of his painting he would use gold leaf over his oils to create a golden throne for his floating subjects. Although he painted many landscapes, it was women who were the catalyst for some of his greatest masterpieces.

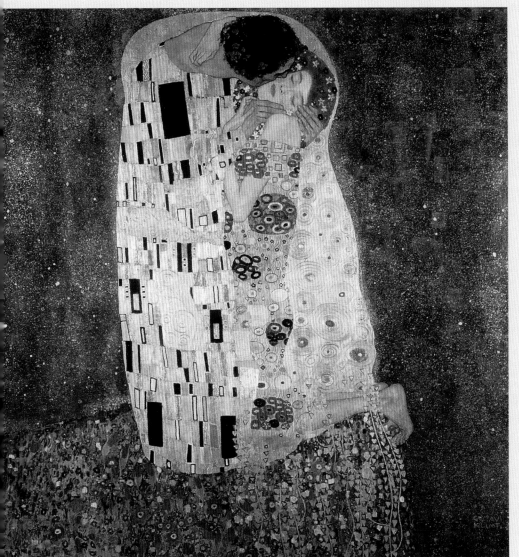

◄ **The Kiss**
Gustav Klimt, 1908–1909
The Kiss is one of the most widely reproduced images in history.

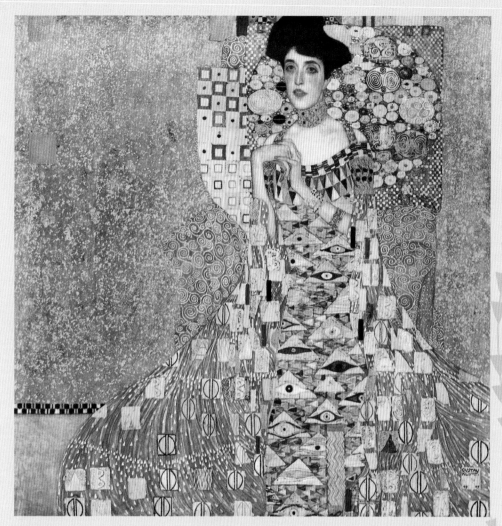

◀ **Adele Bloch-Bauer**
Gustav Klimt, 1907
Adele Bloch-Bauer has been called the 20th-century *Mona Lisa*. Much like the *Mona Lisa*, the painting traveled through many hands before finding its home. The painting was originally commissioned by Ferdinand Bloch-Bauer, the wealthy owner of a prominent sugar refinery. As part of the Aryan Clause of 1933, the painting was confiscated by Nazi authorities and Bloch-Bauer fled to Switzerland where he later died. His estate was bequeathed to his niece, Maria Altmann, who emigrated to the US during the Holocaust. In 1999, Altmann filed a law suit in the US to have five Klimt paintings restored to her, including the painting of her aunt. In 2006, she won her case. *Adele Bloch-Bauer* was sold for US$135 million, at the time making it the most expensive single piece of art ever. The painting was purchased by Ronald Lauder, philanthropist and son of Estée Lauder, co-founder of the cosmetics company of the same name. The painting can today be viewed at the Lauder family's Neue Gallery in New York City.

They also became the poison in his veins. At an early age he contracted syphilis and suffered through the disease's debilitating attack on the body. In the pre-antibiotic age, there was no cure and in 1918 Klimt died from a stroke after he was hospitalized with advanced stages of syphilis.

In this tutorial, we will start off by creating an underpainting with blue skin tones on a gold background. We will then use Painter's Pattern brushes and fills to create an ornamental landscape for our figures. This is probably the only tutorial in the book where you will need to work on many layers, so make sure you do not have several programs running in the background: you will need to maximize your computer's memory usage.

For my painting of *The Three Furies*, I borrowed many symbols from Ancient Egyptian art. The first figure in the background is the merciless goddess, Hathor, while the figure to the far right is Isis, the forgiving goddess. According to legend, Ra, King of the Gods, became angered with mankind for not administering justice so he sent Hathor to earth in the form of a lion. She became Sekhmet, the "Eye of Ra" and caused the fields to run red with human blood. Ra ordered her to stop, but she could not control her lust. So Ra sedated Sekhmet with alcohol until she fell asleep. She slept for three days and mankind was saved.

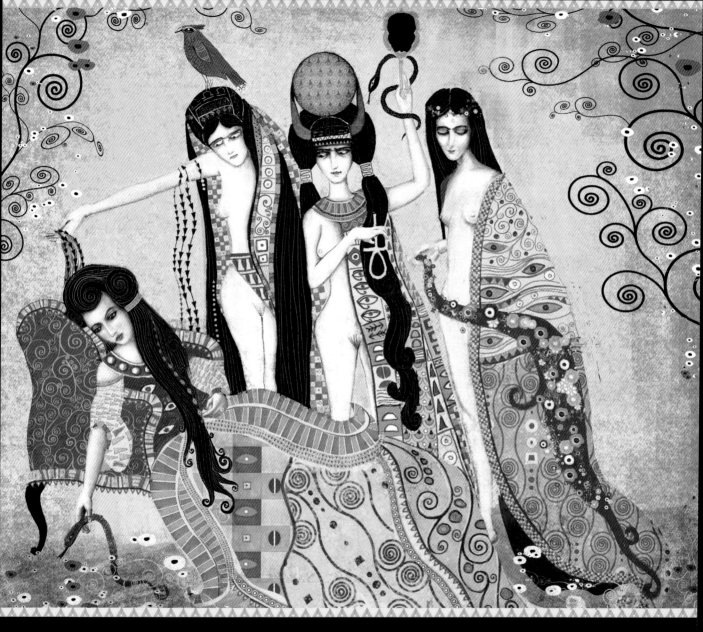

▲ The Three Furies

This painting is a true mixed digital
media piece. I used Corel Painter Oils,
Pastels, and Pencils. I then overlaid
my painting with patterns using
Corel Painter pattern brushes.

STEP 1 SKETCH WITH PENCIL

Klimt used a sharp pencil on very thin paper to sketch his figures. He first used gesture drawings to find the movement of the pose and his lines always had a nervous energy to them. In this step, we will create a sketch using Painter's pencil brushes.

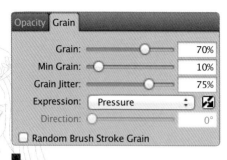

1. First, fill the Canvas with light beige by selecting the Paint Bucket tool and clicking on the Canvas Layer. This yellowish color will give your overall composition a warmer hue.

2. From the Paper Library (Window/Paper Panels/Paper Libraries), select the Fine Hard Grain paper. This paper will give you a smoother tooth and result in sharper, cleaner lines.

3. Create a New Layer (Layer/New) and name this layer "Drawing."

4. Select the Real Sharp Pencil found in the Pencil brush category. In the Property Bar, increase the Stroke Jitter to 0.3, set the Opacity to 100%, and the Brush Size to 1.0 to get a deep, thin line.

6. In the Grain panel (Window/Brush Control Panels/Grain), set Grain to 70%, Min Grain to 10%, Grain Jitter to 75%, and Expression to Pressure.

7. Roughly sketch out your figures, varying the Grain as you draw. A Grain of 70% will create a smoother line, while decreasing the Grain to 15% will create a line that is deeper. You can also create a rougher line by increasing the Spacing (Window/Brush Control Panels/Spacing).

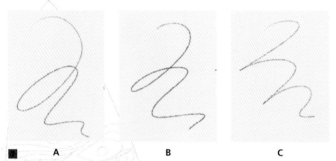

A B C

◄ CHANGE THE BRUSH
A Grain of 70% will create a smoother line (A), while decreasing the Grain to 15% will create a line that is more textured (B). You can also create a rougher line by increasing the Spacing (Window/Brush Control Panels/Spacing) (C).

STEP 2 UNDERPAINTING

Klimt began many of his portraits using a blue underpainting for the skin tone. Blue gives skin a very translucent feel and contrasts with warmer backgrounds. In this step, we will establish the contrast between the cool skin tones and warmer background using Painter's oil paints.

1. Select the Real Oils Flat brush from the Oils brush category. From the Property Bar, set Feature to 3 and Bleed to 0.

2. In the Color Variability panel (Window/Brush Control Panels/Color Variability), set the Hue, Saturation, and Value to 2%, 2%, and 5% respectively. These settings will apply paint in a "dirty" way, allowing you to see your brush strokes in the paint.

3. Select a light blue color and start painting in the flesh with blue tones. This blue color will be the base color for the skin.

4. Next, glaze over the blue with thin washes of light pink. To make the flesh tones blend into the blue, increase the Bleed of the Real Oils Flat brush to 15%. Add dabs of yellow and ocher over the layer of flesh tones and grayish blue to the shadowed areas. The blue undertones should never be covered completely—by using thin glazes of color, the blue will always show through the flesh color of the skin.

5. Switch to the Fine Feather Brush found in the Oils brush category to create even thinner glazes of paint and pick up the texture of your surface. To create this look, increase the Impasto (Window/Brush Panels/Impasto) to 80%. From the Property Bar, set the Grain to 20%, Resaturation to 50%, and Bleed to 20%. Switch the paper to Artists Canvas and lower the paper scale to 35%. Use this brush to glaze over your colors with thin layers of paint.

6. Repeat this process for the three other figures, but use flatter colors.

7. Finally, select the Real Sharp Colored Pencil brush and use it to paint a decorative pattern on the hair in yellow.

TIP

Paint in the bright yellow background before you begin to model the flesh. As you paint, sample this yellow color and pull it back into the flesh color with small dabs of paint.

STEP 3 PATTERN BRUSHES

In most of Klimt's compositions, the tension between the foreground and background is created purely through pattern and color. His figures appear as if they float above their backgrounds because of the way he surrounds them with one-dimensional, geometric shapes. In this next step, we will make a custom pattern brush that will allow us to create a repeat pattern.

1. Open a new File (File/New) and create a new layer (Layers/New Layer).

2. From the Property Bar select the Straight Line tool. Choose the Real Hard Pastel brush from the Pastel brush category.

3. Draw a short straight line and then create another new layer. Using the Straight Line tool, draw a small triangle across the line. Switch to the Freehand Strokes tool and fill in the triangle.

4. Make six copies of the triangle by holding down the Alt key and dragging the triangle to the right.

5. Merge the triangle and line layers together by Shift + clicking on the layers and selecting Collapse layers (Layers/Collapse Layers). Do not include the Canvas layer. I named my combined pattern layer "Arrows."

6. With the Arrows layer selected, create a selection around the arrow design using the Box Selection tool.

7. From the Patterns Library (Window/Media Libraries/Patterns), click on the Capture Pattern button. Name your pattern "Black arrows." Your new brush will now appear in your brush library.

8. You can created an entire library of Klimt brushes by clicking on the New Pattern Library Button and then repeating steps 2–7 using different geometric shapes.

STEP 4 CREATE FILL PATTERNS

Painter allows you to create a seamless pattern, so you can fill larger areas with a repeating design. In this step, we will create a pattern fill and use it in the chair behind the girl.

1. Open a new File (File/New) and set the dimensions to 5 x 5 inches.

2. Select a deep gold from the Color Panel (Window/Color Panels/Color) and fill the Canvas layer using the Paint Bucket tool.

3. Create a new layer (Layers/New Layer) and select a lighter gold color from the Color Panel.

4. Open the Pattern Controls panel (Window/Media Control Panels/Patterns). Click on the small right arrow and select Define Pattern from the drop-down menu. Define Pattern is like a magic wrapping tool that will allow everything you draw off the right of the canvas to wrap to the left (it will also wrap top to bottom).

5. I drew a swirling pattern, allowing my pen to go past the edges of the canvas in order to create the wrap. When you're done, select the Capture Pattern button and name your pattern.

6. Using the Freehand Selection tool, select the boundaries of the chair. Then, pick your new pattern from the Pattern Library. Using the Paint Bucket tool, click inside your selection to fill your chair with the pattern.

QUICK TIP
ADJUSTING PATTERNS

Any time that you want to change a pattern's color or design you can check it out of your library and make adjustments. If you wanted a warmer gold color, for example:

1. Open the Pattern Controls panel and choose "Check Out Pattern" from the drop-down menu.

2. Select Effects/Tonal Control/Adjust Color and move the Hue slider to get a warmer color.

3. Press the Capture Pattern button and name your new pattern. Both your new pattern and the original pattern will appear in the library.

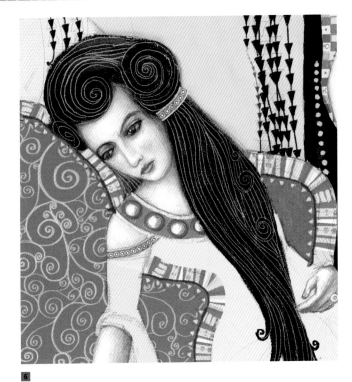

STEP 5 PAINTING WITH NOZZLE BRUSHES

In this step, I'll be demonstrating how you can create a flower nozzle brush. A nozzle brush is different to a pattern brush because it allows you to scatter different designs across the canvas.

1. Create a new document (Ctrl/Command + N) with dimensions of 5 x 2 inches.

2. Select black from the Color panel (Window/Color Panels/Color) and fill the Canvas layer with black.

3. Create a new layer (Layers/New Layer) and name it "Flower 1."

4. Choose the Real Flat brush from the Oils brush category of the Brush Selector. Draw a flower on the "Flower 1" layer.

5. Create a new layer (Layers/New Layer) and name it "Flower 2." Draw another flower shape on this layer.

6. Repeat the previous step to create 8–10 flower shapes in two rows. Each one should be on its own layer.

7. Select all the layers by Shift + clicking on them and group them together (Layers/Group Layers).

8. From the Nozzle panel (Window/Media Library Panels/Nozzle), click on the New Nozzle Library icon. For this tutorial, I named this Library "Klimt."

9. Click on the right arrow at the top of the Nozzle panel and choose Make Nozzle From Group... from the drop-down menu. This will create a new, flattened file with a black background. Save this.

10. In the Nozzle panel, click on the small right arrow again and select Load Nozzle... Select the flowers nozzle created in the previous step.

11. Click on the small right arrow again and select Add Nozzle to Library... from

the drop-down menu to add your new Nozzle to your Nozzle Library

12. To use this nozzle, select the Spray-Size-P-Angle-B brush from the Image Hose brush category. In the Property Bar, set the Brush Size to 60 and Stroke Jitter to 2. Increasing the Jitter will increase the randomness of how the images spread.

13. Under Spacing (Window/Brush Control Panels/Spacing), increase the amount to 125%: a higher value will spread the flowers out more as you paint.

14. In your painting, create a new layer and spray in your stream of flowers. Adding the flowers pattern to a new layer means that you can quickly remove any flowers that stray outside of the stream.

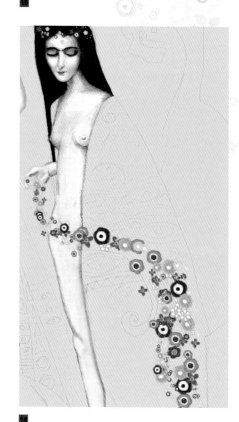

STEP 6 A PATTERN EXPLOSION

Klimt worked in such detail on his painting that some patrons had to march into his studio and steal a painting off his easel to see it finished. It is pretty amazing considering how many patterns Klimt used without the use of being able to turn layers on and off. Fortunately, we have the flexibility to add and subtract elements. In this step, I added several more patterns using the nozzle and pattern brush in Painter. Here are a few of the patterns that I used to paint with: you can download these files from the companion website to experiment with them.

▲ I created this repeating square pattern with Painter's Real Hard Pastel brush and then used the Capture Pattern button to turn it into a pattern. I used my selection tool to select areas of the dresses to fill with the repeating square pattern. I varied the size of the pattern by adjusting the Pattern Scale in the Pattern Controls Panel (Window/Media Control Panels/Patterns).

◀ I created this pattern in Adobe Illustrator and then exported it into Painter so that I could match the seams.

◀ I created these circular shapes using Painter's Freehand Selection tool and then filled the shapes with color so that I would have a clean edge. I used these shapes as a Nozzle brush in the trees and garden floor.

◀▲ I created this swirl pattern using the Pen tool in Adobe Illustrator. I then exported the shapes into Painter by selecting File/Export and saving them as a .PSD file. Once in Painter, I created a pattern brush for each swirl and used this brush on the garden floor and in the trees.

TIP LAYERS

I don't usually work with multiple layers, but this in an example where it pays to have them. Keeping every pattern on its own layer means that you can alter the color and shape of a pattern, or remove it completely, without affecting anything else.

STEP 6 TEXTURE AND IMPASTO

Klimt's backgrounds were rich in texture and impasto effects. For this last step, I switched to Photoshop and painted in the background texture using a custom brush that reminded me of acid applied over paint. (Note that you can download this brush from the companion website if you want to skip making a custom brush.)

1. Take a photograph of a suitable rough surface, such as bricks, old doors, or rotting wood (I took a picture of a concrete pavement).

2. Open the image in Photoshop and go to the Levels panel (Image/Adjustments/ Levels). Move the white and black sliders toward the middle to create a more posterized black-and-white image. This will give your brush a sharper texture.

3. Create a layer mask (Layer/Layer Mask) over the image and use a soft brush with black as the foreground color to paint away the edges.

4. To change the image into a brush select Edit/Define Brush Preset.

5. Open the Brush panel and increase the Spacing to 75% under Brush Tip Shape. As you increase the spacing, you will see the preview update.

6. In your original image, select a dark gold color and paint the acid texture into the background. Use a darker gold toward the edges and a brighter gold toward the center of the image.

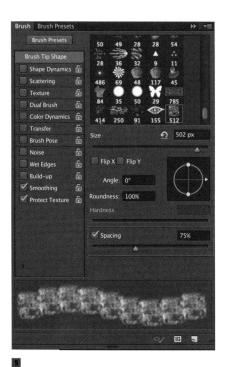

5

2A

2B

6

FEATURED ARTIST CHRISTINA HESS: GEOMETRY INTERSECTS NATURE

"When I was 16, I visited Vienna and saw *The Kiss* by Gustav Klimt. This colossal painting became a pivotal point in my appreciation of art. I was in awe of the use of colors and organic shapes, and fell in love with the juxtaposition of geometry with realism. Inspired by Klimt, many of my illustrations are created digitally using scanned organic paper to create a textural surface. *The Fitzgeralds* pays homage to Klimt's *The Kiss* by telling a love story about two San Diego Zoo snow leopards while paralleling the relationship of F. Scott and Zelda Fitzgerald. I created the underpainting using Photoshop and Painter, and then mounted the 16 x 20-inch print to masonite. Finally, I applied acrylic, gold, and silver leaf, metallic paint, pencil, and oil paint."

▲ Cleocatra

Christina Hess
www.ChristinaHess.com
Christina@ChristinaHess.com

Christina is a freelance illustrator living in Philadelphia, USA, where she graduated from University of the Arts with a major in illustration. Some of her honors and features include *Imagine FX* magazine Artist of the Month, Phillustration 4—Best of Show, Spectrum 18, 19 & 20, Exotique 7, Silver Award for Self Promo category in the Society of Illustrators 50 LA, Expose 10 & 11, and *3x3 Magazine*'s Pro Show. Christina is currently finishing her first ebook, which is entitled *Animals From History*.

▲ The Fitzgeralds

▲ Patchwork Girl

▲ Mother Earth

09
HENRI MATISSE 1869–1954
PART 1 THE WILD BEAST OF COLOR

LEVEL 1 2 3

What you will learn in this section
- Create a color palette based on a painting
- Understanding dramatic use of color
- Create a repeating pattern
- Painting in impasto
- Sharpening impasto

Application
PAINTER

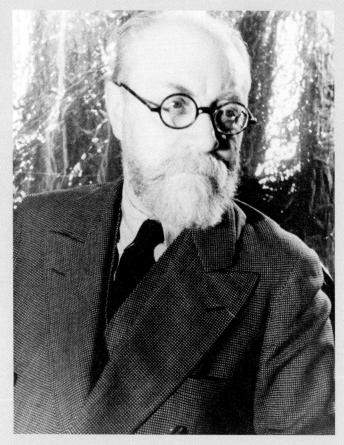

▶ Henri Matisse
May 20, 1933

It couldn't have been easy for Mrs Matisse. She got gussied up in her best dress, wore quite an extravagant hat, and kept her head turned in a classical pose for hour upon hour. And what did she get for her efforts? A green nose. Her embarrassment did not stop there. When *Woman with a Hat* was first exhibited in the 1905 Salon d'Automne, critics mocked Matisse's color choice by claiming it must have been done by "des fauve"—wild beasts. Soon after, Matisse found himself the unwilling leader of a new art movement— the Fauvists.

"There are always flowers for those who want to see them."

HENRI MATISSE

◀ **Harmony in Red**
Matisse, 1908
Harmony in Red began as "Harmony in Green"
and then became "Harmony in Blue:" Matisse
would often rework compositions, sometimes
changing the colors completely.

Ironically, Matisse was no wild child. He was born in a small, isolated textile village in France in 1869 to a seed merchant and the daughter of a well-to-do tanning family. To please his father he studied law and passed the bar in 1888. He then became a dutiful lawyer's clerk, trudging through the streets of Paris every day with a sturdy briefcase filled with paperwork.

Matisse might have continued his dreary paper shuffling until he went blind if it wasn't for a very special gift from his mother—a box of paints. Matisse would later recall, "I threw myself into it like a beast that plunges towards the thing it loves." From then on, he decided to pursue art. Yet even as he "plunged" into art, Matisse continued to dress like the button-down attorney he had once been. He woke at the same time every day and ate the same supper (vegetable soup, two hard-boiled eggs, salad, and a glass of wine). He had such a staid air about him that years later his students would nickname him "the doctor." Matisse liked the nickname. He believed that art should be like "a good armchair, which provides relief from bodily fatigue."

However, the art critics did not find his colorful canvases relaxing in the least. Fortunately, the art collector Leo Stein had faith in Matisse and purchased *Woman with a Hat*, restoring Matisse's confidence. When Stein first bought the painting, he called it, "the nastiest smear of paint I have ever seen." But he eventually warmed to it, and the rest of the art world followed suit: by the 1940s, Matisse had become one of most sought after artists in Europe.

Matisse attributed much of his success to his hard work ethic. He would work all day and then the next day would rub out the previous day's work with turpentine. This was because he felt that what he painted one day was leading to what he would do the following day. Each stage in the process was photographed so he could understand how a painting was evolving.

He applied paint using flat zones of bright color, always careful to use black and white to organize his compositions. He felt color needed room to breath and many of his compositions use large swathes of color to give the composition structure. He said, "an avalanche of color loses all its force. Color can achieve its full expressive power only if it is organized, and its degree of intensity corresponds to the emotion of the artists."

Patterns were also an integral part of his paintings, with many of his patterns inspired by Islamic art. He even had an oriental background installed in his studio that included a Moorish screen and Arab drapery.

Matisse was drawn to the human figure more than any other subject and once said, "Painting the human form was the best way for me to express what I might call my own peculiar religious feeling about life." He always used models, even for his more abstracted art. When a young reporter asked Matisse why he needed a model when he planned to deviate so drastically from it, Matisse replied, "If there were no model, one would have nothing from which to deviate." Taking Matisse's advice, I recommend bribing friends or family members to pose for you so you will have this vital point of deviation.

For this tutorial, I chose to paint an *odalisque;* a concubine in a harem, and a subject that became a common theme in Matisse's work. I also recommend studying Matisse's color choices so they become instinctual. It is like learning a dance—your muscles will eventually convert it to memory, allowing your brain to just turn off. Of course, learning to paint like Matisse is going to be more like learning the quickstep than a slow waltz, so you might want to make sure you are good and awake for this one. Now, let's dance!

▼ **Madame Cézanne in a Red Armchair**
Paul Cézanne, c. 1877
Matisse would probably have approved of this book because he strongly advocated learning from others. He once said, "One would have to be pretty silly to avoid studying how other people work." He was often criticized for borrowing styles from other artists, but these more derivative works were an integral part of his developing style. Matisse was most influenced by Cézanne, and used similar flat planes of geometric color to build volume into his forms.

"Painting the human form was the best way for me to express what I might call my own peculiar religious feeling about life."
HENRI MATISSE

▼ **Woman with a Striped Fan**
I created this in Painter using Oils, Impasto, and Pattern brushes.

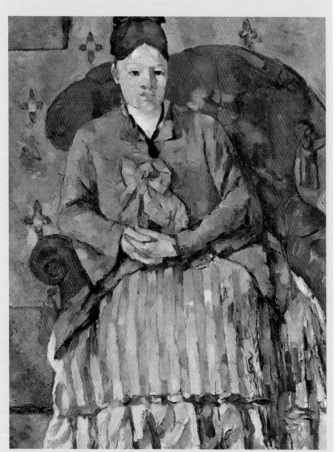

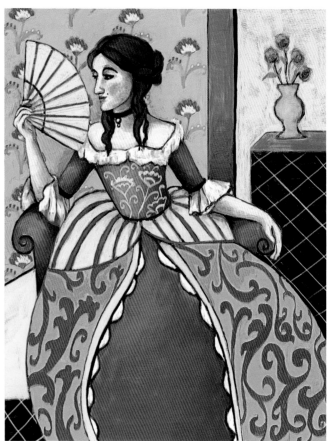

STEP 1 EXPRESSIVE GESTURES

Matisse wrote numerous essays on drawing, but was opposed to a formulaic approach. He was especially against using a grid to "square up" a drawing to scale. He felt that sucked the life of out each line, as the lines only had meaning in relationship to the size of the paper. Instead, he did hundreds of preliminary drawings until he felt he had found the form and simplified his painting. He drew in many mediums, but some of his more interesting sketches occurred in the late 1940s when he started making bold gestural drawings in pen and ink. In this first step, we will follow this and make a rough contour drawing to establish the foreground and background relationships.

1. Create a New Document (File/New) and set the canvas size to 8 x10 inches.

2. From the Liquid Ink brush category, select the Smooth Bristle brush.

3. From the Property Bar, change the Size to 9, the Smoothness to 150%, the Volume to 200%, and the Feature to 4. As shown, Smoothness controls the drag of the pen, with a higher number making a more fluid mark, while Volume controls the amount of ink loaded into the pen. Features controls the amount of bristles in the brush, with a low number creating a tight brush with fewer bristles.

4. Create a new layer (Layer/New Layer) and name it "Sketch." Use the Smooth Bristle brush to sketch your figure. Increase the Volume and lower the Feature when you want to make a blockier mark loaded with more ink. To create a thinner, smoother line, increase the Smoothness and lower the Feature.

5. Select a bright blue color from the Color panel (Window/Color Panels/Color). Using the Paint Bucket tool, fill the Canvas layer with this blue.

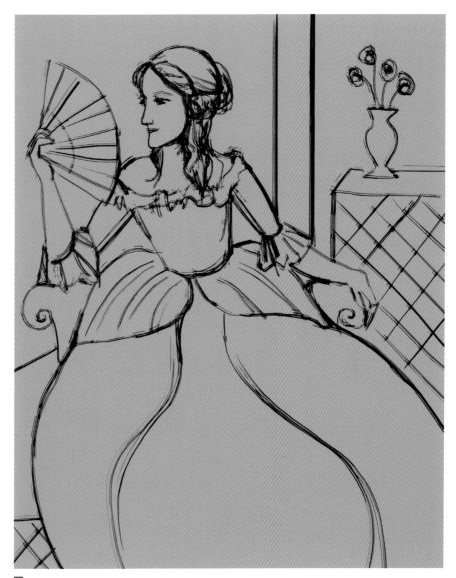

5

STEP 2 MATISSE'S PALETTE

Matisse did not always choose the most obvious colors. He once said, "Both harmonies and dissonances of color can produce agreeable effects." In this next step, I've taken a Matisse painting (*Harmony in Red*) and created a color palette from it. Keep in mind that Matisse also said, "I put down my tones without a preconceived plan," so you are not tied to this color palette.

1. To simplify the color set you have created, create a new color set by clicking on the right arrow at the top of the Color Set panel and selecting New Color Set. Name this "Matisse."

2. Drag the colors you want from the full color set created in step 1 into the new Matisse color set. I chose a palette of complimentary colors: yellow, bluish violet, red, and greens.

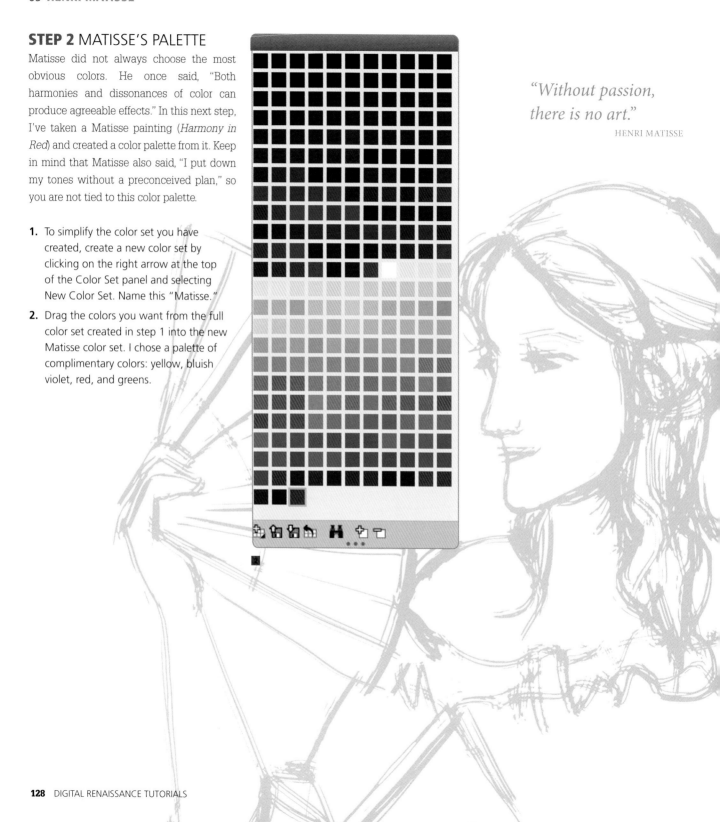

"Without passion, there is no art."

HENRI MATISSE

STEP 3 ADDING COLOR

Matisse applied paint using sweeping brush strokes with a dry, matte texture similar to frescoes on plaster. In this next step, we will use a dry brush loaded with paint to map out zones of color.

1. From the Oils Brush category, select the Real Tapered Flat brush variant. In the Property Bar, set the Resaturation to 65%, the Bleed to 100%, and the Feature to 4.8.

2. In the Impasto panel (Window/Brush Control Panels/Impasto), set the Draw To method to Color and Depth and set the Depth to 3%. This will give your brush a slight impasto look.

3. As you apply color, vary the Feature to alter the brush strokes in your marks.

4. Switch to the Wet Oils Impasto brush found in the Impasto brush category. In the Property Bar, set Opacity to 40%, Grain to 0, Viscosity to 25%, Bleed to 40%, and Wetness to 85%. In the Impasto panel (Window/Brush Control Panels/Impasto), set the Depth to 40%. Use this brush to build up the paint, using black to frame the composition.

"I feel through color"
HENRI MATISSE

3A

A Smoothness 200%, Volume 400%, and Feature 3.
B Smoothness 150%, Volume 200%, and Feature 4.
C Smoothness 100%, Volume 75%, and Feature 5.

3B

4

STEP 4 ADDING BACKGROUND PATTERN

Growing up in a textile town full of weavers, Matisse couldn't help but be influenced by patterns. He used patterns to create a more dynamic space, but his patterns never got caught up in minute details. They are always made with broad, painterly brush strokes so that the viewer's eye is drawn to them, but they do not take away from the other elements in his paintings. In this next step, we will create a painterly flower pattern and apply it to the background.

1. Select the Wet Oils Impasto brush that you created in the previous stage and paint a simple flower shape on a plain blue background.

2. Click on the Capture Pattern button in the Patterns Library panel (Window/Media Library Panels/Patterns). Name this pattern "Matisse Flowers" and set the Horizontal Shift to 50%. This creates a repeating pattern of flowers.

3. In the Patterns panel (Window/Media Control Panels/Patterns) set the Pattern Offset to 50% and the Scale to 75%.

4. Create a new layer (Layer/New Layer) and name the layer "Flowers."

5. Select the Paint Bucket Tool and set Fill to Source Image in the Property Bar. Click inside the document to fill the entire layer with the repeating flower pattern.

6. Create a Layer Mask over the flowers layer (Layer/Create Layer Mask). With the layer mask selected and black as your paint color, paint over the areas that should not be visible. If you take too much away use white to paint back the areas that should be visible.

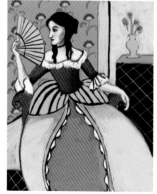

TIP MAKE A MATISSE PATTERN BRUSH

Matisse often used flowers in his art. To create your own "Matisse" pattern brush, follow these simple steps.

1. Create a horizontal flower vine in a straight line on a new layer, using any brush.

2. Use the Rectangle Selection tool to make a selection around your flower vine, leaving enough space from top to bottom.

3. In the Patterns Library (Window/Media Library Panels/Patterns) select the Capture Pattern button.

4. Name your pattern and set the Horizontal Shift to 0.

5. Select the Pattern Pen Masked brush from the Pattern Pens brush category. Paint in a new document. Your flower vine will now follow the direction of your hand.

STEP 5 ADD FOREGROUND PATTERNS

Matisse believed that "the painter must have no preconceived notion of the model—his spirit must be open and receive everything." He believed color was applied through instinct and, as such, he was against studying the science of colors. He certainly believed that choosing "complementary colors is not absolute". In this step, we'll add a pattern over the skirt to create a more harmonious relationship between the foreground and background. I also tried out different color choices, allowing my "instinct" to guide me.

1. Create a new layer (Layer/New Layer) and name it "Dress." Set the layer's Composite Depth to Add.

2. Select the Loaded Palette Knife brush from the Impasto brush category.

3. In the Impasto panel (Window/Brush Control Panels/Impasto), lower the Depth to 15%. This brush creates angled strokes that are perfect for creating a swirling pattern.

4. Make sure you are working on the Dress layer and paint in your swirling pattern.

5. After painting my pattern, I decided that the blue and green colors I had chosen were not dramatic enough. To change them, I selected Effects/Tonal Control/Adjust Color and moved the Hue slider to 34% to get a redder color.

6. Finally, I chose a white paint color, decreased the size of my Loaded Palette Knife, and drew a swirling pattern on the figure's bodice.

5A

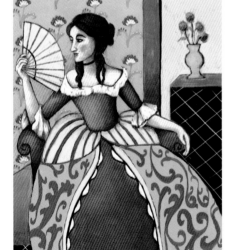

4

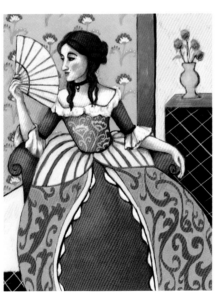

5B

6

STEP 6 SHARPENING IMPASTO

Throughout his life, Matisse varied the thickness of his paint, using thin washes for some pieces and thick layers of paint for others. I prefer to see the thickness of my paint, so in this final step I will show you a trick to sharpen the impasto effect.

1. Flatten your layers down to the Canvas layer (Layers/Drop All).

2. Duplicate the Canvas layer by selecting it (Select/All), copying it (Ctrl/Command + C), and then pasting it into a new layer (Ctrl/Command + V). Name this layer "Highpass."

3. Select the Highpass filter (Effects/ Esoterica/Highpass). Under Aperture, select Gaussian and set the Amount to around 10. This value defines the edge to be sharpened. Hit OK.

4. Sharpen the image further by selecting Effects/Focus/Sharpen. Set Aperture to Gaussian and set the Amount to around 10. Set Highlight and Shadow to 100%. Hit OK.

5. Your Highpass layer will look fairly flat and ugly, so change the layer's Composite Method to Overlay and reduce its Opacity to 75%. The Overlay Composite Method preserves the color, altering the highlights and shadows. With the Highpass filter applied, the paint has more depth and the colors appear brighter.

"Drawing is like making an expressive gesture with the advantage of permanence."

HENRI MATISSE

TIP

You can get some interesting effects by playing with other Composite Methods such as Hard Light and Luminosity, so experiment.

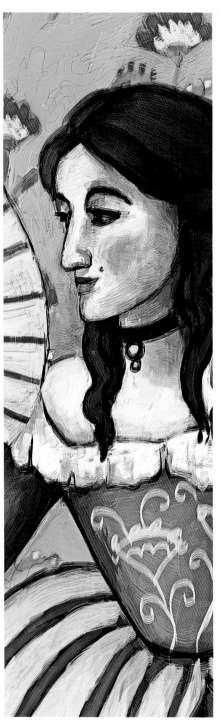

"If I had to pick one artist in history who inspires me more than any other, it would be Henri Matisse. I love his playfulness and freedom of color, his beauty, power, and simplicity of line, his mastery of design and composition, and his integration of pattern, rhythm, and repetition into his work. I appreciate his fascination with, and documentation of, the journey and creative process his paintings went through. Matisse used photography to record stages very much like I use the 'Save As' in Painter to record versions. I enjoy Matisse's love of the human figure and how he revisited different media throughout his life—drawing, print making, painting, sculpture, and finally, paper cutouts. He had a passion, even an obsession, for exploring ideas and different ways to express what he sees, through reworking, transforming, destroying, rebuilding, and creating series of related works."

Jeremy Sutton
PaintboxTV.com
jeremy@jeremysutton.com
@jeremydsutton

Corel Painter Master Jeremy Sutton is author of the *Painter Creativity* series of books and founder of PaintboxTV.com. Jeremy's art commissions have ranged from painting a live digital portrait of Sir Richard Branson on the Virgin Atlantic San Francisco Inaugural to performing live painting as a *tableau vivant* at the de Young Museum, painting one of the large Hearts on Union Square, San Francisco, and performing live digital painting for the Cirque du Soleil *TOTEM* show. Jeremy teaches Painter and iPad art workshops, and is on the Corel Painter Beta Testing Team and Advisory Council. Please see PaintboxTV.com for more info.

10
HENRI MATISSE
PART 2 **DRAWING WITH PAPER**

What you will learn in this section
• Drawing with cut paper
• Color relationships
• Creating gouache overlays

▶ **Icarus**
Matisse, 1947
Plate VIII from the illustrated book, *Jazz*. Matisse's deceptively simple form communicates the descent of Icarus, who flew too close to the sun.

Ps Application
PHOTOSHOP

In 1940, in his late 70s, Matisse was diagnosed with bowel cancer and had to undergo major surgery. He begged his doctors for three more years to live to complete his art. After the surgery, Matisse was extremely frail and confined to his bed, but cancer would not stop him from creating art. During this time, he painted gouache on sheets of paper and then used large scissors to cut out his shapes. His cut paper was compiled into a book entitled *Jazz*. In this book he was able to take his passion for color and reduce it to a more simplified expression.

Today, some of our strongest logos and graphic prints work in a similar fashion, but Matisse was the first to reduce his paintings to just color and form. Excluding primitive cave paintings, they became the first examples of modern art. In this chapter we will use Photoshop's lasso tool to create a painting using shapes that we "cut out" digitally.

◀ **Digital Cutouts**
Drawing with the
lasso tool gives
the loose feeling
of cut paper.

STEP 1 EXPRESSIVE GESTURES

In this first step, we will use the Freehand Lasso tool to roughly form shapes, in a similar way to scissors cutting paper. You may feel that the lasso tool is a little unwieldy to draw with, but that is exactly the point of this exercise—we want an organic shape.

1. In Photoshop, click on the Foreground color to call up the Color Picker. Choose a light beige color and press Alt/Option + Backspace to fill the Background Layer with beige.

2. Create a new layer (Layer/New/Layer...) and name it "Blue."

3. From the Toolbar, choose Photoshop's Freehand Lasso tool.

4. Draw the main body form with the Freehand Lasso tool and close it off.

5. Press Alt/Option + Backspace to fill your shape selection with blue.

6. Repeat step 3–5 to create arms, legs, and a head.

7. Finally, cut into the form at her mid section to suggest a waist, and also cut in to define her hair. Create a negative space where her eyes should be.

STEP 2 SCULPTING THE FIGURE

I wasn't fully happy with how the form was filling the space, so in this next step I will show you how to use the Warp tool to push and pull pixels.

1. Select the Warp tool (Edit/Transform/ Warp). This creates a grid over the image that allows you to pull it in any direction.

2. For my figure, I clicked inside the image and pulled it out to the right.

3. I then clicked inside the image again and pulled it to the left.

4. When I was happy with my new shape, I pressed the Return key.

STEP 3 ADD COLOR AND SHAPE TO BALANCE

In this next step, we'll be adding organic plant shapes to balance the negative space, and then adding brighter colors to give the woman a tribal feel.

1. Create a new layer (Layer/New/Layer…) and name it "Plants."

2. Select the Freehand Lasso tool again and draw organic plant shapes.

3. Click on the Foreground color to bring up the Color Picker; I chose a blue color. Press Alt/Option + Backspace to fill the plant shapes with your chosen color.

4. Create a new layer (Layer/New/Layer…) and name it "Green Girl."

5. Make a rough selection around the figure's body.

6. Click on the Foreground color to bring up the Color Picker. I chose a turquoise color, then pressed Alt/Option + Backspace to fill the selection area.

7. Next, create a clipping Mask so that the turquoise will only show through the girl (Layer/Create Clipping Mask).

8. Repeat steps 3–8 for the plants, this time using yellow.

9. Draw in a small red dot on the figure's forehead using the Pencil tool.

10. Select the Plants layer and click on Preserve Transparency at the top of the Layers panel. Select a bright yellow color and fill the plants with it by pressing Alt/Option + Backspace.

11. Select the Background layer and fill it with blue.

TIP THE DOT TRICK

Matisse said, "If I put a black dot on a sheet of white paper, the dot will be visible no matter how far away I hold it: it is a clear notation. But beside this dot I place another one, and then a third, and already there is confusion. In order for the first dot to maintain its value I must enlarge it as I put other marks on the paper." When deciding to keep or remove elements, always ask this question: what role does this addition serve? Matisse felt that any element that did not play a role damaged the composition.

STEP 4 ADD TEXTURE

You could stop at this point, but we'll go a step further and make our colors resemble the washes of gouache used by Matisse when he designed his illustrations for *Jazz*.

1. Create a new layer (Layer/New Layer…) at the top of the layer stack and name this layer "Gouache."

2. Click on the Foreground color to bring up the Color Picker. From the Color Picker, choose a dark blue.

3. Click on the Brush Preset Picker and choose the Chalk 44 Pixels brush.

4. Open the Brush Panel and change the Size to around 175px and Spacing to roughly 40%.

5. Check the Shape Dynamics button at the left of the Brush panel and set the Size Jitter to 100%.

6. Then, check the Scattering option and set Scatter to 393%, Count to 1, and Count Jitter to 1%.

7. Check the Texture option and click on the small right arrow next to the texture preview window. From the drop-down menu choose Gray Scale Paper to load a range of paper surface textures. Click on

the small gear tool next to the texture preview window again and choose the newly loaded Kraft Waffle paper from that set. Change the Scale to 87%, then check Texture Each Tip and set the Depth Jitter to 25%.

8. Begin painting on the Gouache layer using straight up and down strokes. You will need to vary the Size and Opacity of your brush to get less repetitive brush strokes

9. In the Layers palette, reduce the overall Opacity of the Gouache layer to 10%.

TIP THE MATISSE YELLOW TRICK

Our eye perceives light in wavelengths. Each color can have a short, medium, or long wavelength. Red has a long wavelength and violet has a short wavelength, while the color yellow is in the center—a perfect medium.

For this reason, yellow is the most visible color and our eye will actually be drawn to it before other colors. Consequently, no other two colors create more contrast than black and yellow. Yellow is also my favorite color and I use it often to play with depth perception. In *Woman with a Striped Fan*, the eye is drawn to the flat, yellow shapes in the background, tricking the eye into thinking those shapes are vibrating forward. Use yellow to create a tension between foreground and background objects.

TIP RECORDING STEPS

Matisse had photographers take pictures of his work at different stages so he could understand how his painting evolved. In Painter you can also record your steps:

1. Open the Scripts menu (Window/ Scripts). The control icons are the same as those used by all media players (stereos, Blu-Ray players, and so on).

2. Press the Record button and begin painting.

3. When you are done painting, press the Stop button.

4. Your recorded script will now appear in Painter's Scripts panel. Press the Play button to play back your script.

"An artist must possess Nature. He must identify himself with her rhythm, by efforts that will prepare the mastery which will later enable him to express himself in his own language."

HENRI MATISSE

11
AMEDEO
MODIGLIANI 1884–1920
DIABOLICAL BEAUTY

What you will learn in this section
- Creating weight within a line
- Creating varnish impasto effects
- Using Divine Proportion to abstract a figure

Ps Application
PAINTER/PHOTOSHOP

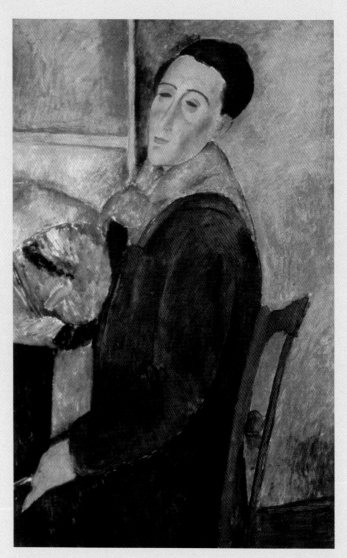

▶ **Self-portrait**
Amedeo Modigliani, 1919
Wearing his trademark scarf to hide the fact that he had tuberculosis.

In 1910 Modigliani was like many other avant-garde artists. He traveled from café to café with his blue portfolio tucked under his arm and a scarf tied haphazardly around his neck. (He wore the scarf to hide the highly contagious tuberculosis that had cursed him throughout his life.) On a typical night, Modigliani would sit down and begin a portrait of a friend or stranger in the hope that he could trade the painting for his next meal. Modigliani went hungry a lot.

But 1910 was a tough year for most artists. It was the year that Halley's Comet streaked over a panicked Paris. People believed its coming surely presaged the end of the world, and while the comet did not bring the predicted death and destruction, that same year the Seine river flooded the city, overflowing sewers and subway tunnels and costing the city over 400 million Francs. Four years later,

▼ Large Seated Nude
Amedeo Modigliani, 1917
Modigliani's style is instantly
recognizable. Notice the
elongated facial features,
the provocative pose, and
the almond-shaped eyes.

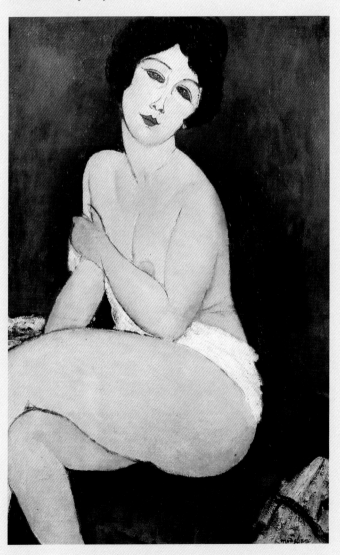

Germany would declare war, leaving the city in fear and feeding on wartime rations: these were tough times for everyone.

Outside the cafes, new inventions called "horseless carriages" clattered through the narrow, cobblestone streets as the newly constructed Eiffel Tower loomed over the city. Its steely frame became a beacon of promise and a constant reminder of how the gilded hopes of a new century could clash so fiercely with the hardships of the industrial age. Modigliani's paintings were caught between these two worlds: the old Renaissance and the new; classical Italian painting and expressionism. When critics asked Modigliani which "ism" he belonged to, he would reply "Modigliani"—his art simply could not find its place in these helter-skelter years of upheaval.

Modigliani ate regularly at Chez Rosalie, which was owned by Rosalie Tobia. The artist paid for his meals in drawings, which Rosalie kept in a kitchen cupboard. After his death, when Modigliani drawings could fetch a small fortune, she went to find her treasures only to discover that they had been eaten by rats. In another apocryphal story, he left behind several canvases that a landlady used as dust covers for her mattress and sofa. Unfortunately, she had also scraped off the paint before putting the canvases to good use—there is no telling how much the paintings might have been worth if they were intact.

Yet although Modigliani never became the darling of the belle époque, he did become one of the most copied artists of the 20th century. His style today is instantly recognizable: elongated facial features, provocative poses, almond-shaped eyes without pupils, and that "sentimental Italian line" that does not merely contain the figure, but caresses it.

Modigliani left behind very few letters, so what we know of his technique comes mainly from those who watched him paint. He began his work doing several quick sketches in charcoal, ink, or sometimes chalk on paper. Many of his subjects sat for him, but he also worked from photographs, beginning his drawings with the nose, then the eyes, then the mouth, and lastly, the outline of the face. He would then place a white sheet and piece of graphite paper beneath his first drawing and trace over them to simplify his lines. After several studies he would begin painting in thin washes of color, usually oils.

Modigliani worked with great speed, but in the end he was always dissatisfied with his work. Indeed, from the start his life was full of disappointments. He was born into an Italian Jewish family of merchants who experienced several ups and downs in their financial status. Unfortunately, Modigliani's birth came at a downturn. All the family's belongings were in the midst of being liquidated when Modigliani's mother was about to give birth. The family discovered an old Jewish law that stated if a mother was giving birth then anything on her bed could not be taken. Legend has it that to save the family's valuables, they piled everything on top of Modigliani's mother while she was in labor. Whether true or not, it is a depressing way to come into the world.

Modigliani's mother predicted her son would be an artist at a very young age. He began his artistic education in Florence and Venice where he was allowed to copy the paintings at Accademia di Belle. In 1906 he went to Paris, and much like his friend Picasso, became influenced by African sculpture. At this time he went through a period focusing purely on sculpture.

In 1915, he returned to painting, but his days as a sculptor would impact his painting style. One of his favorite subjects was Jeanne Hébuterne, an artist who became the mother of his first child. His paintings of her have a sculptural quality where the viewer can almost feel how the artist chiseled away at her features.

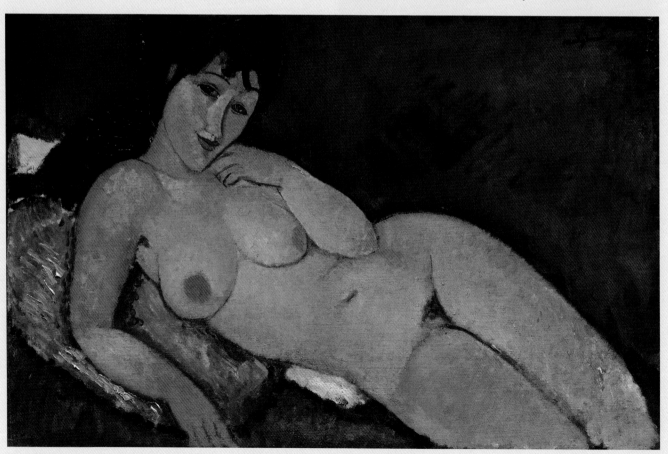

In December 1917, Modigliani had his first solo art show, but it was banned by the police due to the sensual nature of his nudes. The public saw his figures as more than just classically nude: they were *naked*. Modigliani had dared to use frontal gazes and even added pubic hair; women in paintings did not have pubic hair.

Undeterred, Modigliani began to paint at a prolific rate, probably because he knew he was dying. All his life he had battled with tuberculosis, and eventually, he began to lose the fight. Before antibiotics, tuberculosis was the leading cause of death in France, with no cure.

Typically, tuberculosis began in the lungs and then migrated to other parts of the body. In Modigliani's case, it went to his head and attacked his brain. He even lost his teeth. His friends thought he was drinking heavily and he became infamous for picking fights and walking through the streets of Paris naked. Sadly, what most people saw as alcoholism was actually a man staring death down—the disease probably gave Modigliani a sense of his own mortality. We can see that mortality in the corpse-like expressions of his figures. Their vacant eyes and gaunt faces possess a quiet strength, almost reminiscent of the death portraits that had become so popular with the birth of photography.

In 1920, tuberculosis finally took Modigliani's life: the artist was only 35 years old. Distraught, and nearly nine months pregnant, Hébuterne threw herself from her parents bedroom window, killing herself and their unborn child.

In this chapter, we will paint an expressive figure in the style of Modigliani. This painting should be done quickly, with direct intention. Finding the line in your figure will be a large part of its success. I recommend that you complete your first studies away from the computer to really feel the direction of the line.

"They see, even if I have not drawn their pupils."
AMEDEO MODIGLIANI

◄ **Nude on a Blue Cushion**
Amedeo Modigliani, 1917
Modigliani's work was considered far too sensual and his first solo art show was banned by the police as a result of this.

▲ **Adrienne (Woman with Bangs)**
Amedeo Modigliani, 1917
Modigliani was heavily influenced by African sculpture and the exaggerated facial features in his work are indicative of this.

"*To paint a model is to possess her.*"

AMEDEO
MODIGLIANI

◀ **Woman in Red**
Painted using Corel
Painter's Acrylic
and Impasto brushes

STEP 1 PREPARING YOUR CANVAS

In Modigliani's earlier work, he applied paint so thinly that you can still see the canvas. In later work, however, he built up layers of thin, translucent paint that covered his surface completely. He often worked with oil on canvas but also produced quick oil on cardboard studies. In this step, we will prepare a canvas surface.

1. Start by scanning a canvas texture and opening it in Photoshop.

2. Over the canvas texture create a new layer (Layer/New) and give it the title "Scraped Paint."

3. Select a light beige color from the Color panel and use the Scraped Paint brush created in the Arthur Rackham tutorial (p110) to draw a criss-cross pattern.

4. Set the Scraped Paint layer's blend mode to Overlay. Merge this layer down (Layer/

TIP RESOURCE SITE

Although I don't recommend it, you can skip this stage and open the background image from the companion website instead. The Sandy Pastel paper is part of the default Painter Paper Library set but you can also download it from the companion site or you can scan in your own papers and create your own textures.

Merge Down) and save the file. This paper will create a tonal start for your painting and also add texture. The brushes that you use later will blend this beige color with the paint.

5. Open your saved paper texture image in Painter. From the Paper Panel Library (Window/Paper Panels/Paper Libraries), select the Sandy Pastel paper. This paper has a very tight grain that allows the paint to go on smoothly.

6. Click on the Show Paper Controls button to launch the Papers panel. Increase the Scale amount to 150%, the Contrast to 150%, and set the Brightness scale at 60%. This will give you a sharp, slightly larger tooth to your paper.

7. Duplicate the Canvas layer by selecting all of it (Select/All) and then copying (Ctrl/Command + C) and pasting it (Ctrl/Command + V). Reduce the Opacity of the duplicated layer to 50% and drop it down (Layers/Drop).

8. Create a new layer (Layers/New) and draw a simple sketch using the Grainy Variable Pencil brush found in the Pencil brush category.

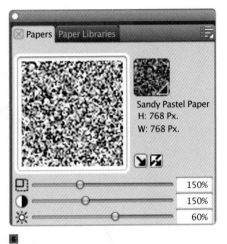

STEP 2 WEIGHT IN LINE

Modigliani started with a very simple sketch, before making quick brush strokes over the lines. Most of his lines appear to be dragged across the surface, resulting in a jagged stroke that is full of energy—there are very few sharp lines. These gestural strokes would become the basis for how negative and positive shapes played off each other, so here we will create a jagged brush to emulate Modigliani's line work.

1. Select the Large Chalk Brush found in the Chalk & Crayons brush category. In the Property Bar, set the Grain to 15%, Resaturation to 100%, Bleed to 0, and Stroke Jitter to 1.

2. In the Grain panel (Window/Brush Control Panels/Grain), set the Grain Jitter to roughly 34% and keep the Min Grain at 0%. Set the Expression to Pressure. This will cause your brush to randomly apply a Grain value of 0–15% based on the pressure of your hand.

3. Increase the Spacing (Window/Brush Control Panels/Spacing) to 50% to get a more jagged look to the mark.

4. In the Dab Profile (Window/Brush Control Panels/Dab Profile), set the Dab to Medium Profile. As you paint, alternate between Medium Profile and Pointed Profile, depending on whether you want a duller or sharper line.

5. In the Opacity panel (Window/Brush Control Panels/Opacity), set the Opacity Jitter to 25% and the Expression to Pressure. These settings will vary the Opacity, depending on the pressure of your hand.

6. With your brush complete, go over your initial pencil lines. Use a variety of thick and thin marks to help convey the weight of your figure. My figure's bottom uses a thicker line, for example, as it is weighted to the chair.

> *"Happiness is an angel with a serious face."*
> AMEDEO MODIGLIANI

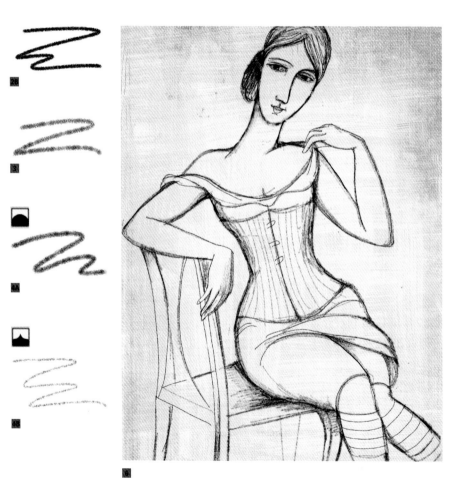

STEP 3 ADD GLAZES

Modigliani used a very limited color palette and preferred to layer colors directly on the canvas, rather of pre-mixing them. X-rays of his work show that he used short linear dabs to model his figures and longer, sweeping, zig-zag strokes for backgrounds. In this step, I will demonstrate how to follow a similar pattern to build up the paint.

1. You want to keep your existing lines above the paint layer so set the "sketch" layer's Composite Method to Multiply.

2. Select the Canvas layer. It is important that you paint directly on the Canvas because the Dry Brush used in the next step will pick up the beige tones and mix it with your colors.

3. Select the Dry Brush from the Acrylics brush category. In the Property Bar, increase the Wetness to 75% so that the paint is applied in thin washes.

4. In the Dab Profile panel (Window/Brush Control Panels/Dab Profile), select the Flat Rake Profile so that your marks have the feel of a bristly brush.

5. In the Color Variability panel (Window/ Brush Control Panels/Color Variability), set the Hue to 0%, Saturation to 6%, and Value to 11%. Color Variability will apply the paint in a slightly "dirty" way, by varying the value and saturation as you lay down color. Use this brush to apply your first layer of paint.

6. After you have got your first pass of color down, select the Dry Bristle brush (also found in the Acrylics brush category). In the Property Bar, set the Opacity to 15%, Grain to 10%, Resaturation to 75%, Bleed to 50%, and the Stroke Jitter to 0.10. Use this brush to apply another glaze of color—this will allow more blending of the colors.

7. Finally, select the Confusion brush found in the F-X brush category. In the Property Bar, set the Opacity to 100%, the Grain to 20%, and the Stroke Jitter to 0.14. Use this brush to break up and blend the paint, especially along lines that you want to recede into the background.

4

7A

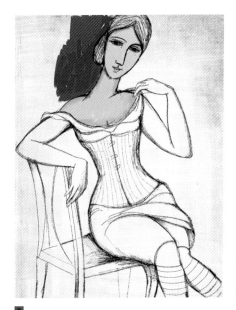

5

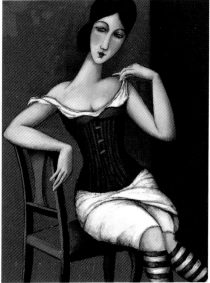

7B

TIP FINDING YOUR MARK

An artist's brush stroke is a unique part of the painting process. Your stroke length is very important, as it will convey the energy of the painting. Modigliani tended to use shorter strokes for facial features (to allow greater detail), and broader strokes in areas that would remain out of focus, such as the background.

STEP 4 BUILD UP PAINT

In Modigliani's later paintings, his brush work became looser and less smooth. He often sealed his work with layers of varnish that gave the look of heavy impasto. In this step, we will use several impasto brushes to build up the paint and then use the Highpass filter to enhance the texture's depth.

1. Varnishes often crack the surface of the paint so open the Paper Panel Library (Window/Paper Panels/Paper Libraries) and select the Crackle paper. This can be found in the Crack Textures paper library, which can be downloaded from the companion website.

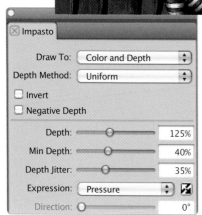

2. Select the Dry Brush from the Acrylics brush category. In the Impasto panel (Window/Brush Control Panel/Impasto) set Draw To to Color and Depth, the Depth to 125%, Min Depth to 40%, Depth Jitter to 35%, and Expression to Pressure. Use this brush to build up paint in the background.

3. Next, select the Dry Bristle brush from the Acrylics brush category. In the Impasto panel set Draw To to Color and Depth, Depth to 75%, Min Depth to 10%, Depth Jitter to 15% and Expression to Pressure. Use this brush to add impasto effects to the figure.

4. To add globulous paint, select the Graphic Paint brush found in the Impasto brush category. This brush will add the texture of whatever pattern you select. From the Pattern Library (Window/Media Library Panels/Patterns), select the Gravel pattern from the default pattern library.

5. Select the Square Hard Pastel brush. In the Property Bar, set the Opacity to 10% and the Grain to 5%. From the Paper Panel Library (Window/Paper Panels/Paper Libraries), select the Scraped Paint paper (that you can download from the companion website.) Use this brush over the face and body to introduce a softer crackle texture.

6. Duplicate the Canvas layer by selecting all of it (Select/All) and then copying (Ctrl/Command + C) and pasting it (Ctrl/Command + V).

7. Select the Highpass filter (Effects/Esoterica/Highpass). Set the Aperture to Gaussian and the Amount to around 6, then press OK.

8. Change the duplicated layer's Composite Method to Overlay. This acts like a "magic" edge sharpening tool that makes the paint appear more raised.

STEP 5 DIVINE PROPORTION

Most of Modigliani's figures retain a classical beauty through the use of Divine Proportion. For my finished image I adjusted the tilt of the figure's head to put it in a classical proportion to her body. I also lowered the nose to keep it in "divine proportion" to her eyes. Here's how it's done:

1. Open the Divine Proportion panel (Window/Composition Panel/Divine Proportion) and check the Enable Divine Proportion option. Set the Orientation, Size, and Rotate angle to suit your image (my settings were Orientation: Portrait Top Left, Size: 72%, and Rotate 25°).

2. Select the Divine Proportion tool from the Toolbar and move the spiral overlay into the desired position on your image.

3. For this image, I used the Lasso Selection tool to draw around the figure's head. I then copied (Ctrl/Command + C) and pasted the head above the Canvas layer (Ctrl/Command + V). I selected the Transform tool and rotated the head to tilt it to the right. I then painted over areas of the neck to combine the new tilted head with the body.

4. I repeated this process for the face, lowering the nose slightly so that it was in "divine proportion" to the eyes.

5. Finally, I painted over the eyes using the Square Hard Pastel Brush created on the previous page. This gave her eyes the soulless stare that Modigliani made so popular.

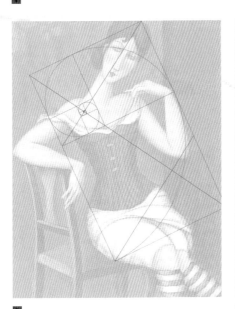

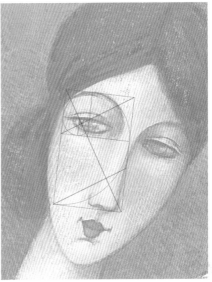

12
PABLO PICASSO 1881–1973
THE ART OF DESTRUCTION

LEVEL 1 2 3

What you will learn in this section
- Drawing upside down
- Breaking up planes of color
- Chalk techniques

Application
PHOTOSHOP

▶ **Weeping Woman**
Pablo Picasso, 1937
Shortly after painting *Guernica*, Picasso painted a series of "weeping women" portraying his mistress, Dora Maar. Picasso described women as "suffering machines" and in his case, he wasn't exaggerating: two of his lovers were driven to mental breakdowns, while another two committed suicide.

What began as a simple evening at Leo and Gertrude Stein's apartment in Paris turned into an encounter that would forever change Picasso as a painter. The Steins were the most influential art collectors of their day with their home visited by the premier artists, including Matisse, Picasso, and Renoir. On this particular night, Picasso never intended to have anything more than an evening discussing painting and politics, but seated in one corner was the artist's friend (and greatest rival), Henri Matisse.

Beneath his long beard and round-rimmed glasses, Matisse held something lovingly in his lap. It immediately piqued Picasso's interest and he politely inquired what Matisse was holding. Matisse handed the item over to Picasso dismissing it as nothing of importance—just a trinket he had picked it up at a curio shop on his way over. Picasso was immediately transfixed by the wooden head and absorbed every inch of its crude shape with its black, piercing eyes.

Shortly after that fateful night, Picasso visited the Musée d'Ethnographie du Trocadéro to study their neglected, dusty collection of African art. He then created hundreds of sketches before creating his final work—*Les Demoiselles d'Avignon* (originally entitled *Le Bordel d'Avignon*). The painting depicts a brothel scene, with distorted figures in seductive poses. The women are extremely angular, with sharp elbows and pointed limbs breaking the planes of the canvas like a hammer breaking a sheet of glass. The painting was first shown in an exhibition in 1916 where Leo Stein called it a "horrible mess" and Matisse described it as "the death of painting." After the exhibition, Picasso turned the painting toward the wall and would not show it again for another 10 years.

The artist's attitude toward women perhaps stems from his childhood: as a child, Picasso's mother and sisters fawned over him, while his father wheedled away his evenings at the local brothels. Picasso would later inherit his father's fondness for women and became an incurable philanderer—only his appetite for art matched his appetite for women.

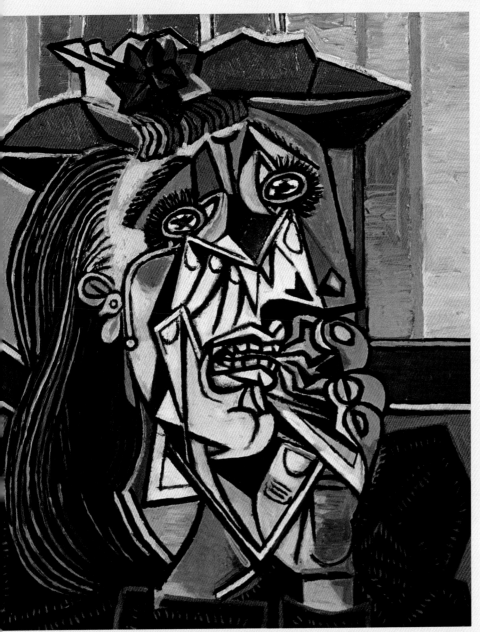

Yet when it came to the women in his life, he could also be a mass of contradictions—sweet and romantic one minute; spiteful and cruel the next. He referred to women as either "goddesses" or "doormats," and if you were Picasso's girlfriend you wanted to stay on his good side—any female paramour could find herself painted as a beautiful virgin one minute, and the next a she-devil monster with eyes hanging off her face.

Biographers tend to fixate on Picasso's love life, and this is for good reason—his artistic style would change with his women. Consequently, Picasso's artistic style changed so much through his life that it is impossible to zero in on one painting technique for this tutorial.

There were some common denominators throughout his work, though. Chemical analysis reveals that Picasso used a combination of industrial paint and oil paint, for example, while the female nude also became a repeated theme in his art. However, he is perhaps remembered most as a pioneer of the Cubist movement, and it is an amalgamation of these three ideas that we will emulate here.

"If only we could pull out our brain and use only our eyes."
PABLO PICASSO

▲ **La Prostituée Regarder**
For this painting, I took the same
pose used in the Modigliani

STEP 1 UPSIDE DOWN DECONSTRUCTION

Picasso would delineate form with angular, sweeping brush strokes and then fill the divisions that his lines made with bold colors. In this first step, I am going to take the drawing I made for the Modigliani tutorial (see p145) and then stretch and deform each of the shapes to produce a more geometric study of the figure. I am going to do this with the painting turned upside down so that I "turn off" the logical side of my brain.

1. Open the drawing in Photoshop and select Edit/Transform/Flip Vertical so you have an upside down image to work on.

2. Select the Brush tool from the Toolbar. To outline your figure in pen and ink you will need to customize a brush, so click on the Brush Preset Picker and select the Flat Point Medium Stiff Brush.

3. Open the Brush panel and set the Size to 2, Bristles to 1%, Length to 500%, Thickness to 200%, Stiffness to 1%, and the Angle to 35°.

4. At the bottom of the Brush Panel, turn on the Live Brush Tip Preview so you can see how your brush changes. With my brush, the preview window shows that I have a long, thin brush that will bend as I paint.

5. Create a new layer (Layer/New/Layer...) and name it "Pen & Ink." On this layer, outline your figure with your new brush, following the lines loosely (I tried to not

pick up my hand so that it would be more of a contour drawing). When you are satisfied with the line work, delete the original sketch layer by dragging the Background layer onto the trash can icon.

6. Finally, select parts of the body using the Freehand Lasso tool and then use the Warp tool (Select/Transform/Warp) to distort them.

7. Lastly, flip the image right-side up by selecting Edit/Transform/Flip Vertical.

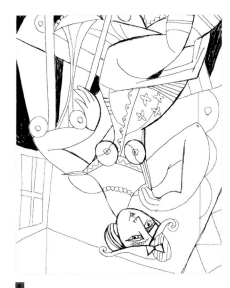

STEP 2 ADD COLOR

In his Cubist work, Picasso focused less on color and more on form. Color was still used to instill emotion, but its main objective was to fragment the form into abstracted shapes. In this next step, we will use Photoshop's Fill tool to add geometric planes of color.

1. First, you need to make sure all your lines are closed off, so the color fill does not spill out of them. Zoom into your image and use the Brush tool you created previously to close off all of your shapes.

2. Once the shapes are closed, select the Paint Bucket tool, choose a color, and click inside a shape to fill it.

3. Add geometric lines to force the eye in different directions. In my image, these lines include vertical lines in the background, diagonal lines on the chair, and the lines across the figure's stockings. Drawing lines in different directions create movement.

4. Increase the Size of your brush to 4, and use this to thicken the lines that separate each shape.

5. Finally, fill some of the background elements with black and fill some of the foreground elements with white. These black and white shapes create a direct tension between objects.

"Colors, like features,
follow the changes
of the emotions."

PABLO PICASSO

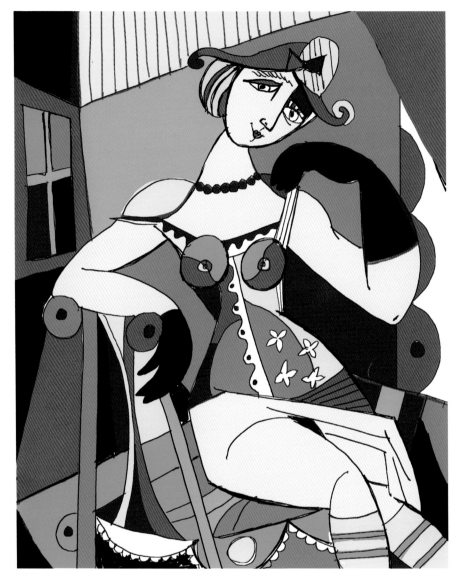

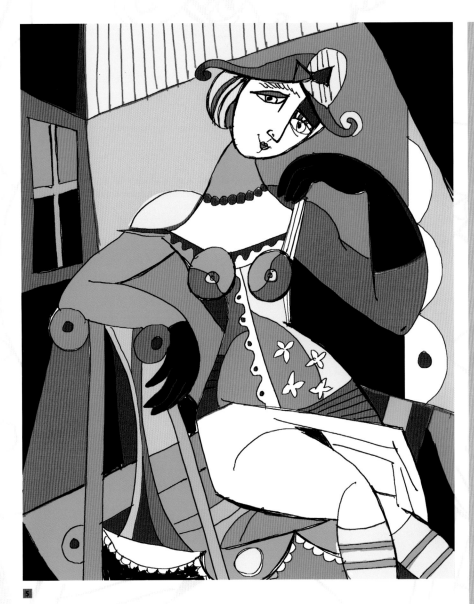

Whenever you want to thicken your lines up quickly:

1. Select Filter/Other/Minimum.

2. Set the Radius to 1.

3. Set the Preserve to Squareness.

The original sketch, without the Minimum filter applied.

The same sketch with the Minimum filter applied (Radius set to 1 and Preserve set to Squareness).

STEP 4 CHALK OVER

The final step is to paint over the flat colors with the chalk brush and add symbolic details. The purpose of this step is not to add depth, but to further delineate the shapes by outlining them and adding texture.

1. Select the Brush tool from the Toolbar.
2. Click on the Brush Presets and select the Chalk 23 Pixels brush.

3. Open the Brush panel and click on the Brush Tip Shape option. Change the Spacing to 50%. This causes the chalk brush to spread out 50% when applying paint. You should see the preview window update to show how the brush will make a mark.

4. Click on the Shape Dynamics option. Many of the Shape Dynamics options control the randomness of the brush. For Size Jitter, set the Control to Pen Pressure, which varies the size of your brush depending on the pressure of your hand. Set Minimum Diameter to around 80% to prevent your brush from dropping below 80% of its size, and set Angle Jitter to 50% and Control to Direction. These last two settings mean that the angle of your brush starts out at 50% and then varies depending on the direction your hand moves in. Working down the dialog window, check the option for Flip Y Jitter to flip the brush

shape across the horizontal axis, then check the Brush Projection option. This setting causes the brush tip to look larger or smaller depending on the angle that you hold your stylus.

QUICK TIP: ORGANIZING YOUR BRUSHES

If you have a particular texture that you like, or a way of scattering the paint that you want Photoshop to apply to all brushes, click the lock item next to the Texture option. However, as this locks the settings across every brush, it is not recommended if you are create an organic feel in your work.

Unlike Painter, Photoshop will not save the last settings used for each brush. If you were to select a different brush, and then go back to the brush created in step 4, you would

find that all your hard work of customizing the brush had been undone. To avoid this, a brush must be saved as a Preset:

1. In the Brush panel, click on the small right arrow at the top of the dialog window and select New Brush Preset from the drop-down menu.

2. Name your new brush and it will subsequently appear whenever you open Brush Presets.

5. Next, click on the Scattering option at the left side of the Brush panel. Set the Scatter to 30% and the Count to 2. These settings will add a slightly random scatter to your paint.

6. Click on the Texture option at the left side of the Brush panel, then click on the Pattern Picker. Select the Extra Heavy Canvas Pattern. (Note: This pattern can be downloaded from the companion website; to load it, click on the small gear icon in the pattern picker window and select Load Patterns from the drop-down menu.)

7. Having picked your pattern, check the Invert option and also Texture Each Tip. These settings will invert your pattern and apply it to the brush every time you make a new mark. Finally, set Mode to Subtract to make your texture pattern "subtract" from the color laid down by the brush.

8. This final brush applies a dry, chalky medium that slowly builds up paint with each subsequent stroke.

9. Use this brush to add pattern, lines, and texture to your abstracted figure. I also drew in symbolic elements, such as eyes.

"Every act of creation is an act of destruction."
<div align="right">PABLO PICASSO</div>

INDEX

ACKNOWLEDGMENTS

> *"One can have no smaller or greater mastery than mastery of oneself."*
> LEONARDO DA VINCI

Many thanks to the talented artists who contributed to this book. Christina Hess, Kimberly Kincaid, John Malcolm, Nancy Stahl, and Jeremy Sutton, you inspire mastery.

PICTURE CREDITS

The Bridgeman Art Library/Palazzo Pitti, Florence, Italy: 36

Corbis: 69; Francis G. Mayer: 151

Getty/Apic: 90; DeAgostini: 92; Mondadori Portfolio: 91

Christina Hess/ChristinaHess.com: 123

© Imagine Publishing Ltd.: 65TL, 65BL, 65BR

Kimberly Kincaid/www.artbykimkincaid. com: 111

Library of Congress, Washington D.C.: 7, 124

John Malcolm/www.johnmalcolm1970. co.uk: 65TR

© Succession H. Matisse/DACS, London 2014/Archives H. Matisse: 125, 134

NGA Images: 23, 34, 35, 39BL, 40TL, 46BR, 53TL, 67, 74, 142, 143

© Succession Picasso/DACS, London 2014: 151

Scala/The Metropolitan Museum of Art/ Art Resource: 24

Shutterstock/Georgios Kollidas: 22

Nancy Stahl/nancystahl.com: 123

© 2013 Jeremy Sutton/PaintboxTV.com: 133

H. Zell: 57L

This book is accompanied by a website where my more recent work can also be found: **www.CarlynBeccia.com**

Find more digital painting tips and tutorials on my blog: **http://blog.CarlynBeccia.com**

I answer emails (eventually) at: **info@carlynbeccia.com**